HOLLYWOOD
THEN & NOW

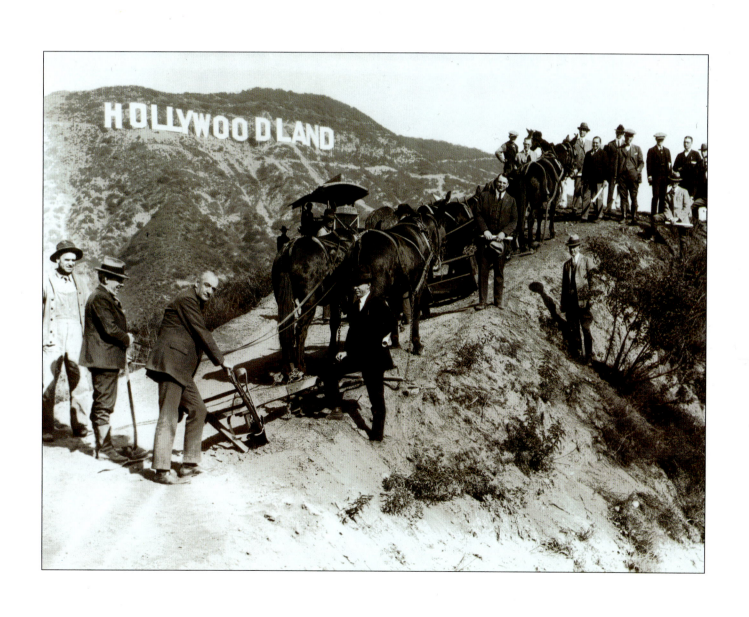

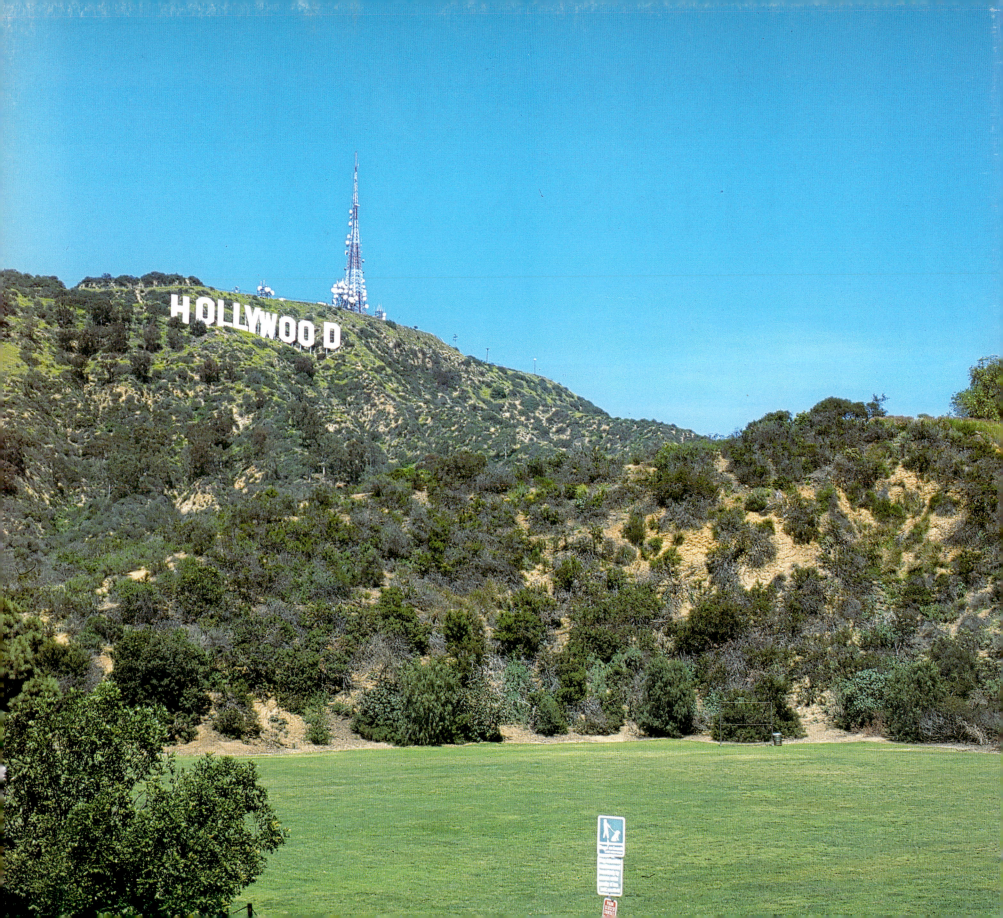

HOLLYWOOD THEN & NOW

ROSEMARY LORD

THUNDER BAY
P·R·E·S·S
San Diego, California

Thunder Bay Press
An imprint of the Advantage Publishers Group
5880 Oberlin Drive, San Diego, CA 92121-4794
www.thunderbaybooks.com

Produced by PRC Publishing Limited
The Chrysalis Building
Bramley Road, London W10 6SP, U.K.

An imprint of Chrysalis Books Group plc

Library of Congress Cataloging-in-Publication Data
Lord, Rosemary.
 Hollywood then & now / Rosemary Lord.
 p. cm.
 Includes index.
 ISBN 1-59223-104-7
 1. Hollywood (Los Angeles, Calif.)--Pictorial works. 2. Hollywood (Los Angeles, Calif.)--History--20th century--Pictorial works. 3. Hollywood (Los Angeles, Calif.)--Buildings, structures, etc.--Pictorial works. 4. Los Angeles (Calif.)--Pictorial works. 5. Los Angeles (Calif.)--History--20th century--Pictorial works. 6. Los Angeles (Calif.)--Buildings, structures, etc.--Pictorial works. 7. Historic sites--California--Los Angeles. 8.Historic sites--California--Los Angeles--Pictorial works. I. Title: Hollywood then and now. II. Title.

 F869.H74L67 2003
 979.4'94--dc22

 2003060834

Printed in China

1 2 3 4 5 07 06 05 04 03

ACKNOWLEDGMENTS:
Bruce Torrence, for so generously sharing his extensive knowledge; Jeannette Adler, for the gift of her time and her skills; Helene Demeestere of Historically Correct, for her invaluable help; Ron Kirchhoff, for always pointing us in the right direction; Dr. C. E. Krupp and Anthony Cook of the Griffith Observatory; Sam Cole of the Hollywood Roosevelt Hotel; Ben Barbose, Laval Howe, and Tiffany at Grauman's Chinese Theatre; Chantal Dinnage of the Hollywood Foreign Press Association; Alex Yemenidjian and Adrienne Sortino at MGM; Antoinette and Delmar Watson; The Immaculate Heart Community; Anna Martinez Holler of the Hollywood Chamber of Commerce; The Mary Pickford Foundation; Hollywood Forever Cemetery; Catherine Kort of Hollygrove; and most of all—my brilliant husband Rick Cameron, my coconspirator, for his support, encouragement, and his gift of laughter.

PHOTO CREDITS:
The publisher wishes to thank the following for kindly supplying the photographs that appear in this book:

"Then" Photography
All "then" photography was supplied courtesy of the Bruce Torrence Hollywood Historical Collection, with the exception of the following:
Pages 6, 7, 54 (top and bottom right), and 55 (bottom) courtesy of Hollywood Forever Cemetery
Pages 18, 38 (top and bottom), 39 (top), 74, and 75 courtesy of the Lord-Cameron Collection
Page 24 (top and bottom) courtesy of Immaculate Heart Community
Page 30 (top and bottom) courtesy of the Griffith Observatory/Austin Chalk Collection
Pages 39 (bottom), 42 (inset), 45, 47 (bottom), 70, 71, 72, 73 (top), 104 (top), 106 (inset), 138 (main), and 159 courtesy of Delmar Watson (Watson Family Photograph Collection)
Pages 58 and 59 courtesy of the Woman's Club of Hollywood
Page 62 (top and bottom) courtesy of Hollygrove
Page 64 (left) courtesy of © Bettmann/CORBIS
Page 65 courtesy of © Bettmann/CORBIS
Page 69 courtesy of Hollywood Professional School (photo: Elaine Ballace)
Page 73 (bottom) courtesy of Hollywood Foreign Press Association/Cecil B. De Mille Awards 1972
Page 82 courtesy of Church of Scientology Celebrity Centre
Page 106 (main) courtesy of Lance Alspaugh
Page 133 (right) courtesy of Greenblatt's
Page 138 (inset) courtesy of California Historical Society, Title Insurance, and Trust Photo Collection, Department of Special Collections, University of Southern California
Page 148 (left) courtesy of © Underwood & Underwood/CORBIS
Page 148 (right) courtesy of © Hulton-Deutsch Collection/CORBIS
Page 155 (bottom) courtesy of Hollywood Foreign Press Association/Cecil B. De Mille Awards 1985
Page 158 (inset) courtesy of © Bettmann/CORBIS

"Now" Photography
All "now" photographs were taken by Simon Clay (© PRC Publishing 2003), with the exception of the following:
Page 16 courtesy of Hollywood Presbyterian Church (photo: Lorynne Young)
Page 31 (inset) courtesy of Griffith Observatory/Anthony Cook
Pages 50 (top) and 51 (main) courtesy of MGM Studios, Inc.
Pages 77, 117 (right), 133 (left), 144 (bottom), and 145 (left) courtesy of Jeannette Adler Photographs
Page 79 (left and right) courtesy of the Chateau Marmont (photo: Tim Street-Porter)
Pages 123 (inset, left), 152 (top left and right, bottom), and 153 (main and inset) courtesy of Bob Freeman, Hollywood Chamber of Commerce
Page 144 (top) courtesy of The Ivy
Page 145 (right) courtesy of Morton's
Page 146 (left and right) courtesy of House of Blues
Page 147 (left and right) courtesy of Wolfgang Puck Collection
Page 149 (top left) courtesy of © SIEMONEIT RONALD/CORBIS SYGMA
Page 149 (top right) courtesy of © Rufus F. Folkks/CORBIS
Page 149 (bottom) courtesy of © CORBIS SYGMA
Page 154 (main) courtesy of © 2003 Hollywood Foreign Press Association/60th Golden Globe Awards
Page 154 (inset) courtesy of © 2001 Hollywood Foreign Press Association/58th Golden Globe Awards
Pages 155 (top) and 156 (left) courtesy of © 2002 Hollywood Foreign Press Association/59th Golden Globe Awards
Page 157 (top left and top right) courtesy of Crollalanza (ADC)/Rex Features
Page 157 (top center and bottom center) courtesy of Dan Steinberg/BEI/Rex Features
Page 157 (bottom left and bottom right) courtesy of Mirek Towski/DMI/Rex Features
Page 158 (main) courtesy of Stewart Cook/Rex Features

All inquiries regarding images should be addressed to Chrysalis Images, The Chrysalis Building, Bramley Road, London W10 6SP, U.K.

Front and back covers show: Pantages Theatre on the night of the 28th Academy Awards, 1956 (photo: © Bettmann/CORBIS) and the Pantages Theatre, 2003 (photo: Jeannette Adler Photographs). See pages 116 and 117 for further details.
Front flap photographs show: Hollywood and Vine, c.1949 (photo, top: Bruce Torrence Hollywood Historical Collection) and in 2003 (photo, bottom: Simon Clay/© PRC Publishing). See pages 122 and 123 for further details.
Back flap photographs show: Prospect Avenue and Wilcox in 1900 (photo, top: Bruce Torrence Hollywood Historical Collection) and in 2003 (photo, bottom: Simon Clay/© PRC Publishing). See page 20 for further details.

Pages 1 and 2 show: Hollywoodland sign in 1923 (photo: Bruce Torrence Hollywood Historical Collection), and in 2003 (photo: Simon Clay/© PRC Publishing). See page 29 for further details.

CONTENTS

INTRODUCTION

There was a time when the only stars in Hollywood were found in the night sky, a time when Hollywood was a sleepy, undeveloped place called Cahuenga (Place of Little Hills) by the local Gabrielino Indians, who were themselves named after the San Gabriel Mission by the Spanish who had sent them there for "spiritual and earthly well-being." When the Spanish first came, they divided the Cahuenga Valley into two: The west (the Hollywood area) became Rancho La Brea, while Rancho Los Feliz was to the east. As the Indians were systematically displaced, the farmers came and tilled the dry soil. The agricultural community flourished with subtropical fruits: oranges, lemons, and figs. The pioneers built adobe homes, planted bean fields, and tended their cattle.

In 1886 Harvey and Daeida Wilcox (*right*) from Kansas bought an area of Rancho La Brea that was covered in fig and apricot trees, with the plan to subdivide the land and call it Figwood. Lured by the pleasant climate, wealthy people would come from the Midwest, build beautiful homes along the wide streets, and "winter in California," Harvey predicted. While Daeida shared his dream, she did not like the name Figwood, so the new township was christened Hollywood. Wilcox divided his land into tracts and paved Prospect Avenue, the main road. Soon it was a prestigious residential avenue with elegant Victorian mansions and pepper trees. After Harvey's death in 1891, Daeida, a devoutly religious woman, continued his vision and offered land to anyone wishing to build a place of worship. She could not know that only decades later, the innocent word "Hollywood" would be synonymous with a Hollywood she could not have foreseen.

Meanwhile, other pioneers came to the land of sunshine pursuing a dream. John T. Gower came from Hawaii and brought harvesting machines and mowers for his new land. Jacob Miller bought land east of Laurel Canyon in the foothills, and Dennis Sullivan and his family planted pepper and eucalyptus trees on their new homestead. A Welsh colonel, Griffith J. Griffith, bought the Verdugo land, Rancho Los Feliz, in 1882. After developing some fine residential areas, he would later donate over 3,000 acres of his wilderness for city parkland, which would be called Griffith Park.

Hollywood's population neared 700 as the nineteenth century grew to a close. But that was about to change when oil was discovered in the Farmers Market area near Third Street and Beverly Boulevard. By 1900 the rush was on for black gold.

The community of Hollywood was prospering; churches, hotels, and schools were built, railroad tracks were laid, and the first horseless carriages appeared. But the Hollywood Board of Trade was not satisfied. Not enough of Hollywood's tax revenue was being spent by the County of Los Angeles on Hollywood street maintenance, more schools were needed, and many Hollywood residents wanted to ban alcohol to keep the cowboys and laborers from getting drunk in public and riding their horses wildly through the streets. The board members wanted to incorporate Hollywood as a city. On November 14, 1903, Hollywood gained its independence, not yet as the mecca for moviemakers, but as a bastion of sobriety for law-abiding citizens. With this came a number of ordinances: prohibiting sales of alcohol (except by pharmacists) and banning the riding of bicycles or tricycles on the two sidewalks in Hollywood. The driving of more than 200 cows (or 2,000 hogs) down Prospect Avenue at a time

was forbidden. Gambling, drunkenness, and disorderly conduct were also outlawed.

Hollywood's independence, however, was short-lived. With the rapidly growing population, Hollywood did not have enough water. Los Angeles County had plenty of water, however. In 1907 William Mulholland, a Dublin-born city engineer, had already realized there had not been enough available water to sustain the growth of a major city like Los Angeles. He had come up with a plan to divert water from the Owens Valley to Los Angeles, over 200 miles away. The longest aqueduct in the world was eventually inaugurated on November 5, 1913, when fresh water finally roared into Los Angeles. Hollywood needed that water.

By 1910 the city of Hollywood was technically no longer—it had become part of the city of Los Angeles. This was the price for water. But people, to this day, continue to call the area Hollywood. One of the final acts of this annexation was to change the name of Prospect Avenue to Hollywood Boulevard, thereby preserving the name for posterity. At that time, many street names were changed to honor the original settlers: Beachwood Drive, Cole Street, DeLongpre Avenue, Whitley Avenue, Wilcox Avenue (after Harvey Wilcox, *right*), Gower Street, Gardner Street, and so on.

Around this time, agriculture in Hollywood had begun to disappear. With a population now estimated to be 5,000, new residential areas were planned and new businesses opened. A new phenomenon had come to Hollywood—the moving picture business, which would put the area on the world map forever. The quiet times were over. Moviemaking started in Hollywood around 1907. Film companies were active in New York, but the Motion Picture Patents Company mercilessly controlled the movie industry, and the weather was unpredictable, with hostile winters causing costly delays. The independent film companies escaped to Hollywood.

The first Hollywood film studio was founded in 1911. Filmmakers came from New Jersey, Illinois, and New York. Great filmmakers such as D. W. Griffith, Cecil B. De Mille, Jesse Lasky, David Horsley, Al Christie, Hal Roach, and Carl Laemmle arrived in Hollywood in those first years. This was a time when Lillian Gish, Mack Sennett, and young Mary Pickford, later to become "America's Sweetheart," relocated to the land of the orange groves. Not long thereafter other filmmakers left New York and the wilds of New Jersey, where they were constantly mired by the inclement weather. They made their one- and two-reel westerns, "easterns" (sophisticated dramas), and comedies—all silent—in the California sun. Westerns were the most popular genre. Filmmakers were drawn by the year-round sunshine, the variety of landscapes, and the longer daylight hours for filming. These short films took less than a week to shoot, and studios were producing two or three films a week, creating a huge collection of silent films—few of which have survived. Many small film companies fell by the wayside and many more stood in line to take their place.

Rudolph Valentino, Charlie Chaplin, Buster Keaton, and Harold Lloyd brought their unique talents to Hollywood. In 1927 the advent of talking pictures spurred Hollywood filmmakers to create more blockbusters and sagas. Along came the movie moguls—Louis B. Mayer, Jack Warner, Adolph Zukor, David Selznick, and Sam Goldwyn—who brought Hollywood to worldwide attention with the combination of entertaining films and gorgeous movie stars. In 1923, a twenty-one-year-old Kansas farm boy and his brother set up a studio in their uncle's Hollywood garage. Five years later the brothers brought us a different type of movie star, Mickey Mouse, and the Walt Disney Studio was born. Step by step, Hollywood had become the permanent and recognized heart of the film industry.

Soon thousands of hopeful young men and women were pouring into Hollywood seeking fame and fortune in the motion picture industry. Labor unions were later formed to help the struggling actors, writers, directors, and various industry craftspeople that sought a future here. But this thriving industry created radical changes on the Hollywood skyline. Gone were the remaining lima bean farms. Sprouting in their place were new, tall buildings: offices along Hollywood Boulevard and towering apartments to house the huge number of workers that moviemaking required. From the biggest of the stars in their ivory mansions, the directors, producers, writers, and crew members, to the struggling thespians and extras who stood in line daily hoping to get picked to appear in a crowd scene, Hollywood had to provide housing for them all.

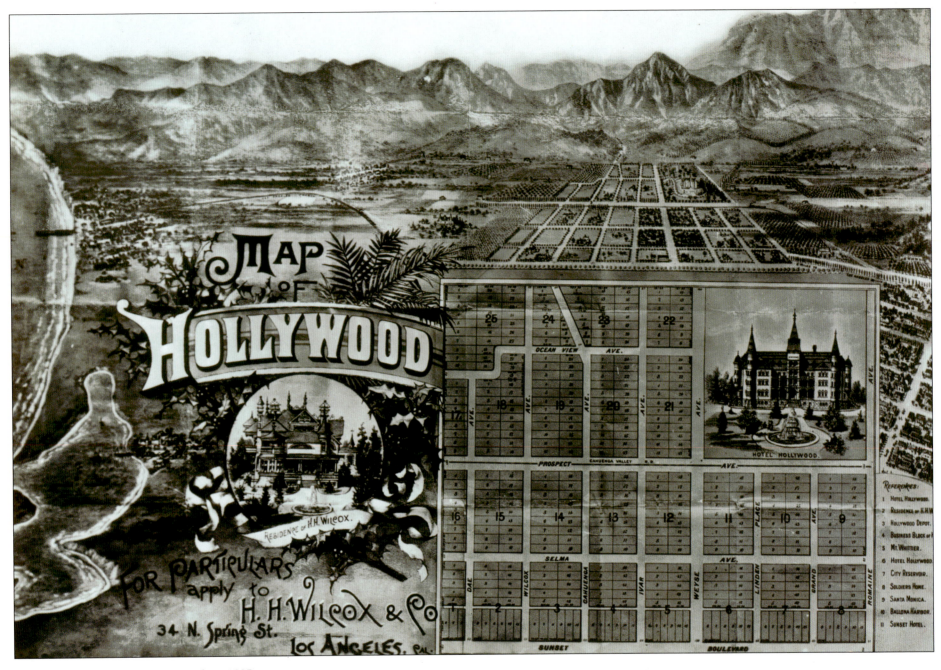

Above: Hollywood's first tract map, from 1887.

Stores, banks, restaurants, and clubs were also built, catering to the demands of the movie business.

In the 1920s and 1930s, forty million Americans were going to the movies each week, and the major film studios were pouring out fare for their unquenchable appetites. Movie magazines and trade papers, including *The Hollywood Reporter* and *Variety*, kept the world apprised of Hollywood comings and goings. The public emulated the hairstyles, clothes, and mannerisms of these screen gods and goddesses. With the help of master showman Sid Grauman and dedicated Hollywood promoter Charles Toberman, fanciful and exotic movie palaces had been erected along Hollywood Boulevard. The fans thronged in the thousands to the grand premieres at the Chinese and the Egyptian Theatres, content to sit in the specially erected bleachers or stand quietly outside waiting for a glimpse of a favorite movie star.

While America suffered through the Depression, the magic of Hollywood gave them a glimpse of a better time to come. That was Hollywood's job. The glamour of the nightlife in the 1930s and 1940s was unsurpassed and the stars dressed like royalty for their adoring public. Fans stood patiently outside the restaurants frequented by celebrities, waiting for autographs. In the golden days of Hollywood, the fans were an integral part of the Hollywood scene.

Throughout the World War II years, Hollywood rallied. Jimmy Stewart, Clark Gable, director John Ford, William Wyler, Mickey Rooney, Audie Murphy, and many more brave souls joined the military. Others raised money for war bonds (Gable's wife Carole Lombard was killed in a plane crash on just such a mission). Some, like Bob Hope, traveled overseas to bring the magic of Hollywood to the troops.

The next decade saw one of Hollywood's darkest times. Joseph McCarthy's attempts to ferret out and blacklist suspected Communists and Communist sympathizers persecuted and silenced many talents in the entertainment world. The hearings were broadcast on a new medium: television, the new face of Hollywood.

For decades, Hollywood was the glamour capital of the entertainment industry, but in recent years other parts of Los Angeles have become popular. Many of the fashionable stores moved to Beverly Hills. The old dining and dancing favorites closed and were replaced by modern eateries. Hollywood was diversifying and changing with the times. In the postwar era, there were new screenwriters and a new breed of actors. The raw performances of James Dean, Montgomery Clift, a now fully grown Elizabeth Taylor, and the young Marlon Brando changed the face of Hollywood. In the 1960s a young Jack Nicholson, Anne Bancroft, Steve McQueen, a fresh-faced Goldie Hawn, Rita Moreno, and Sidney Poitier all did things their own way as the system that bound stars to one studio crumbled away.

The movie moguls are long gone, but the dreams that drove them are still alive. Major studios have adapted or died. Some have sold off the lots where they made their big movies, while others have been absorbed into large media corporations. But the smaller, independent film companies have risen as if from the ashes of those first, struggling, independent companies circa 1911.

We still celebrate the success of this city of dreams. The first three months of each year are crammed with award shows recognizing excellence in all fields of this magical industry, including writing, directing, editing, and acting. The Hollywood Foreign Press Association hands out the Golden Globe awards, while the 5,607 actors, directors, and industry professionals of the Academy of Motion Pictures and Sciences vote on the Academy Awards—also known as the Oscars. The ultimate moviemaking prize is still the Academy Award and the ceremony is watched by a massive global television audience.

Since 1985, Hollywood's commercial and entertainment district has been on the National Register of Historic Places, protecting it from further architectural erosion to ensure that the important sites of its past will be part of its future. Hollywood still advertises itself: The giant Hollywood sign, probably the most famous sign in the world, still watches over the area that bears its name, though the custodians are no longer the same people wishing to sell tracts of "Hollywoodland."

People originally came to Hollywood for the lemons, the oil, and the sunshine, but they stayed because of the movies. Everything in Hollywood has been touched by the movies. Every day, young hopefuls arrive in this celluloid paradise.

This book matches historical archive photographs with current images to reveal the fascinating history behind the Hollywood dream factory. As legendary gossip columnist Walter Winchell once said: "Hollywood is a town that has to be seen to be disbelieved."

BEFORE THE MOVIES

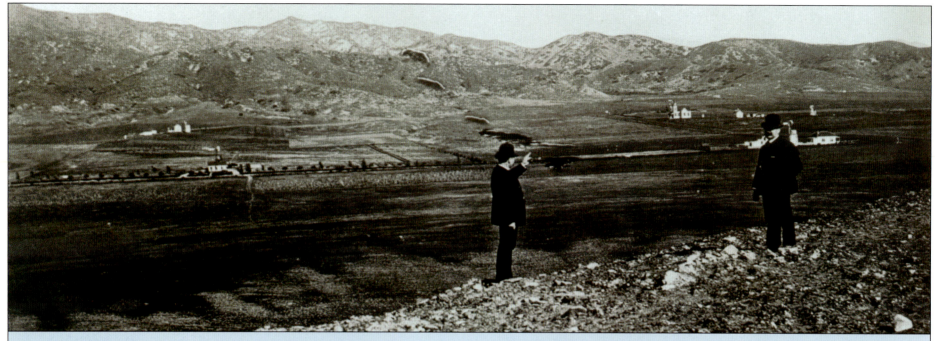

This dry, desert area became a magnet for people wishing to escape the blizzards and snows of the East Coast and the rain and hurricanes of the Midwest. Traveling by horseback and in horse-drawn wagons, hardy pioneers headed west in search of a better life and a better climate. The first settlers in the Cahuenga Valley found an arid basin of land surrounded by lush green hills. Sycamore trees and nopal cactus grew in the baking sun. The pioneers were used to hard work and soon established their homes and farms.

Before it bore the name Hollywood, this part of California was marked by mountain ranges, deserts, and tar pits. When Gaspar de Portola, the Spanish governor of the Californias, first explored this region in 1769, asphalt swamps were discovered. Early Native Americans burned the black tar for fuel, and later settlers dug into the swamps for waterproofing their adobe roofs.

The Mexican and Spanish governments had given large allotments of land to settlers to encourage colonization. One of these was Rancho La Brea (The Tar Ranch), and ownership was granted to Antonio Jose Rocha. John and Henry Hancock eventually became the Rancho La Brea owners. Henry built a refinery to prepare the tar for market.

During these excavations, ancient fossils were uncovered, which proved the existence of saber-toothed tigers, sloths, and early man in this area. Twenty-three acres of this land was eventually donated to the city in 1915 as an excavation site, the La Brea Tar Pits. This western part of Hollywood is also where oil was found around the turn of the twentieth century. With Henry Hancock dead, his widow Ida permitted speculative drilling for oil on her land in 1895.

That same year, a newspaper, the *Cahuenga Valley Suburban*, was started, with illustrated pieces on local farming aspects and blossoming residential areas. It offered glowing enticements of "lemon groves and sunshine" for prospective land buyers. The *Cahuenga Valley Sentinel* replaced it in 1899, soon becoming the *Hollywood Sentinel*. In 1905, a rival paper, the *Hollywood Citizen,* began with a forty-person subscription list. The two local papers merged in 1911 under the *Hollywood Citizen* name, with an impressive 800 subscribers. They ran advertisements and articles advocating the perfect life in "the land of sunshine, oranges and oil." The magic of the moving-picture business was still a future temptation.

BARNSDALL PARK

To the left of this Hollywood panorama shot (*left*) is Mount Lee, where the Hollywood sign would later sit. Owner J. H. Spires planted his thirty-six acres with olive trees here and called it Olive Hill. On June 3, 1919, oil heiress Aline Barnsdall bought the land, renaming it Barnsdall Park. Frank Lloyd Wright's first Los Angeles commission was Barnsdall's Hollyhock House, where the politically eccentric heiress struggled in vain to establish an artists' colony in her home. Long after Barnsdall's 1946 death, the city took over the deteriorating property for renovation.

The Mayan-influenced Hollyhock House is still standing. In 1975 Barnsdall Park opened as a successful arts center with galleries, studios, a library, and theater. It is currently closed for restoration. The hilltop view (*below*) shows the development of Mount Hollywood and Griffith Park. Though Hollyhock House was the first of its kind, Lloyd Wright went on to refine his ideas and built the Ennis House in 1923. Visible from Vermont Avenue looking north, it was used for Ridley Scott's futuristic film *Blade Runner*.

Left: This 1895 Hollywood panorama is looking north from the hilltop property that stretched from Sunset Drive to Prospect between Vermont and Edgemont.

Below: The current view was taken from Frank Lloyd Wright's Hollyhock House, one of four "textile block system" houses Wright built in California.

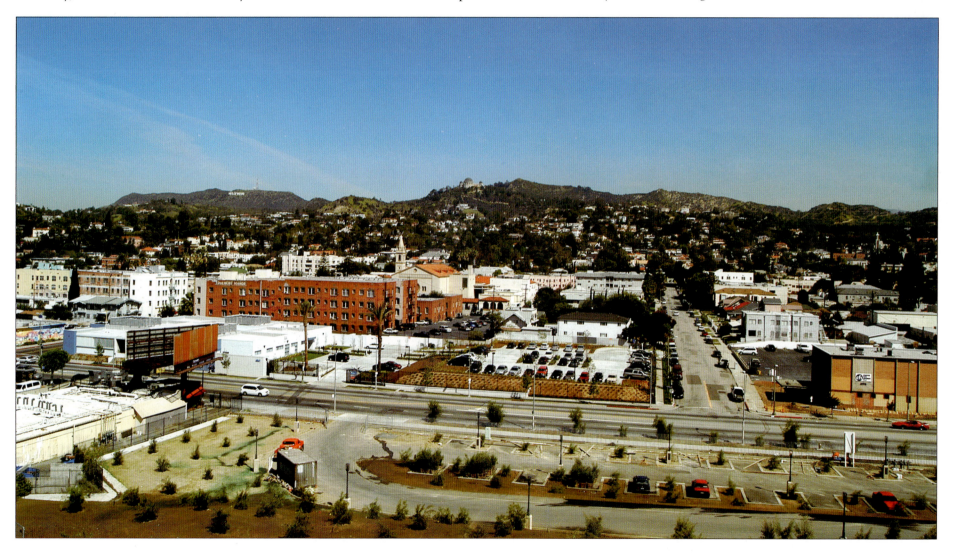

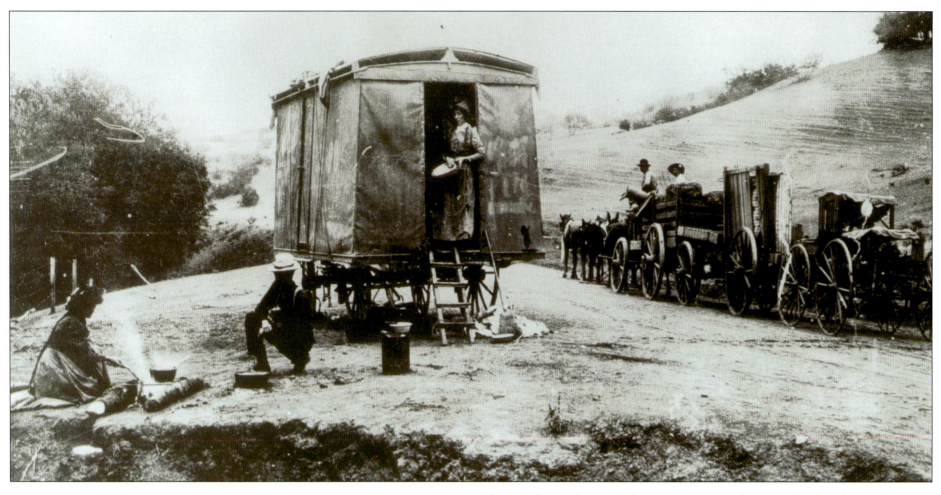

Above: Early travelers in 1892 passing through and camping by the side of the pass.

THE CAHUENGA PASS

There is now scant trace of the Gabrielino Indians, the first recorded residents of what is now Hollywood. There are some Native American place names, however, that have survived, such as Malibu and Cahuenga.

The Cahuenga Pass was the route through the hills to the valley beyond. Originally a simple winding trail over which cattle were driven, it was later used by the Spanish, Mexicans, and early settlers with their wagons and mule teams. Tales of hidden gold, highwaymen, and banditos abounded, but the pass made history with the battles of 1831 and 1845. In 1847 the Treaty of Cahuenga, which ended the U.S.–Mexico War, was signed in a small adobe house at the north end of the pass, the present site of Universal City. The first overland mail delivery to Los Angeles was delivered as early as 1848, and the Cahuenga Pass was used as the route.

Over the decades the pass has been widened and built up, and in 1911 the Pacific Electric Railroad tracks were laid for the famous Red Cars. The project was finally completed in 1926 and cost $500,000. The pass was later paved over for bus routes. When the San Fernando Valley became a center for the movie studios, the pass was the main link between it and Hollywood. The increasing traffic led to the Hollywood Freeway opening in 1954. Today a new subway system is being constructed beneath the Cahuenga Pass.

Right: The Hollywood Freeway opened in 1954 to cope with the heavy traffic between Hollywood and the San Fernando Valley.

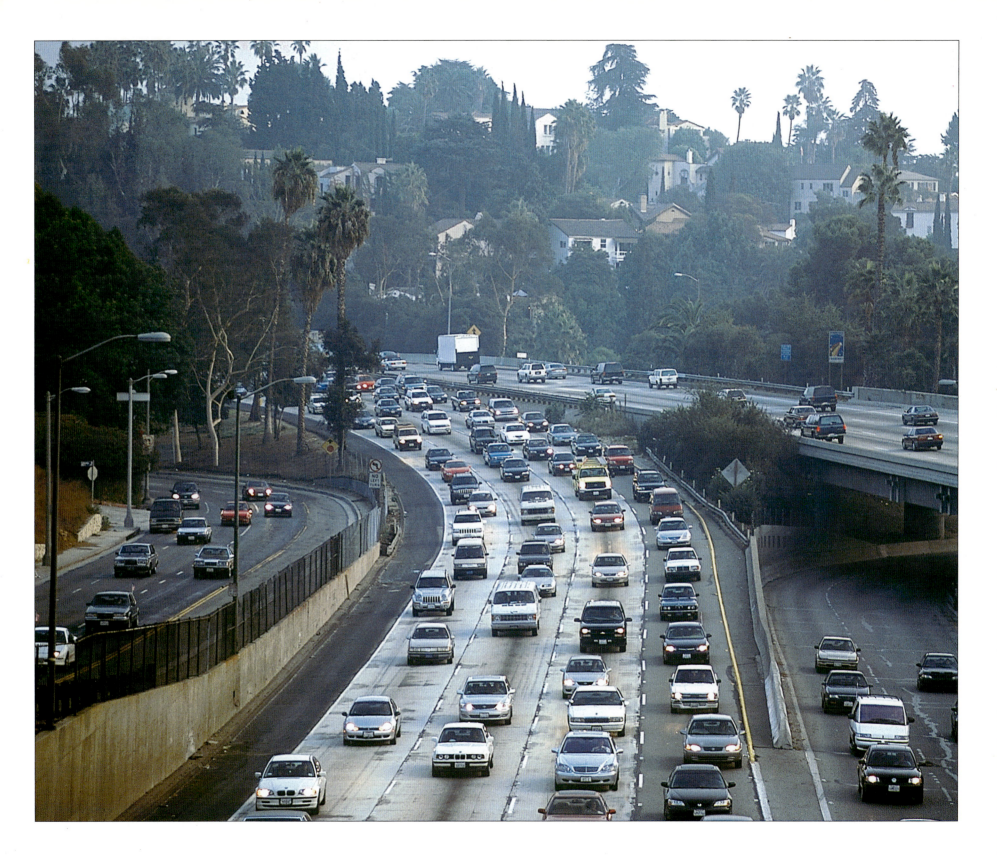

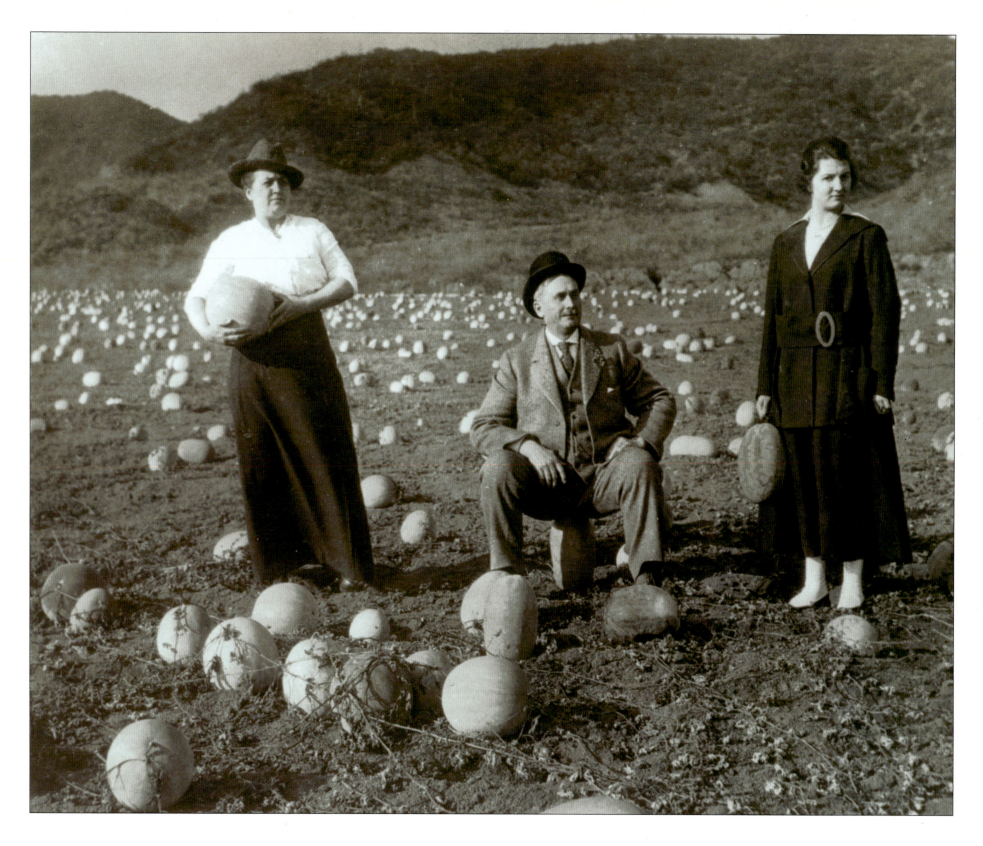

SUNSET BOULEVARD & HARPER STREET

When people traveled west in search of a better life, they found balmy days and longer daylight hours in Hollywood. This climate was ideal for farmers, and the agricultural community flourished. By the 1880s, the farmers' crops of subtropical fruits, such as pineapples, oranges, lemons, and melons, were in plentiful supply. This casaba melon patch (*left*), seen here in the early 1900s, was the original site of the Sunset Strip, so named for the real estate term used for strips of land not incorporated in the city. A no-man's land, the Strip was dismissed as merely a link between Beverly Hills and Los Angeles. Owned by the county, this area was subject to lower taxes and less rigid laws. In the 1930s, Frances Montgomery constructed four French-style stores for his Sunset Plaza project. The Hollywood agents then moved in, attracted by the lower rents. As Hollywood grew, elegant homes and apartment houses sprang up along the Sunset Strip. This was an ideal place for gambling and nightclubs. Movie stars invested in clubs and businesses here. Film director Preston Sturges's Players' Club opened in 1940. Here Humphrey Bogart, Mario Lanza, Orson Welles, and other show-business friends tended bar and flipped hamburgers with him. The Players' Club was replaced by the Imperial Gardens, which then became the Roxbury club. This was recently replaced by the Japanese restaurant Miyagi's, seen below on the right of the photo.

Left: This melon patch was part of 200 acres of land bought by Belgian developer Victor Ponet in 1890.

Below: The impressive Norman-style Chateau Marmont hotel, towering behind Miyagi's, still stands unchanged almost eighty years after it was built.

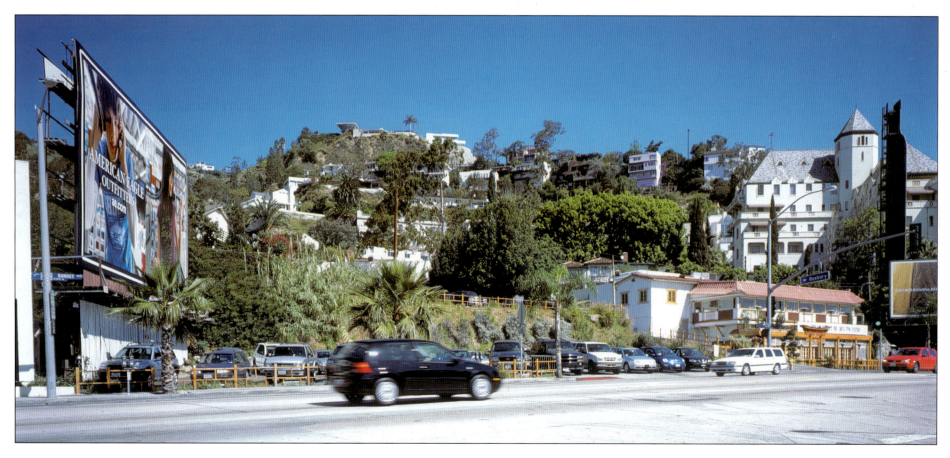

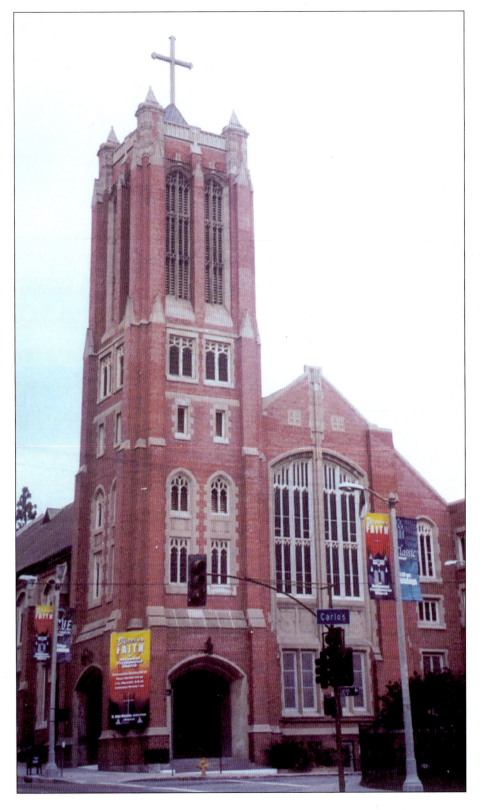

THE CITY OF CHURCHES

Before the movie industry arrived, Hollywood was a city of churches. Prohibitionists Harvey and Daeida Wilcox, devout Christians, encouraged all religions in the city they called Hollywood. After Harvey Wilcox's death in 1891, Mrs. Wilcox, who was as generous as she was prayerful, offered land to those who wanted to build a place of worship.

In 1876 the German Methodist Church was the first church to be built. The Hollywood Christian Church was founded in 1888 and the First Methodist Episcopal Church South in 1889. Hollywood's Jewish citizens worshipped at the Wilshire Temple, then later established the Hollywood Beth El Synagogue on Crescent Heights Boulevard. The Cahuenga Valley's first Catholic church was Blessed Sacrament in 1903 —the same year the Sisters of the Immaculate Heart (an order founded in Spain in 1884) bought the land to build their church school and convent. As Hollywood grew, so did the places of worship. The First Presbyterian Church started construction on Gower Street in 1903. In the same year the First Baptist Church met at the Masonic Temple, moving to their own Las Palmas premises in 1908. Today many of these original churches are gone—but some of these glorious buildings remain, and new houses of worship have since sprung up in Tinseltown.

FIRST PRESBYTERIAN CHURCH OF HOLLYWOOD

Organized in 1903, members of the First Presbyterian Church of Hollywood paid $3,000 for the present site at the northeast corner of Gower and Carlos. The original sanctuary (now a gymnasium) was built in 1909 and the current neo-Gothic sanctuary was constructed in 1923. Featuring the historic Wylie Chapel, this church is one of the oldest places of worship in Hollywood. The original plans for the construction of the Hollywood Freeway in 1954 required the church's demolition, but the church was saved. In the heart of old Hollywood, the Presbyterian Church has been sanctuary to stars such as Rhonda Fleming and Virginia Mayo. Since 1987, the Actors Co-op has operated two theaters here, and a Hollywood scriptwriting program currently runs on the premises.

Left: The busy First Presbyterian Church of Hollywood has been in service for almost a hundred years.

WILSHIRE BOULEVARD TEMPLE

Congregation B'nai B'rith originated in 1862 in downtown Los Angeles. In 1929 it moved to its present address at 3663 Wilshire Boulevard and was renamed the Wilshire Boulevard Temple. This architecturally outstanding Byzantine-inspired temple is one of the largest and most influential reform synagogues. Over the decades, many Hollywood notables attended temple here, including Jack Benny, Al Jolson, and Irving Thalberg, head of MGM until 1933.

THE CHURCH OF THE BLESSED SACRAMENT

Hollywood's Catholic population had to travel several miles to attend Mass at St. Vibiana's Cathedral in downtown Los Angeles, until 1903, when the Church of the Blessed Sacrament was formed. Drouet's Hall on Cahuenga and Sunset housed the services until the first church was completed on Hollywood Boulevard at Cherokee. In 1928, the magnificent new Blessed Sacrament Church was completed at 6657 Sunset Boulevard. This became the parish for many Catholic Hollywood stars, including Loretta Young, Irene Dunne, and Bing Crosby.

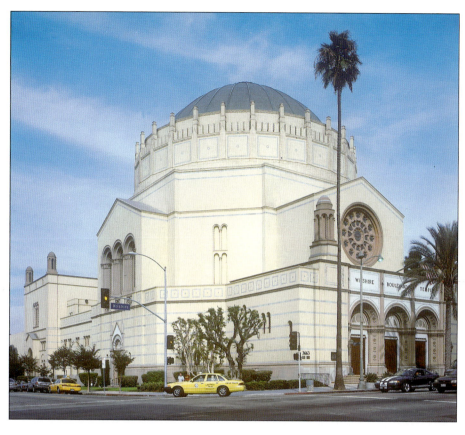

Above: The Wilshire Boulevard Temple was designed by Allison, Norton, and Edelman, and has been listed in the National Register of Historic Places. It is still patronized by many of Hollywood's Jewish stars.

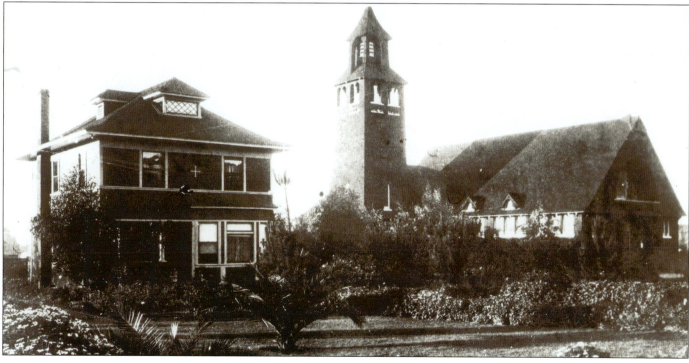

Left: An early shot of the Church of the Blessed Sacrament, which ministered to Hollywood's Catholic population. This photo was taken in 1907.

FIRST METHODIST EPISCOPAL CHURCH SOUTH

The First Methodist Episcopal Church South originated in 1890. Land donated by Mrs. Wilcox on Cahuenga and Selma was its home until 1904, when it moved to the southeast corner of Hollywood and Vine. In 1909 the First Methodist Episcopal Church of Hollywood was formed. In 1911 this stucco church was built on the northeast corner of Ivar and Hollywood Boulevard.

Below: The First Methodist Episcopal Church South, pictured here in 1912.

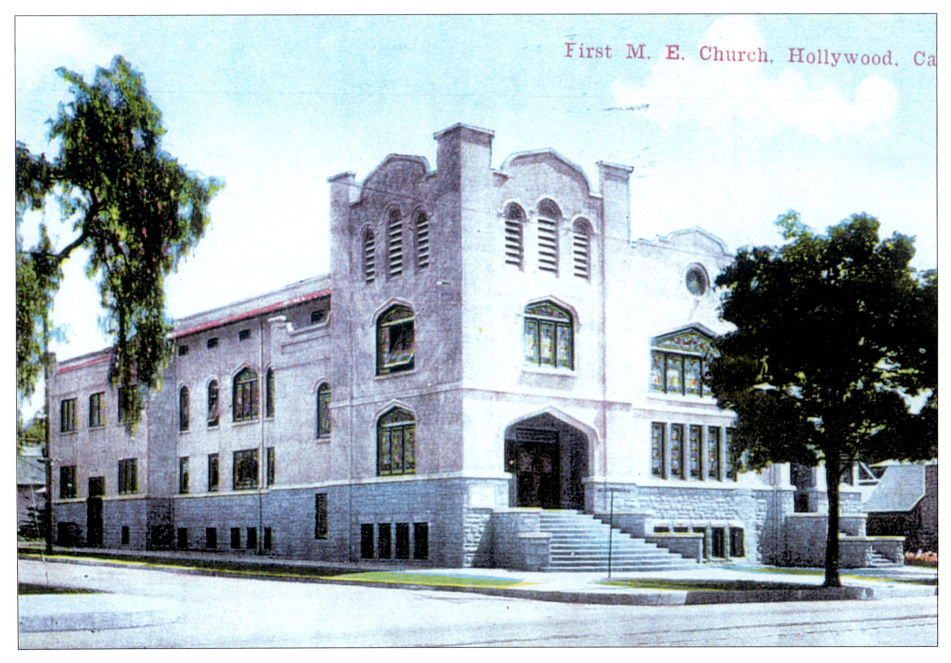

First M. E. Church, Hollywood, Ca

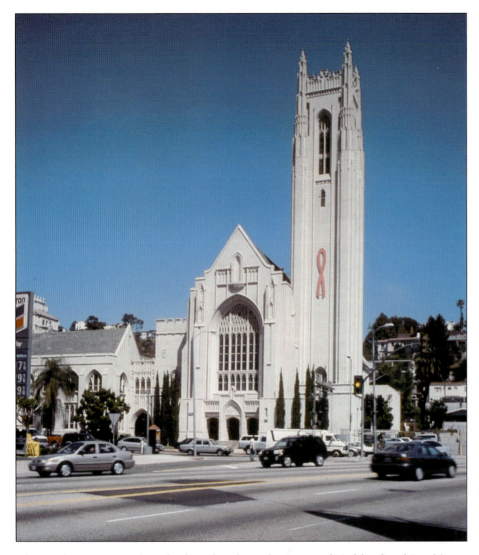

Above: The First United Methodist Church on the corner of Highland and Franklin Avenues. The huge red AIDS ribbon has adorned the building since 1993 to signify the church's AIDS Ministry.

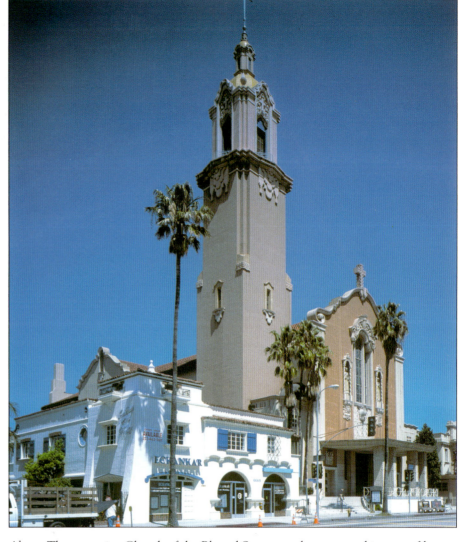

Above: The attractive Church of the Blessed Sacrament has appeared in many films and TV shows. Several scenes for the film *L.A. Confidential* were filmed here.

FIRST UNITED METHODIST CHURCH

In 1929, the church moved to its present location on the northwest corner of Highland and Franklin Avenues. By 1968, it was called the First United Methodist Church. Hollywood celebrities worship here, but the church is also famous in its own right. It has appeared in *Back to the Future, Sister Act, Gilmore Girls, Days of Our Lives,* and *Murder, She Wrote.* The church is also used for auditions and rehearsals for musical productions.

CHURCH OF THE BLESSED SACRAMENT

Although many of the old Hollywood stars moved west, the Church of the Blessed Sacrament, with its Spanish Mission–style frontage, still retains an elegant splendor. Like some of its parishioners, the church often appears in Hollywood films and television shows, including an episode of the hit show *ER.* Crossroads of the World, Hollywood's first shopping mall, has stood brightly next door since 1937.

PROSPECT AVENUE & WILCOX

In 1896 the Consolidated Electric Railway cable cars cut through the very heart of the city that would become Hollywood. In 1898 Collis Huntington and his nephew Henry had taken control of the company from Moses Sherman, and by 1901 the Pacific Electric Railway had been established. They introduced the Red Car streetcars and later the "Balloon Route," which linked downtown with the ocean, via Hollywood. This elegant Queen Anne–style house on the corner of Prospect Avenue and Wilcox was bought by investor and developer H. J. Whitley in 1900.

Prospect Avenue then became Hollywood Boulevard. Private cars soon replaced the railways and streetcars; the tracks were pulled up and freeways were introduced. Today, however, as appreciation for the neighborhood resurges, train cars are once again running along Hollywood Boulevard, but this time they are underground trains. The new Metro Red Line closely follows the routes of the old Red Cars.

Above Right: The tiny vehicle in this 1900 photo was an early two-seater electric car.

Below Right: Discount stores and restaurants now fill the street.

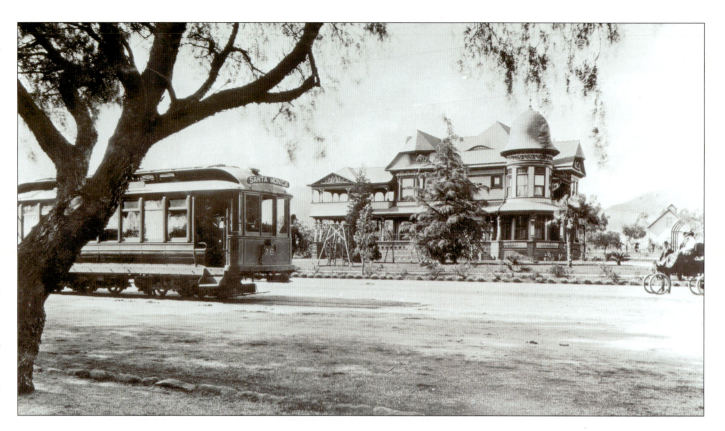

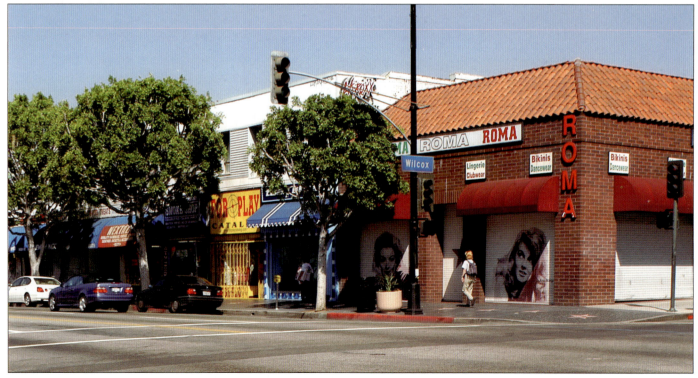

THE SACKETT HOTEL

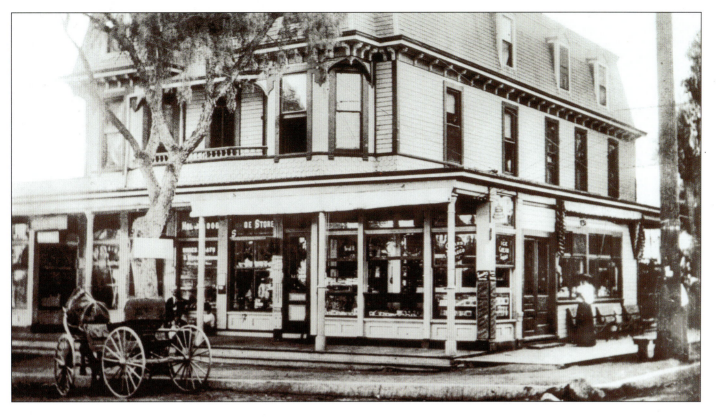

The first structure to be built as a hotel in the Cahuenga Valley was the Sackett Hotel on the southwest corner of Hollywood and Cahuenga Boulevards. Horace D. Sackett bought the land in 1887 and built a general store and the town's first proper hotel. The three-story building soon became a popular overnight spot for tourists and land prospectors. Staff served hot meals and sold dry goods, liquor, tobacco, and shoes. As more visitors came, Sackett added clothing items, hardware, teas, spices, and ice cream to his bill of fare.

In November 1897 an official post office was established in the Sackett Hotel and later Mamie Sackett became the first postmistress in Hollywood. In 1912 this wooden structure was replaced with a two-story building, and at the height of Hollywood's prosperity in 1931, a four-story Art Deco building was built on the enlarged site. Today a fast-food establishment and offices occupy that same brick-and-tile building.

Above Left: The Sackett Hotel, at Hollywood and Cahuenga, pictured here in 1901.

Below Left: The site today has been filled with stores and restaurants.

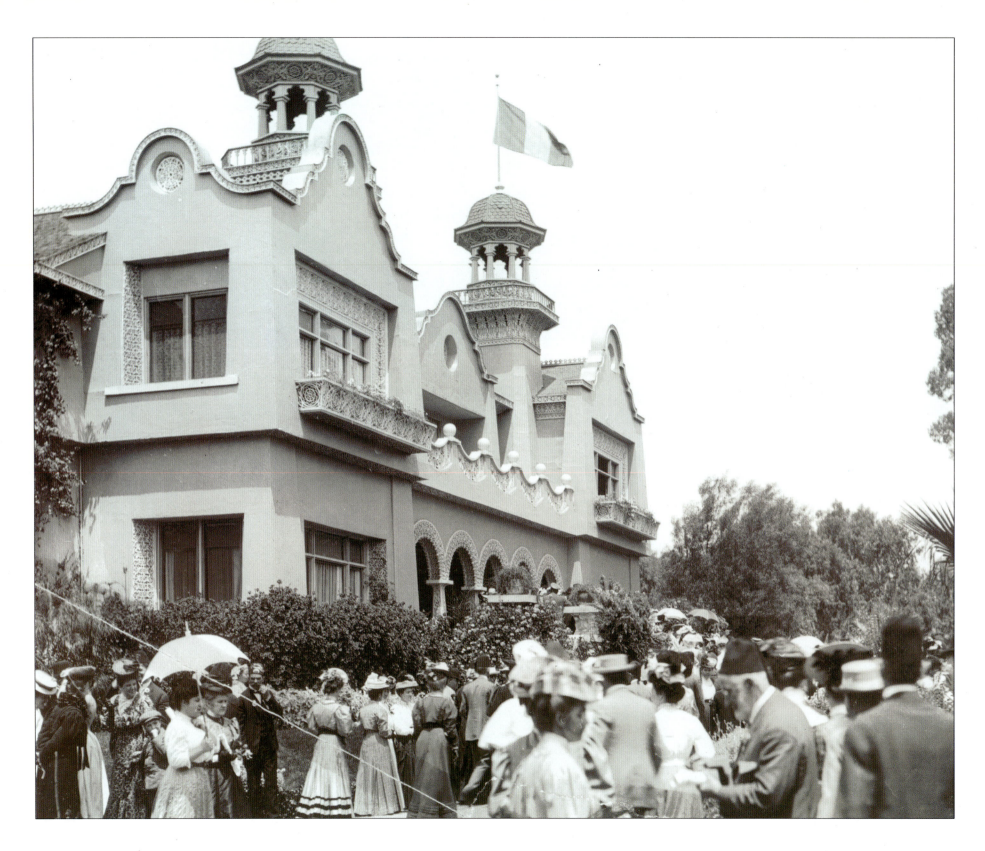

DELONGPRE HOUSE

Hollywood's first tourist attraction had nothing to do with the movies. Born in Lyon, France, in 1855, Paul DeLongpre became Southern California's first nationally renowned still-life painter. DeLongpre moved to Los Angeles in 1899 with his wife, Josephine, and three daughters. After a successful career in Paris and New York, he found the sunny weather perfect for painting the local flora. In 1901 he bought three sixty-five-foot lots on Cahuenga Boulevard near Prospect from Daeida Wilcox (now Mrs. Philo Beveridge). Finding his garden too small, the following year DeLongpre bought the corner lot, for which Beveridge accepted three paintings as payment. Paul DeLongpre's extravagant Moorish mansion soon became a tourist attraction. The DeLongpre House was the first stop in Hollywood for the popular Balloon Route Excursions. After his death in 1911, the DeLongpre House remained a tourist attraction until it was demolished in 1927. Hollywood commemorated the artist by naming the DeLongpre Park for him. It is situated on DeLongpre Avenue at Cherokee and has two statues in remembrance of the silent movie star Rudolph Valentino: a bust and an Art Deco abstract titled *Abstraction*.

Today the site of the DeLongpre House is home to a Greyhound bus station.

Left: The DeLongpre House was a major tourist attraction; thousands of visitors flocked to see his colorful gardens and watch him paint.

Below: The site is now a Greyhound bus station on North Cahuenga Boulevard.

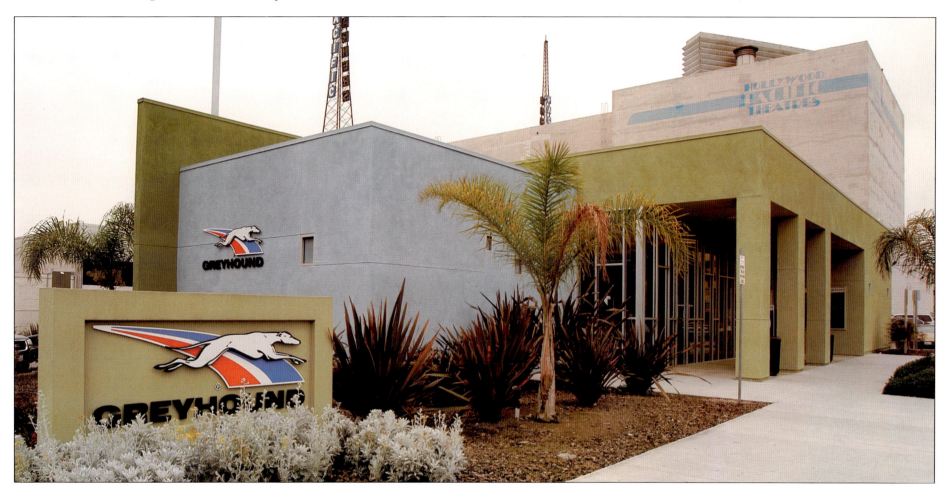

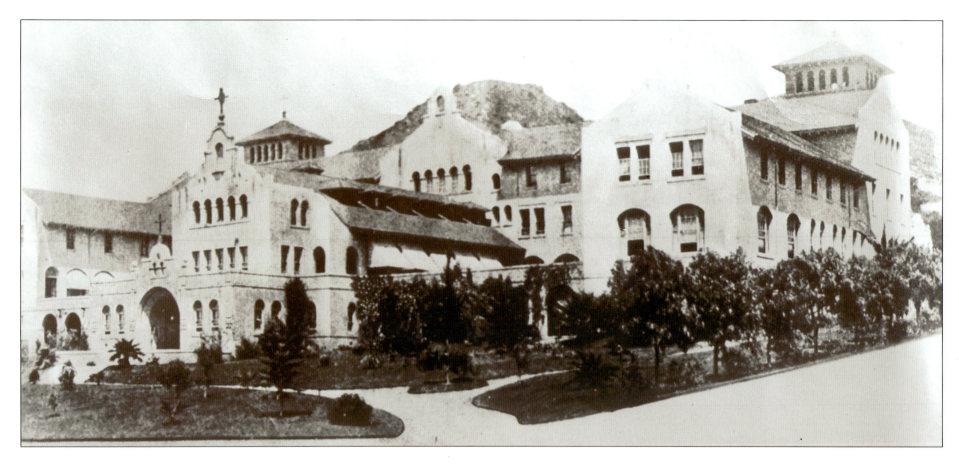

IMMACULATE HEART HIGH SCHOOL

In 1903, Western Avenue was just a rutted wagon road through a mustard field, where, for the princely sum of $10,000, the Sisters of the Immaculate Heart bought a fifteen-acre plot of land at Western and Franklin. In 1906, the Moorish-style Immaculate Heart high school, convent, and boarding school opened. The College for Girls commenced in 1908, welcoming students from all over the world. Immaculate Heart was the first private school to confer college degrees, awarding its first bachelor of arts degree in 1921.

The boarding school closed in 1967, but the high school remained and the middle school opened in 1975. In 1980, the American Film Institute acquired the college building for their library and film school, which funded the renovation of the high school. In 1991 the demolition of the old convent made way for a new playing field. Mary Tyler Moore, Lucie Arnaz, and Tyra Banks are among Immaculate Heart's famous alumnae. Since 1957, all graduation ceremonies have been held at the Hollywood Bowl.

Right: The school still survives, although its appearance has changed dramatically.

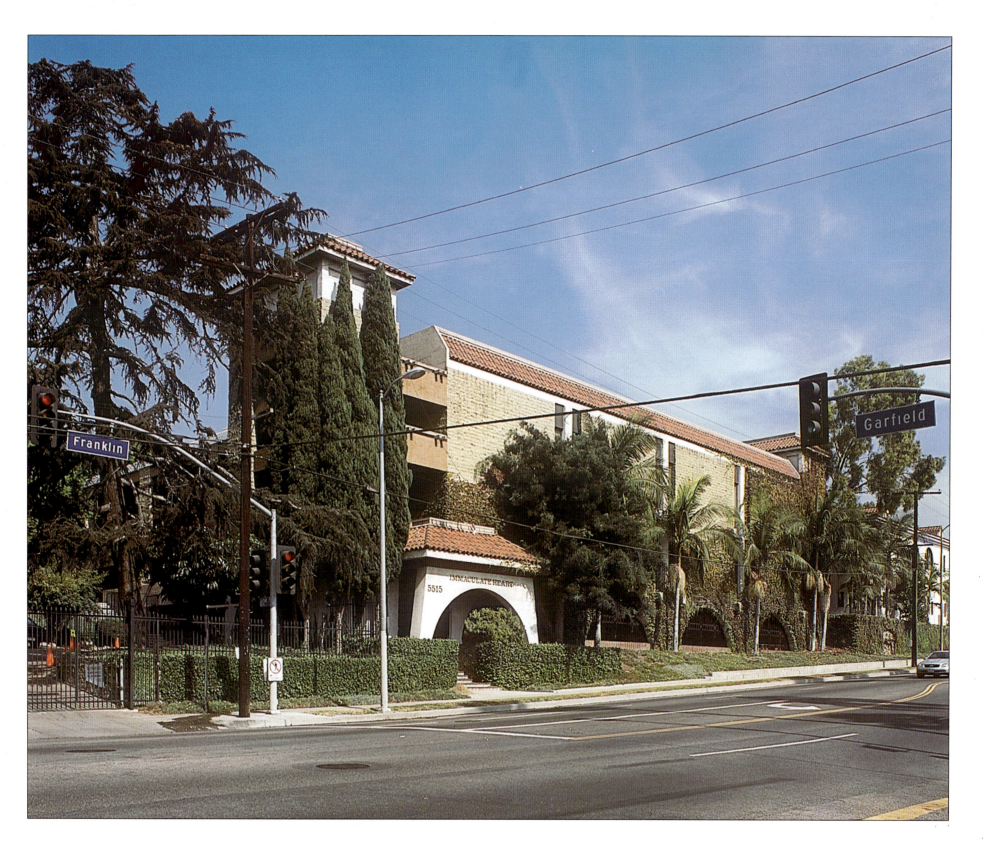

BEACHWOOD VILLAGE

Harry Chandler, developer S. H. Woodruff, and Tracey Shoults joined M. H. Sherman, director of the Pacific Electric Railway, to form the Hollywoodland Tract Office in 1923. They united with Albert Beach, another developer, who paved the way through the Hollywood Hills with a road he named for himself: Beachwood Canyon. Together they planned a major sales campaign for the area, setting up office at the Hollywoodland entrance. Two stone towers were built on either side of the entrance and a gated community with a guard on night duty was planned. The gate and the guard never materialized.

Today Beachwood Village remains relatively unchanged—although property prices have soared. The family-style Village Café is where stars go for breakfast with the rest of the world. There are small shops and there is still a property business, now called the Hollywoodland Realty Company, which occupies the original building. At the foot of the Hollywood sign, Beachwood Canyon now stops at the Sunset Ranch, where cowboys, actors, and horse lovers alike stable their horses and ride through the Hollywood Hills at sunset.

Below: The Hollywoodland Tract Office in 1926.

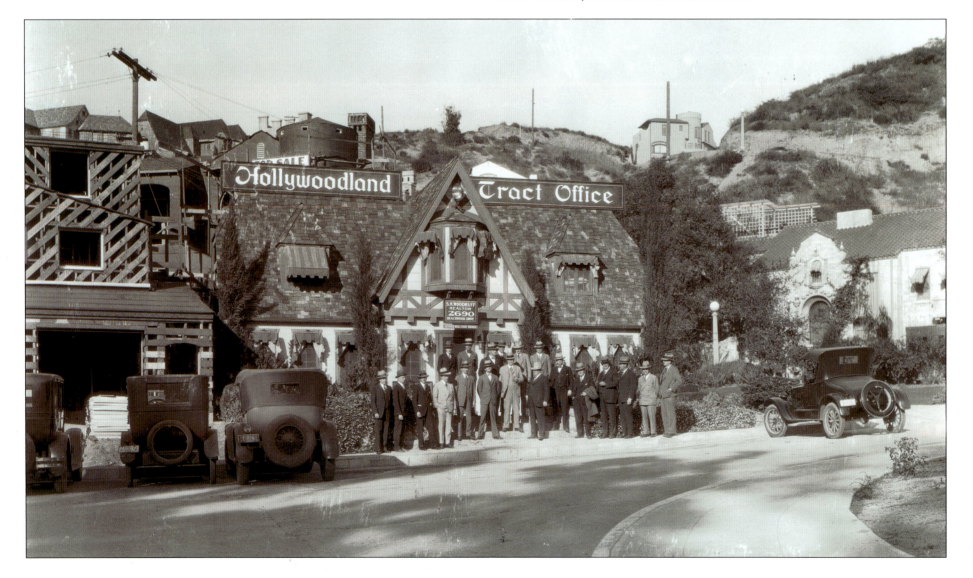

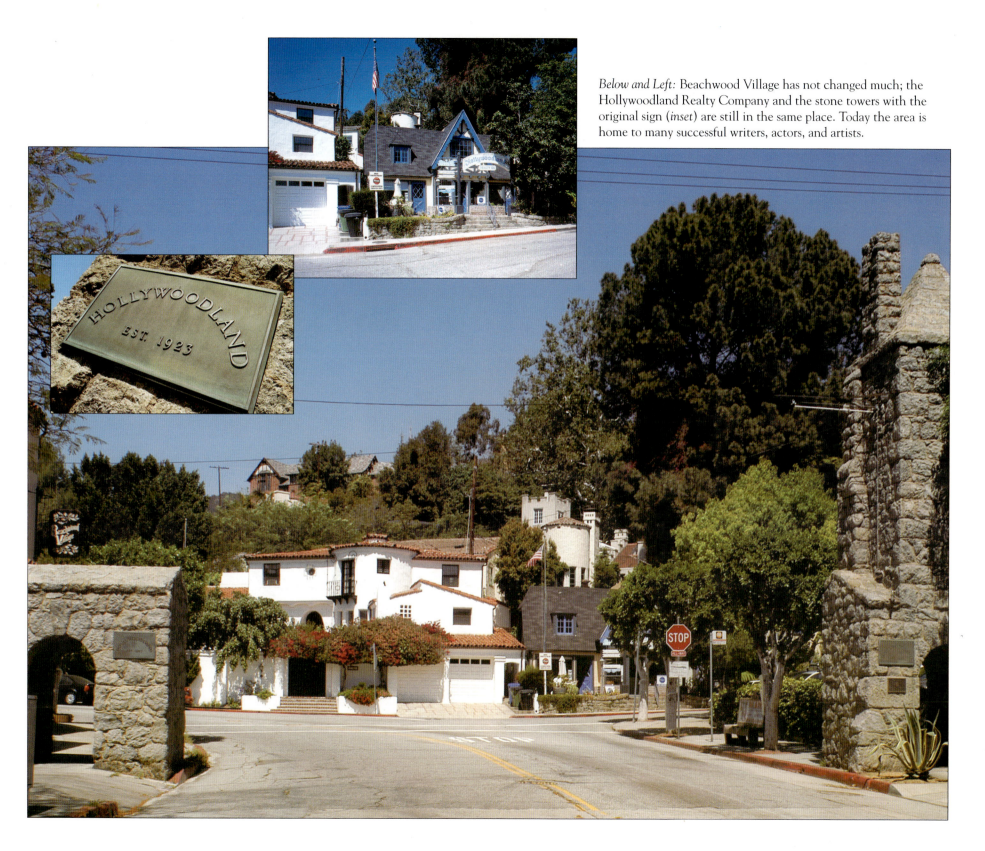

Below and Left: Beachwood Village has not changed much; the Hollywoodland Realty Company and the stone towers with the original sign (*inset*) are still in the same place. Today the area is home to many successful writers, actors, and artists.

HOLLYWOODLAND TOURISM

In 1900 Charles M. Pierce established the first sightseeing service, offering a "tour of the Cahuenga Valley with chicken-dinner" for seventy-five cents. He later started the Balloon Route Excursions, operated by the Los Angeles Pacific Railroad, with eighteen carloads of tourists a day. By 1925, Pierce was one of several guided tour operators in Hollywood. They were now using automobiles and small buses for sightseeing.

A consortium of Hollywoodland developers spent lavishly on promoting the district. They developed an area of more than 500 acres of rugged canyon, woodland, and knolls, which overlooked Hollywood. They built elegant Spanish- and Moroccan-style dwellings to attract an affluent clientele. Hollywoodland residents included Spring Byington, Boris Karloff, and successful English novelist Aldous Huxley, who emigrated to America and wrote screenplays for *Pride and Prejudice* and *Jane Eyre* among others.

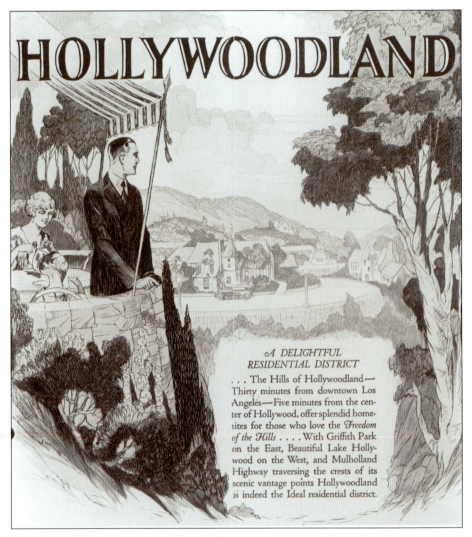

Above: This 1924 poster tried to attract affluent residents to the area.

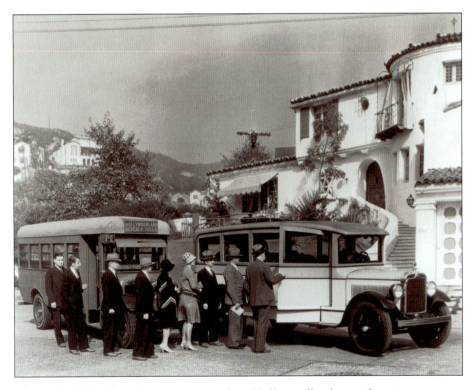

Above: By 1925, when this picture was taken, Hollywoodland was a favorite tour stop.

THE HOLLYWOOD SIGN

One of the most recognizable landmarks in the world, the Hollywood sign began as an advertising gimmick when developer Harry Chandler wanted to promote the 500-acre prime residential hill property overlooking Hollywood. At a cost of $21,000, the sign was made of white-painted sheet metal studded with 4,000 twenty-watt lightbulbs, with letters each fifty feet high and almost thirty feet wide. The Hollywoodland sign was visible from over twenty-five miles away. The original caretaker, Albert Kothe, lived in a small house behind the

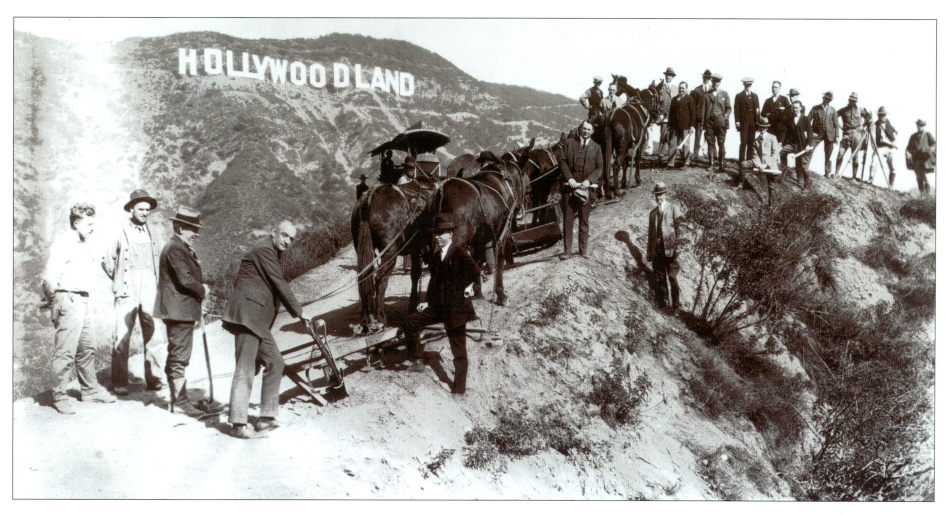

letter *L* and had the job of changing any bulbs that burned out.

Through the 1930s and 1940s, the sign's future seemed bleak. Disillusioned British-born actress Millicent "Peg" Entwistle jumped fifty feet to her death from atop the sign in 1932. By 1939 maintenance had ceased and all 4,000 lightbulbs had been stolen. In 1944, the bankrupt developer donated the sign to the city, which planned to tear it down.

In 1949 the Hollywood chamber of commerce decided to restore the "Hollywood," abandoning the "land." But it wasn't until 1974, when the sign was given landmark status, that a new era of preservation and recognition began. Today the chamber of commerce, the Hollywood Sign Trust, and the City of Los Angeles are the official stewards and the sign remains Hollywood's longest-lived advertisement.

Above: This photograph is of the 1923 dedication ceremony. The sign was changed from "Hollywoodland" to "Hollywood" (*right*) in 1949.

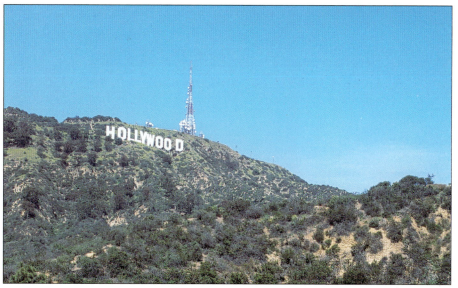

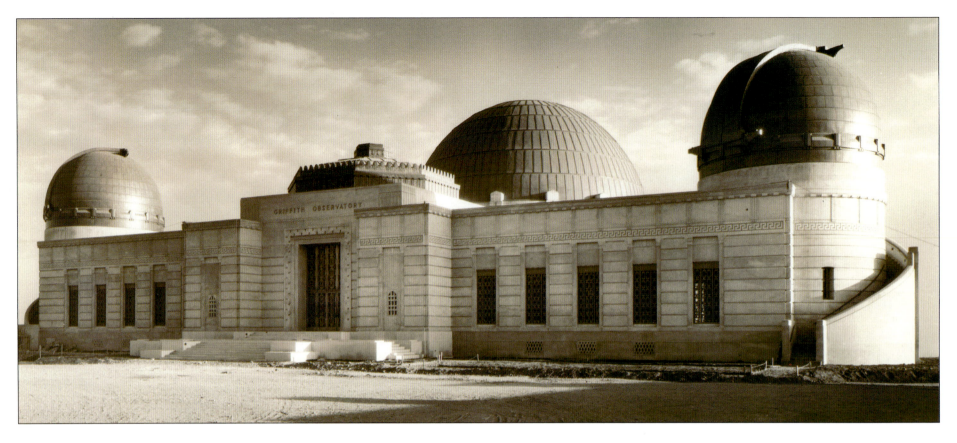

Above, Right, and Far Right (inset): The observatory and its grounds have been used in many films, including *Rebel Without a Cause*. A bronze bust of James Dean sits on the west lawn. This photo was taken in 1934.

Far Right: The observatory is currently closed for renovation—the $83 million, three-year project will restore the observatory and enhance it beyond its original grandeur.

GRIFFITH OBSERVATORY

In 1896, Welsh-born mining speculator Colonel Griffith Jenkins Griffith gave land to the city in gratitude for his prosperity. Once part of Rancho Los Feliz, this land now became Griffith Park. When he died in 1919, he bequeathed a fund for the construction of an observatory. Because the sight was so remote, it went undeveloped for years. Finally, Griffith Observatory opened on May 14, 1935. It is divided into three main areas: the Hall of Science museum, the telescopes, and the planetarium theater.

Popular attractions include the Foucault Pendulum, Camera Obscura, and the famous Zeiss Planetarium Projector, which shows the sky seen at any time or place for several thousand years in the past or future. It projects about 9,000 stars, the sun, the moon, and the planets. The 1934 Astronomers' Monument was a Federal Public Works of Art Project. The observatory and its grounds have been used for many film locations, including *Rebel Without a Cause*, with James Dean and Natalie Wood.

Perched on the eastern slope of Mount Hollywood, the Griffith Observatory overlooks a spectacular panorama of Hollywood. One of the most visited landmarks in California, it was recently voted one of the ten

most romantic places in Los Angeles. Colonel Griffith mandated that the observatory shall be open to the public for free every day and every night of the year. However, after sixty-six years of continuous use and about two million visitors a year, the observatory is currently closed for a long-overdue renovation. The temporary Griffith Observatory Satellite facility has opened just south of the Los Angeles Zoo. Expansions will include the state-of-the-art Leonard Nimoy Event Horizon auditorium, two new exhibit areas, and a restaurant. Funding has come from state, corporate, and private sectors—including $1 million from Mr. Spock himself. "Maintenance is renewal. Renewal inspires belief in the future," said Dr. E. C. Krupp, observatory director. "Griffith Observatory's mission is to inspire the future—one imagination at a time."

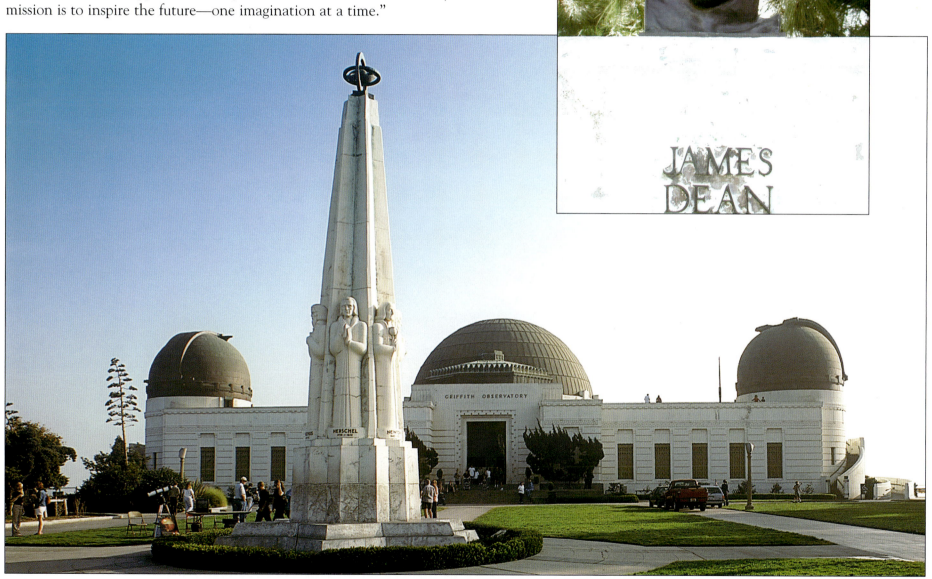

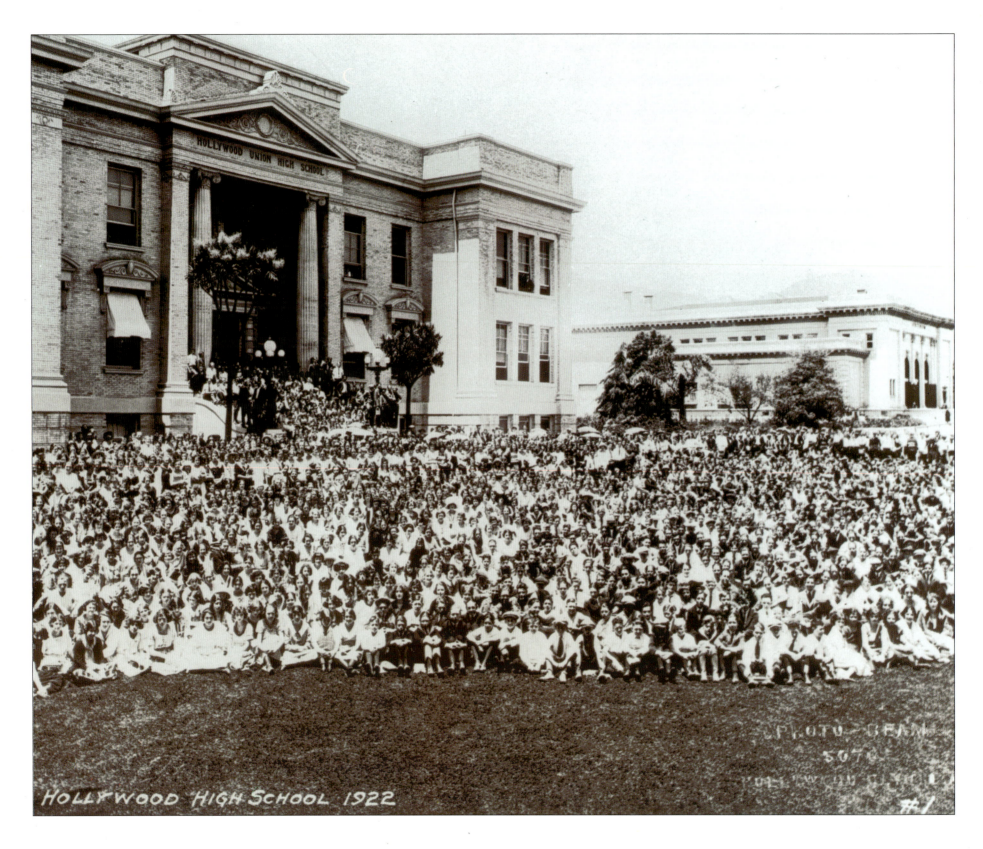

HOLLYWOOD HIGH SCHOOL

In 1904 Hollywood Union High School was founded at Sunset Boulevard and Highland Avenue, just east of a lemon grove. Students tethered their horses on the athletic field. As offspring of the wealthy and famous, they received an excellent education. The school became Hollywood High and it was completely renovated in the 1930s. A large mural of Rudolph Valentino as "the Sheik" now watches over the football field. Judy Garland, Joel McCrea, John Huston, Gloria Grahame, and Jason Robards were students here, but it was Lana Turner who put the school on the map when she skipped class to visit Tops Café across the street. It was out of bounds because of a recent kidnapping scandal, but that day Lana was "discovered" by the *Hollywood Reporter*'s Billy Wilkerson—and the rest is movie history.

The high school is still there today, with its alumni museum of all the stars who attended. Carol Burnett, James Garner, Sharon Tate, Tuesday Weld, Jill St. John, and Tim Burton are in this group. The famous Hollywood High School Marching Band still leads the Hollywood Christmas Parade.

Above Right: The school remains, and today the student body is a colorful mixture of cultures.

Below Right: The movie-star mural on the walls of the high school shows its connection with stars of the past.

Left: Students pose for their school photo on the grounds of Hollywood High School in 1922.

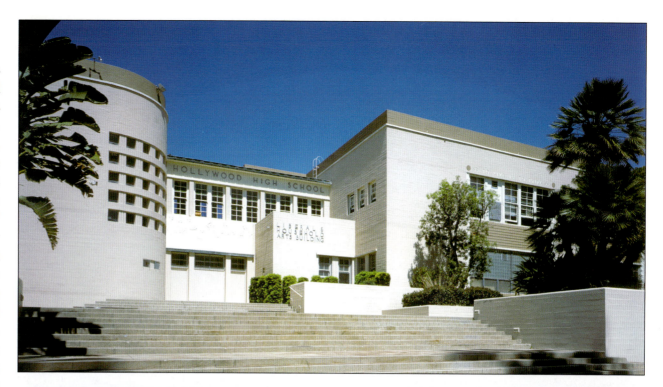

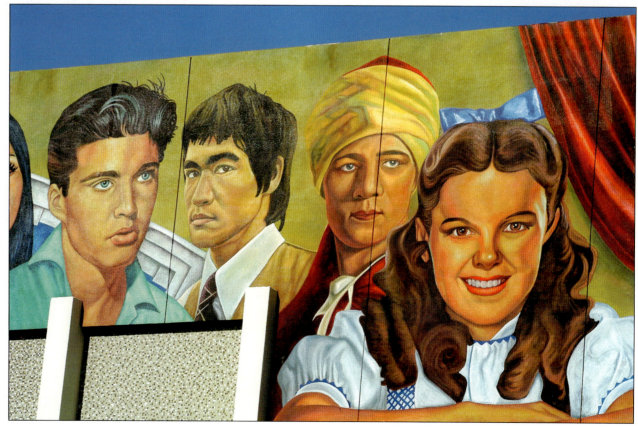

THE MOVIES COME TO TOWN

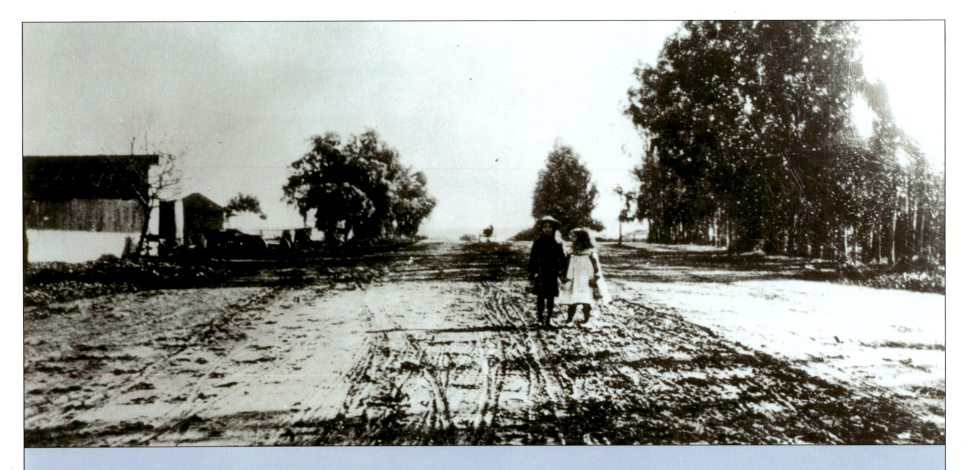

Cecil B. De Mille is credited for putting Hollywood on the map in 1913. He got off the train from New York at Flagstaff, Arizona, seeking locations for his film *The Squaw Man*. Disappointed with the weather and the scenery, he got back on the train and continued west to California. He then sent the famous telegram to Lasky and Goldfish (later Goldwyn), his producers in New York: "Flagstaff no good. Want authority to rent barn for $75 a month in place called Hollywood."

There was a fledgling film industry in the area before De Mille. In 1907 Colonel Selig sent his production company to shoot scenes for *The Count of Monte Cristo* on a Santa Monica beach when bad weather in Chicago halted filming. In 1909 Selig sent director Francis Boggs, actors, and cameramen back to Los Angeles, where they converted an empty Chinese laundry downtown into production offices. Here they

Above: Hollywood, 1905; two girls wander down what will become Sunset Boulevard.

filmed *Heart of a Race Tout*, the first picture to be made entirely in Los Angeles. Selig's company made the move permanent and built studios out in Edendale (between Silverlake and Echo Park). Other filmmakers followed: Biograph's D. W. Griffith came west from New York in 1910, bringing young Mary Pickford, her mother Lottie, Lillian Gish, and Mack Sennett along. Charlie Chaplin began filming at the Keystone Studios, and David and William Horsley came from New Jersey with the Nestor Film Company to set up the first Hollywood studio. Soon other film companies had set up shop at Sunset and Gower in the heart of Hollywood, soon to become the permanent seat of the film industry.

SUNSET BOULEVARD AND GOWER STREET

The scene (*far left*) from 1905 shows an area of Sunset Boulevard close to Gower Street. The first Hollywood Film Studios were built here and more would follow. These pepper-tree lined streets would soon be awash with small film companies churning out short silent comedies and dramas. The turnover was rapid because so many studios failed to make money and by 1920 the right side of Sunset Boulevard was nicknamed "Poverty Row." One- and two-reel westerns were very popular with the small film studios, and cowboy extras—in full costume and often their own horses in tow—would hang out on the southwest corner, waiting for work. This corner became known as Gower Gulch, and extras and actors still frequent it today in the hope of finding work.

Left and Below: Today Gower Gulch on Sunset Boulevard is a small shopping area.

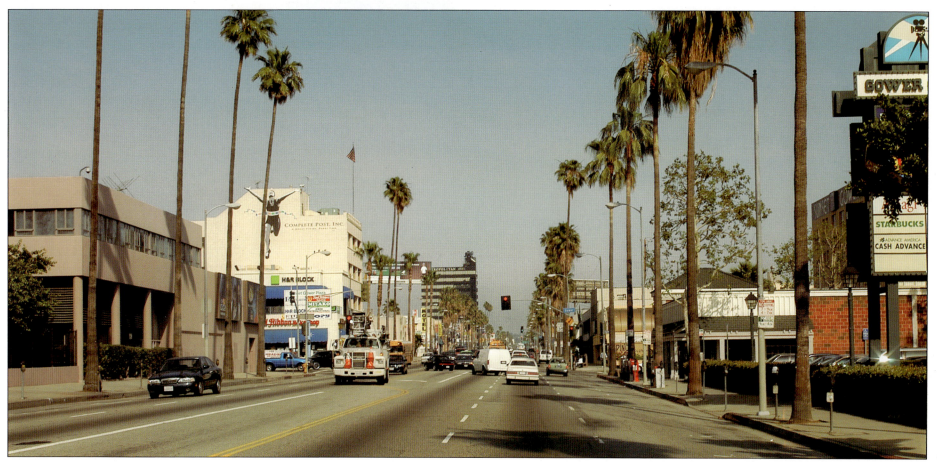

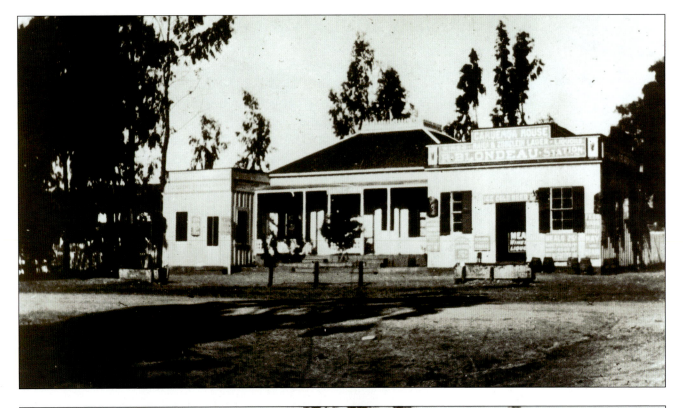

THE BLONDEAU STATION

In 1889 Mr. and Mrs. Rene Blondeau bought six acres of land at the northwest corner of Sunset and Gower in the Cahuenga Valley and built Cahuenga House, which was soon renamed the Blondeau Tavern. It had twelve small rooms, a corral, a barn, and a five-room bungalow, and offered alcohol, meals, and overnight accommodations. Things went well for the Blondeaus until Prohibitionists banned the sale of alcohol in 1903.

NESTOR FILM COMPANY

Bad weather conditions in New York forced a despairing film producer, David Horsley of the Nestor Film Company, to load up his actors and crew members and head for California. On October 27, 1911, he started the first film studio in Hollywood, where he rented the ailing Blondeau Tavern. The bungalow was the production office, the small rooms became dressing rooms, the barn was used for props, and film stages were built in the corral. Under Horsley's supervision they made a one-reel western, a single-reel drama, and a comedy each week. Al Christie, Nestor's noted comedy director, took over the studios in 1916, four years after it merged with the Universal Film Company.

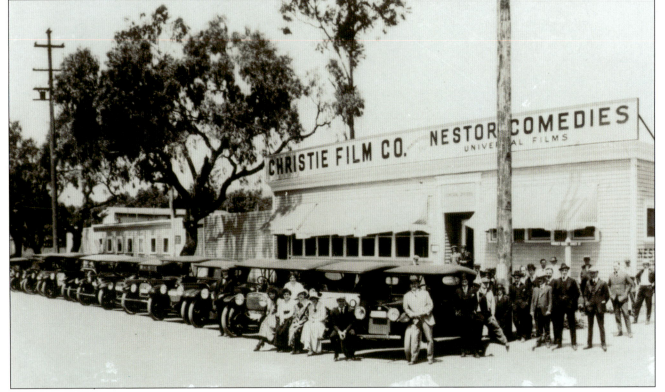

Above Left: The Blondeau Tavern did well until the Prohibition laws banned alcohol in 1903.

Left: The studios are shown here in 1916 under the name of the Christie Film Co.

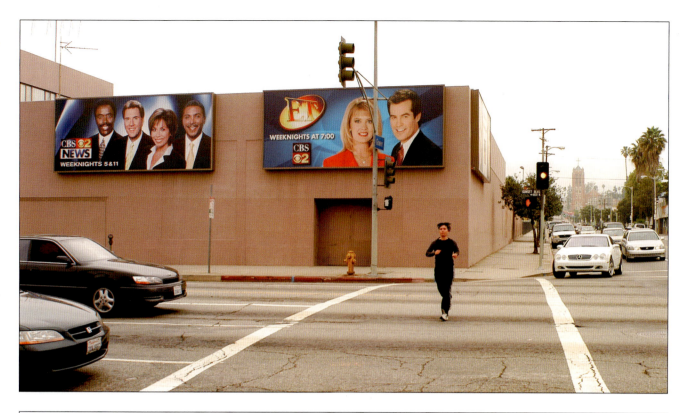

CBS STUDIOS

Under the umbrella of Universal Films, a power struggle began until 1913 when Horsley sold out to Universal's Carl Laemmle. Horsley went back to his native England, returning to California a decade later to make animal films. In 1916 Nestor became Al Christie Studios until 1938 when CBS Radio took over. Today the studio is occupied by the local CBS affiliate KCBS-TV and CBS radio station KNX.

SUNSET GOWER STUDIOS

Harry Cohn chose this site for the West Coast studios for his New York company Cohn-Brandt-Cohn, which later became Columbia Pictures. *It Happened One Night*, *Born Yesterday*, *On the Waterfront*, *Funny Girl*, and *Lawrence of Arabia* were among Columbia's gifts to the world. In 1972 Columbia Pictures moved to share the Warner Studios lot in Burbank. In 1990 Columbia was bought by Sony and relocated to the MGM Studios in Culver City. The Sunset Gower Studios remain busy with independent productions and television shows.

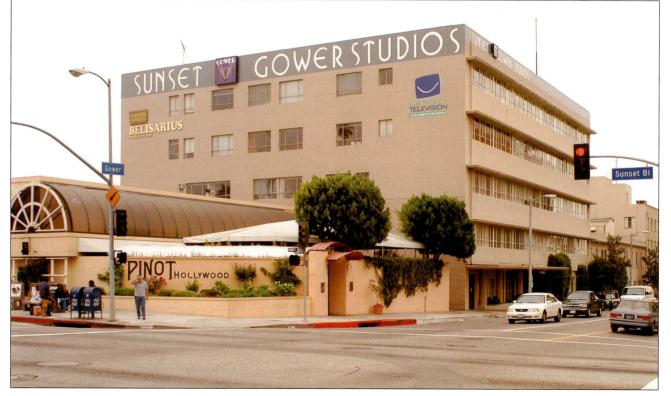

Above Left: Today the Al Christie Studios site is occupied by the local CBS affiliate KCBS-TV and CBS radio station KNX.

Left: The Sunset Gower Studios Building now houses independent productions and TV shows such as HBO's *Six Feet Under*.

BIOGRAPH COMPANY

Born in La Grange, Kentucky, in 1875, D. W. Griffith directed his first film for the American Mutoscope and Biograph Company, New York, in 1908. He began at Biograph as a five-dollars-a-day actor, appearing in eleven features before directing his first film, *The Adventures of Dollie*. Since that time Griffith has been credited with introducing multiple camera-angle shots and other pioneering filming techniques. It took a week in those days to produce one ten-minute feature and by the time Griffith left Biograph, he had directed some 400 short films. In 1910, Griffith brought his cameraman, G. W. Bitzer, and his cast of players, including a very young Mary Pickford, Mack Sennett, and Donald Crisp, to California.

INTOLERANCE

In 1915, D. W. Griffith completed the commercially successful Civil War tale *The Birth of a Nation*, perhaps the most influential and controversial film in cinema history. He followed this in 1916 with an even greater challenge, *Intolerance*. Griffith made this epic at the Fine Arts Studio at 4500 Sunset Boulevard, erecting the largest set in film history, the Babylon set, on a vacant property across the street. Rumored to have been 300 feet high, it stood for over four years because it was too expensive to demolish. This complex spectacular cost $1 million in 1916. *Intolerance* made a star out of Constance Talmadge but was the only financial failure of Griffith's career. He spent the rest of his life trying to pay off the debts the film had incurred.

Above Right: A film card advertises *As It Is in Life* and *A Rich Revenge*, directed by D. W. Griffith.

Right: An advertisement for *Intolerance*, a film that wove three historical stories with one modern tale, all with the theme of intolerance. Critics saw it as Griffith's response to claims of racism in *The Birth of a Nation*.

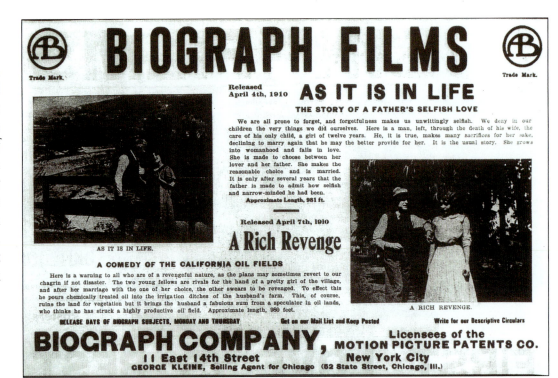

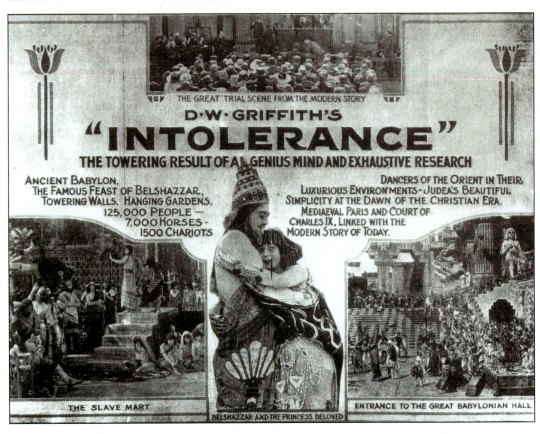

MACK SENNETT COMEDIES

When twenty-nine-year-old Canadian Mack Sennett joined the Biograph Company in 1909, he wrote a script, *The Lonely Villa*, the first film for fellow Canadian Gladys Smith. She became Mary Pickford. With Biograph in California, Sennett directed comedies and appeared in them. He studied Griffith's directing techniques, gleaning tips from the master. In 1912 he founded his own Keystone Studios, where he developed a new style of comedy: larger-than-life vaudeville, a circus with a bevy of beautiful young girls. Sennett's discoveries included Fatty Arbuckle, Mabel Normand, Ben Conklin, Ben Turpin, director Frank Capra, and a young Charlie Chaplin.

MABEL NORMAND

Mabel Normand, one of the original Gibson girls, was a leading light of the Vitagraph and Keystone films. The silent screen comedienne had an unusually dainty but tomboyish quality. A perfect foil for Charlie Chaplin, she directed his first Keystone comedy. *Fatty and Mabel Adrift* was one of several in which Normand costarred with Roscoe Arbuckle. A loyal friend, she stood by him when he was vilified by the press and in public with false rape charges. She was the exuberant star of the Mack Sennett comedies. For Mack Sennett and Mabel Normand, it was love at first sight: The musical *Mack and Mabel* tells their tale. He built a film studio for her: the Mabel Normand Studios at Fountain Avenue and Bates. But her colorful personality often got her into trouble. She liked to drink and swear and eventually was released from her Goldwyn contract for her abuse of alcohol and cocaine. When director William Desmond Taylor was murdered on February 1, 1922, Mabel was the last one, witnesses said, to see him alive. She was later cleared of any involvement, but these scandals affected her career. The onetime "Queen of Comedy" died of tuberculosis in 1930.

Above Right: The Sennett Studio received hundreds of complaints about the exploitation of underdressed bathing beauties, but the films were hits.

Right: Mabel Normand. Sennett once described her as so funny, "she seems to think in sparks."

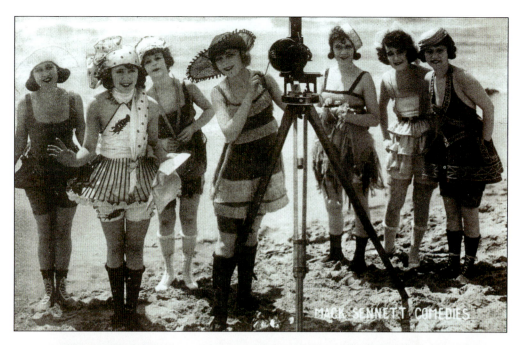

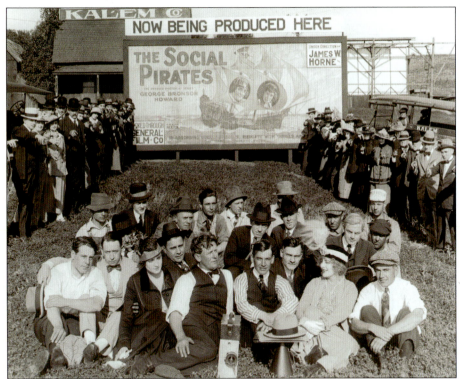

KALEM STUDIOS

The Sigmund "Pop" Lubin Company built studios on Sunset Boulevard in 1912 at 1425 Hoover Street. Lubin's tenure was short. That year the Essanay Company made twenty-one westerns there in almost as many weeks. The Kalem Company occupied the studio from 1913 to 1917 with a large company of players who made comedies and swashbuckling dramas. Allied Artists and Monogram were among the more successful companies to produce movies here. Monogram made numerous B movies, including the Charlie Chan series, *The Bowery Boys,* and *The Shadow. The Babe Ruth Story* was filmed here in 1948 and *The Invasion of the Body Snatchers* in 1956.

Currently owned by KCET, a public broadcasting station, this studio at 4401 Sunset Boulevard, has been in continuous operation since 1912. Since KCET bought the facility in 1971, much has been rebuilt, but a few original remnants remain. Public television programs such as *Visiting . . . With Huell Howser* and *Life and Times* are taped here. Steve Martin shot scenes for *L.A. Story* at these studios, and in 2002, Dick Van Dyke and Mary Tyler Moore teamed up again to film *The Gin Game* here.

Above: The Kalem Company occupied the studios from 1913 to 1917. They are seen here advertising *The Social Pirates* in 1915.

Right: Much of the original studios have been rebuilt.

THE JESSE LASKY STUDIOS

Founded in New York in 1913 by Jesse Lasky, Cecil B. De Mille, his brother-in-law Samuel Goldfish (later Goldwyn), and Arthur Friend, the Lasky Feature Play Company set out for Flagstaff, Arizona, to shoot the film *The Squaw Man*, starring Dustin Farnum. Finding Arizona unsuitable, they continued on to Hollywood. De Mille and Lasky rented a yellow barn at Selma Avenue and Vine Street, where the owner still kept his horses. De Mille and the actors shared the horse stalls. In 1914 *The Squaw Man* was the first full-length motion picture to be filmed in Hollywood. A year later De Mille and Lasky's company owned the whole block. Triumphantly, in 1925 the Lasky Feature Play Company merged with Adolph Zukor's Famous Players to form Famous Players-Lasky Corporation. The original yellow barn was moved—along with the rest of the company—to the massive United Studios on Marathon and Van Ness in 1926.

United Studios became Paramount Studios, where the yellow barn remained until 1982, when it was relocated to Highland Avenue, opposite the Hollywood Bowl. It is now used as the Hollywood Heritage Museum, which is dedicated to the early movie era.

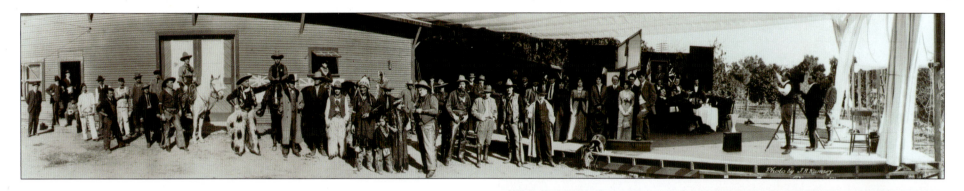

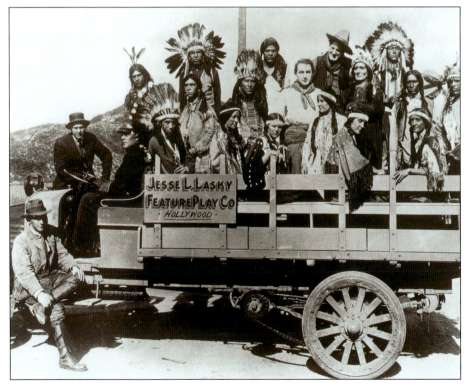

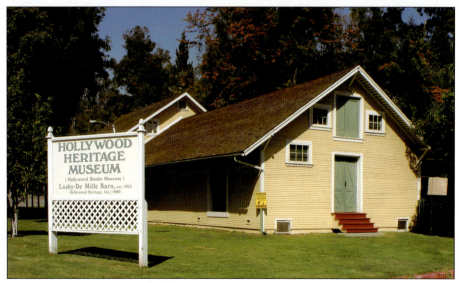

Above: The original yellow barn that Lasky and De Mille first rented as a studio. *The Squaw Man* was De Mille's first film and it went on to gross a massive $200,000.

Top: A panoramic view of the crew for The *Squaw Man.*

Left: Cecil B. De Mille and actors in the movie *The Squaw Man* in 1914.

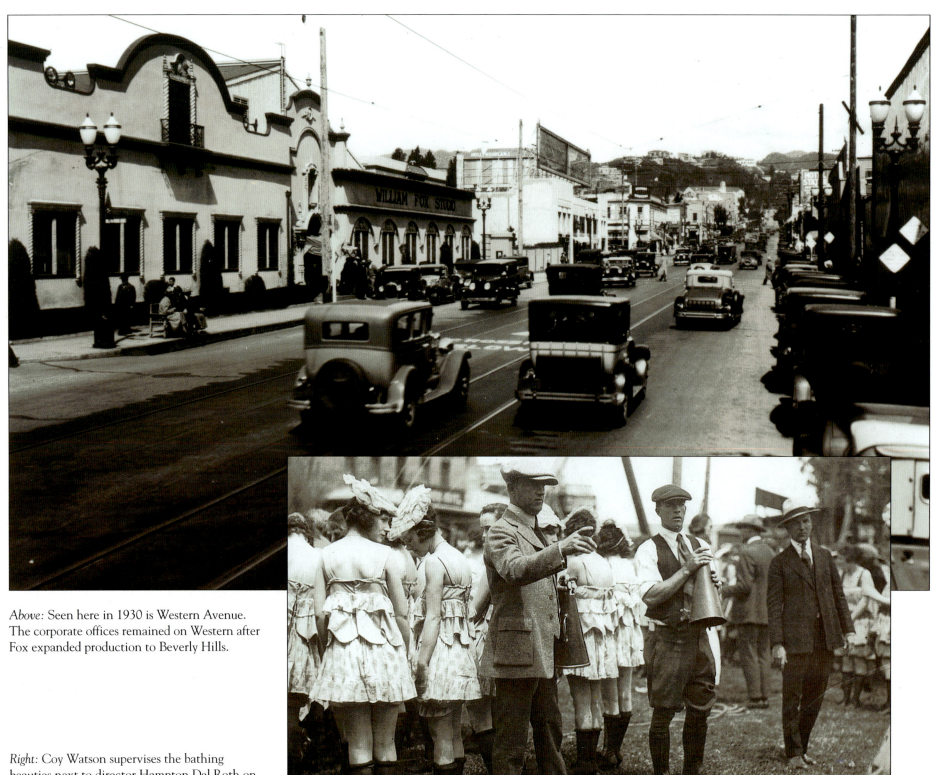

Above: Seen here in 1930 is Western Avenue. The corporate offices remained on Western after Fox expanded production to Beverly Hills.

Right: Coy Watson supervises the bathing beauties next to director Hampton Del Roth on the Fox backlot for the 1921 movie *Skirts*.

WILLIAM FOX STUDIOS

Above: Western Avenue today is home to stores and restaurants. The Hollywood sign can be seen in the distance.

Hungarian-born William Fox moved to Hollywood from New York in 1916 to make movies. In 1917 he bought the old Dixon Studios on the west side of Western Avenue below Sunset, plus eight additional acres across the road, and signed vamp Theda Bara and Tom Mix to contracts. By 1923 William Fox needed more room and expanded his production to Beverly Hills; however, the corporate offices remained on Western. By 1925 they had turned out eighty-three films. Fox merged his company with Darryl Zanuck's Twentieth Century Productions in 1935.

Fox died in 1952, but under Zanuck's guidance, Twentieth Century Fox Studios, now at 10201 West Pico Boulevard, prospered with stars like Tyrone Power, Henry Fonda, and Marilyn Monroe. Fox won Best Picture Oscars for *All About Eve* and *The Sound of Music*, among others. Much of the Pico lot was sold off in 1965 to create Century City. Today, Twentieth Century Fox continues to enjoy success with the Star Wars and X-Men series.

CLUNE STUDIOS

Built in 1915 by theater magnate William H. Clune, the Clune Studios on the northeast corner of Melrose and Bronson is a neighbor to Paramount Studios. It has lived under many different titles. In the 1930s William Boyd and Gabby Hayes made their popular *Hopalong Cassidy* films here. It was renamed The California Studio, and in 1946 *The Best Years of Our Lives* was shot here, as well as the original *A Star Is Born*. In the 1960s it changed name once again, this time to the Producers Studio. Future U.S. President Ronald Reagan starred in *Death Valley Days*, while interior scenes for the Oscar winner *In the Heat of the Night* were filmed here. In 1979, it became the Raleigh Studios, where independent films are now made, as well as a variety of television series.

Above: From left to right, Albert Kaufman; Harold Lockwood; Mary Pickford's mother, Lottie; Mary Pickford; Donald Crisp; and the director Allan Dwan, in front of Clune Studios in 1915.

Right: The Clune Studios is now the Raleigh Studios. Despite offering state-of-the-art facilities the studio has managed to preserve some of the original buildings.

UNITED ARTISTS

The United Artists Corporation was founded in 1919 by Douglas Fairbanks, Mary Pickford, D. W. Griffith, and Charlie Chaplin. They wanted artists to make and distribute their own and other people's quality products. Their early successes include *Pollyanna*, *Broken Blossoms*, and *Way Down East*. In the mid-1920s, they were joined by Joe Schenck, who brought in Rudolph Valentino, Gloria Swanson, Buster Keaton, and Sam Goldwyn. With Howard Hughes, they added *Hell's Angels* and *Scarface*. Everything went splendidly until the late 1940s when, without a studio or contract stars, business slowed down. United Artists regrouped and rose again with successes like *The Magnificent Seven* and *Tom Jones*. In more recent years, with major reorganization, United Artists is now part of the MGM family.

Below: Douglas Fairbanks, Oscar Price, Mary Pickford, D. W. Griffith, and Charlie Chaplin in 1919.

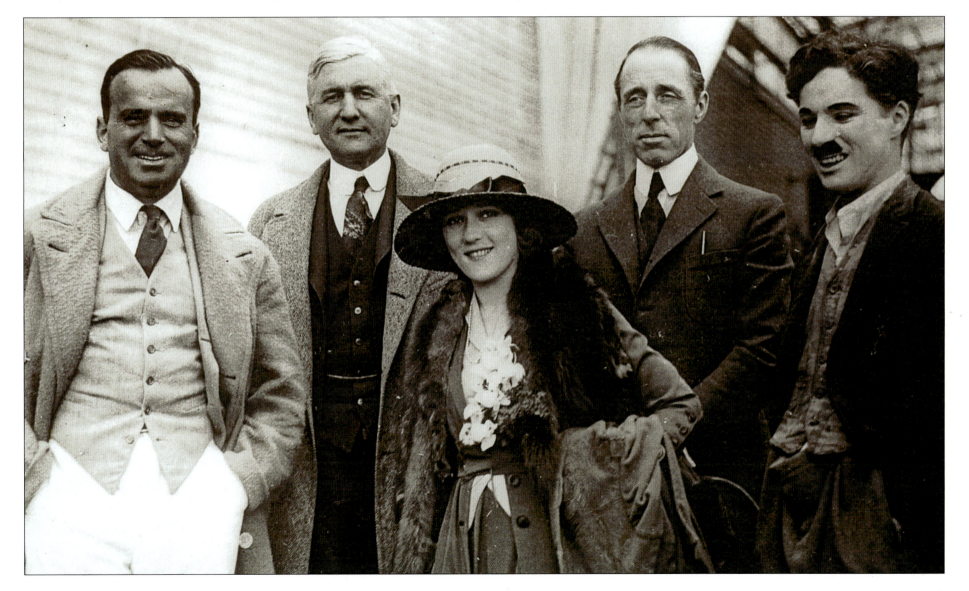

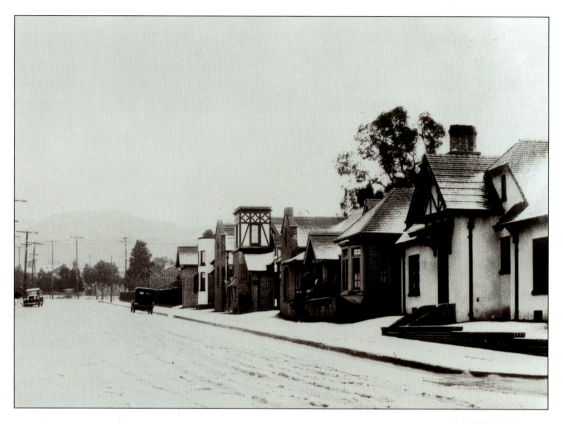

CHARLIE CHAPLIN STUDIOS

Raised in poverty in London, Charlie Chaplin built a Tudor-style home on La Brea Avenue facing Sunset Boulevard where his mother could live in comfort. He built a studio behind it with cottages, chimneys, and green landscaping. The "Little Tramp" now owned his own English village in Hollywood, surrounded by orange groves. His footprints are indelible in the cement outside Sound Stage 3. At his own studios, Chaplin continued committing his comic genius to celluloid with such classics as *The Gold Rush* (1925), *City Lights* (1931), *Modern Times* (1936), and *The Great Dictator* (1940). Chaplin left these studios in 1953, after which several television series were filmed there, including *Superman*, *Perry Mason*, and *The Red Skelton Show*.

Today the studio lot is half the original five-acre size. Until 1999 it was owned by Herb Alpert and Jerry Moss (as A&M Studios), who recorded Alpert's own Tijuana Brass, Quincy Jones, and the Bee Gees. In 1985 the video of "We Are the World" was made here with Bob Dylan, Michael Jackson, Bruce Springsteen, and other singers. Today the studio is owned by Jim Henson Productions and home to Miss Piggy and the Muppets. Perched on the roof above the main gate is a very green Kermit the Frog dressed as Charlie Chaplin's Little Tramp.

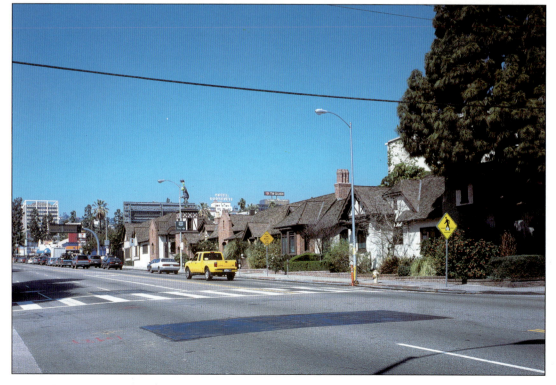

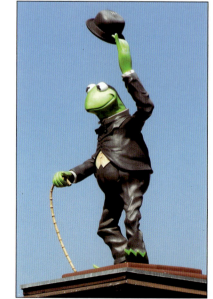

Above Left: La Brea Avenue in the snow, 1921.

Left: Today the Chaplin studio is owned by Jim Henson Productions.

Right: Kermit the Frog pays homage to Charlie Chaplin.

CHAPLIN'S FILM SUCCESS

The comic genius, unmistakable in his battered bowler hat, was actually wearing four hats on the movie *The Circus*. Chaplin had written the script, played the lead, and directed and produced the film. In fact, he did such a brilliant job that at the Academy Awards held in 1929, Chaplin's name was removed from the competitive class and the Academy honored him with a special award not given every year: "To Charles Chaplin for versatility and genius in writing, acting, directing and producing *The Circus*." What must he have thought? Charlie, who used to beg on the streets of London to support his impoverished family, now received the Academy's highest honor. He was the king of Hollywood. Charlie Chaplin was the first actor to grace the cover of *Time* magazine, in 1925. In 1972, he was awarded a special Oscar "for incalculable effect in making motion pictures the art form of the century." He was made a Knight Commander of the British Empire in 1975.

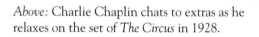

Above: Charlie Chaplin chats to extras as he relaxes on the set of *The Circus* in 1928.

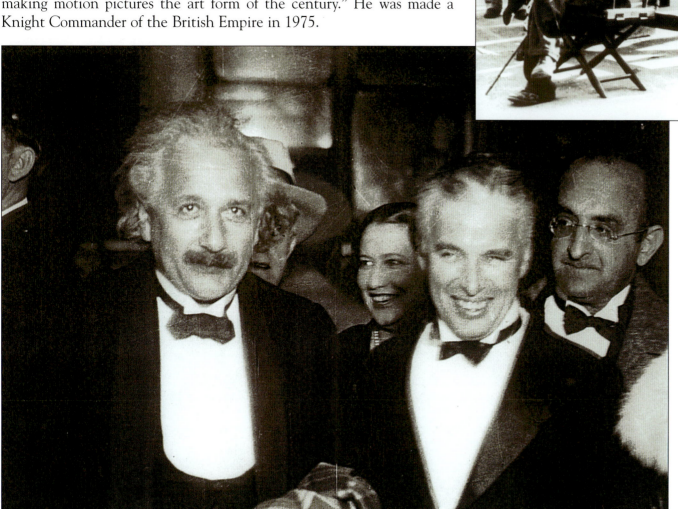

Left: The original odd couple: Physicist Albert Einstein and Charlie Chaplin attend the 1931 premiere of Chaplin's masterpiece *City Lights* at the lavish Los Angeles theatre.

PICKFORD-FAIRBANKS STUDIOS

The Jesse B. Hampton Studios opened in 1920 on Santa Monica Boulevard and Formosa Avenue. In 1922 Mary Pickford and Douglas Fairbanks purchased the facility and renamed it. They made classics such as *Robin Hood* and *The Thief of Bagdad*. In 1924, after leaving his own company, Samuel Goldwyn rented space here. In 1927, the studio was renamed United Artists, though the famous couple had joined Chaplin and D. W. Griffith in their own enterprise eight years earlier. Eddie Cantor filmed *Roman Scandals* here in 1933. By 1948 another name was over the gate: the Samuel Goldwyn Studios. *The Apartment*, *West Side Story*, *Irma La Douce*, and *Some Like It Hot* came under that tenure. Some of *The Alamo* was filmed on the Goldwyn lot, where John Wayne had an office. Natalie Wood, Susan Hayward, and Frank Sinatra were among the many stars at this studio.

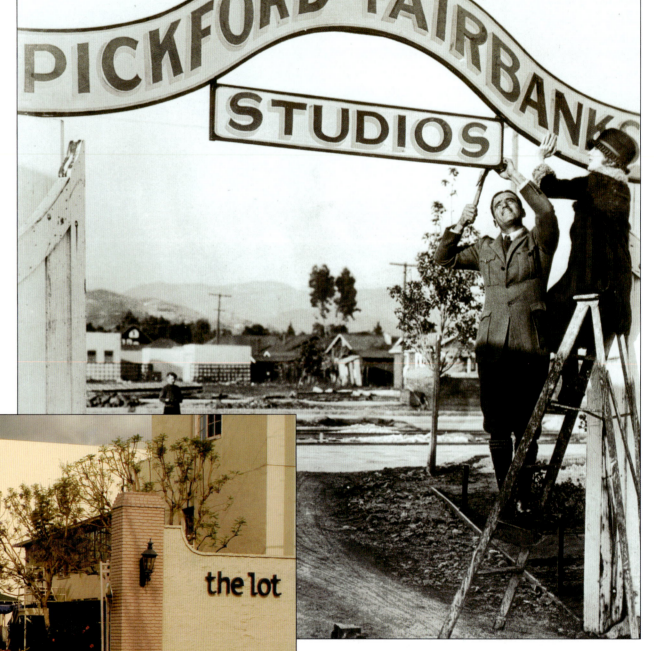

Above: The Pickford-Fairbanks Studios, 1922.

Left: Today it is simply known as the Lot.

From 1980 it was known as the Warner Hollywood Studios, an addition to the studio in Burbank, where in the 1980s and 1990s, television series such as *The Love Boat*, *Dynasty*, and *The Fugitive* were made. Motion pictures included *Basic Instinct* and *The Green Mile*. But in 1999 this historic landmark changed hands once more. Today it is called simply the Lot, with the same postproduction facilities and Warner Brothers Productions as the tenant. Recent filming includes the Gilbert Adler production of *Starsky and Hutch* starring Ben Stiller, Owen Wilson, and Juliette Lewis.

ROBIN HOOD

In 1922, Douglas Fairbanks wrote, produced, and starred in the silent movie version of *Robin Hood* at Pickford-Fairbanks Studios. Wallace Beery played Richard, and Enid Bennett, Maid Marion. Directed by Allan Dwan (who also directed many Shirley Temple films), the movie was originally titled *The Spirit of Chivalry*. Fairbanks's most elaborately designed production, which included a replica of the mammoth castle and village of Nottingham, brought costs to over $1 million. However, the film made over $2.5 million.

Below: The crew and set of the silent film *Robin Hood*.

MGM STUDIOS

The most famous Hollywood movie studio in the world was not actually in Hollywood: MGM Studios began in Culver City, west of Hollywood, in 1924. MGM was founded by Louis B. Mayer in the old 1915 Triangle Pictures Studio, built by D. W. Griffith, Thomas Ince, and Mack Sennett. Sam Goldwyn, having given up ownership of Goldwyn Pictures in 1922, was never part of the studio that carried his name.

MGM claimed it had "more stars than there are in heaven" and was known for its star-studded, glossy productions, such as *The Wizard of Oz*, the Thin Man series, *Andy Hardy*, *National Velvet*, *Gone with the Wind*, and musicals like *Singin' in the Rain* and *Easter Parade*. MGM sold the studio buildings to Lorimar Television in 1980. Owned by Sony Entertainment since 1990, the studio's tenants, Columbia TriStar Films, have produced *A Few Good Men*,

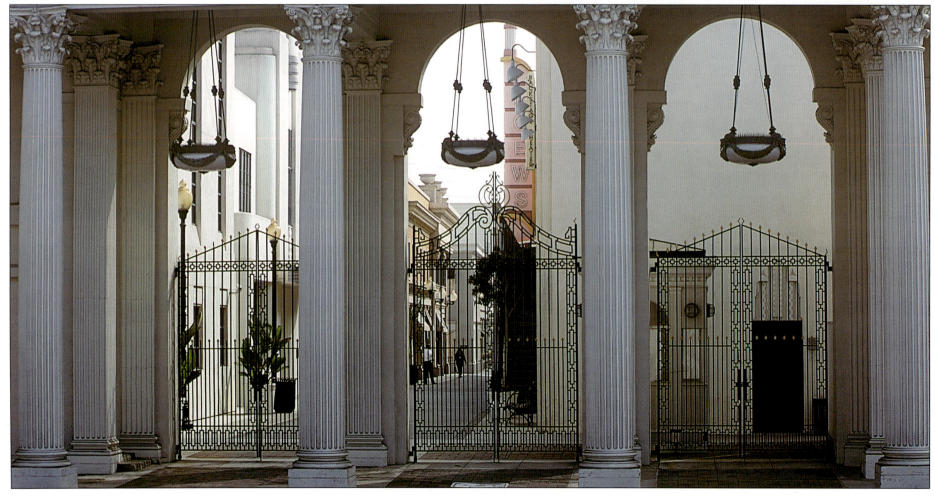

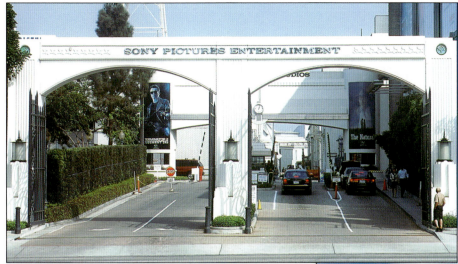

First Knight, and the Charlie's Angels movies.

MGM and United Artists are still actively engaged in motion picture production with recent film successes that include the *Legally Blonde* movies, *Die Another Day*, and *Barbershop*. MGM owns the largest film library in the world, with more than 4,000 titles, and has expanded into the home video and interactive media market. The studio has just completed forty years of successful James Bond features. Coincidentally, their new headquarters in Century City were built on property once part of Twentieth Century Fox Studios.

Left: This 1915 classic colonnade was the original main gate on Washington Boulevard in Culver City.

Above Left: MGM's logo.

Above: The studios have been owned by Sony Pictures Entertainment since 1990.

Right: The new headquarters of MGM are in Century City.

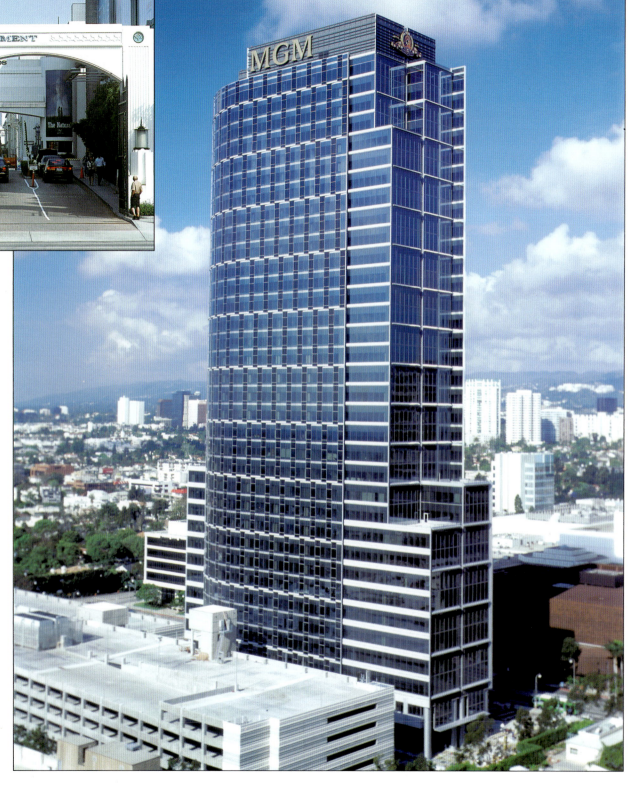

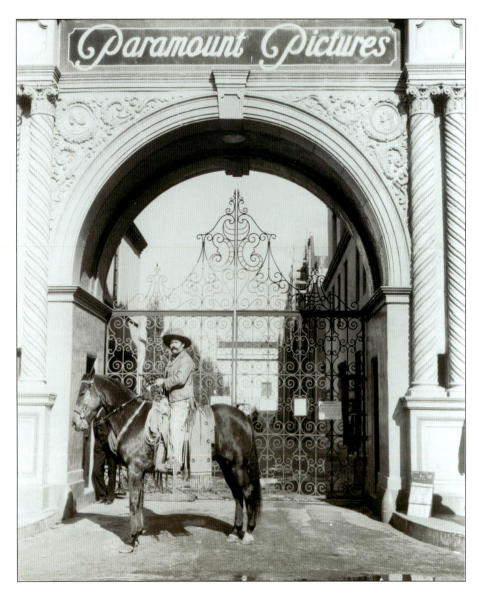

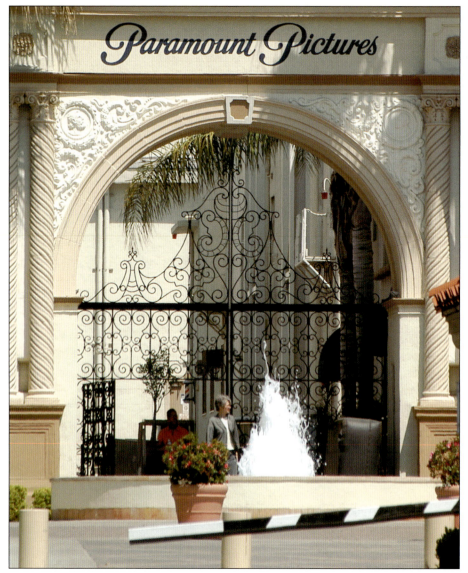

Paramount's Bronson gate in 1934 (*left*). The gate of the only motion picture studio still in operation in Hollywood still remains (*above*).

PARAMOUNT STUDIOS

Paramount Studios is the only major motion picture studio still operating in Hollywood. Adolph Zukor's Famous Players Company, founded in 1912, merged with the Jesse Lasky Company in 1916 and became Paramount Pictures. Directors Cecil B. De Mille and William S. Hart and stars such as Rudolph Valentino, Mae West, Bob Hope, Bing Crosby, W. C. Fields, Cary Grant, and Katharine Hepburn were here. And who can forget Gloria Swanson as Norma Desmond in *Sunset Boulevard* as she drove up to Paramount's Bronson gate?

In 1966 Gulf and Western took over Paramount, which had recently produced *Rear Window*, *White Christmas*, and then *Breakfast at Tiffany's*. *Love Story*, *The Godfather*, and *Chinatown* followed under the new regime. Paramount merged with Viacom in 1994. Paramount Television produces such shows as *7th Heaven* and *Frasier*. The Paramount lot backs onto the Hollywood Forever Cemetery.

RKO RADIO PICTURES

Built in 1921 on Gower Street and Melrose, the Robertson-Cole Studios were bought by Joseph Kennedy in 1923. RKO Radio Pictures took over in 1928. Fred Astaire and Ginger Rogers made two musicals a year in the 1930s. Frank Capra's *It's a Wonderful Life* came from RKO, as did the original *King Kong*, *Bringing up Baby*, and Alfred Hitchcock's *Notorious*, while Orson Welles created his masterpiece *Citizen Kane* in 1941 for the company. The eccentric producer Howard

Hughes bought RKO in 1948, after which it went into decline. The *I Love Lucy* television series was so successful that in 1953 Lucille Ball and husband Desi Arnaz bought the RKO studio and called it Desilu.

Although they continued to produce their television series there for some years, eventually Desilu was sold to Paramount and became part of that huge complex now owned by Viacom. The blue RKO globe remains on top of the corner of Melrose and Gower.

Below Left: The studios were built in 1921 and were taken over by RKO in 1928.

Below: The blue RKO globe remains, although the studios are now owned by Viacom.

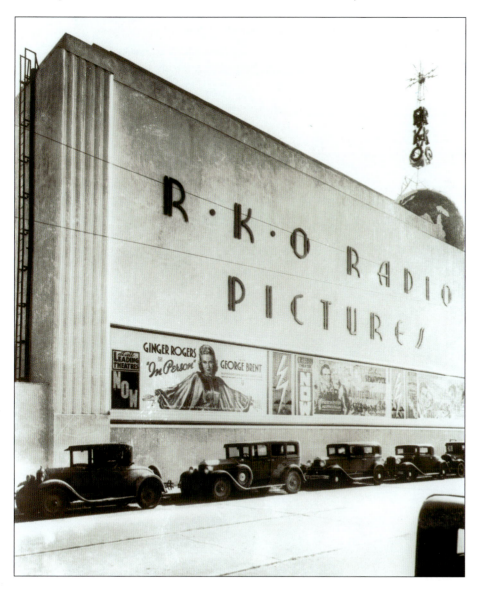

HOLLYWOOD FOREVER CEMETERY

In 1899, the Hollywood Memorial Park was founded on one hundred acres of the Gower family wheat field and included Beth Olem, a Jewish cemetery. In 1920, as the burgeoning film industry needed more studio space, forty acres of unused cemetery land was sold to Paramount Studios. The Paramount back lot is visible through the front gates looking south. At 6000 Santa Monica Boulevard near Gower Street in Hollywood, this serene parkland became the resting place for Hollywood's illustrious figures, including Cecil B. De Mille, *Los Angeles Times* publisher Harrison Gray Otis, Douglas Fairbanks Sr., Tyrone Power, and Janet Gaynor. All that remains of the original front wall is a small crumbling section by the pump house.

After decades of neglect the cemetery was rescued in 1998 by Tyler Cassity and his family, who recognized the unique history contained in

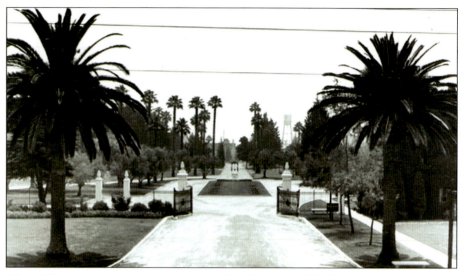

Above: The cemetery became the resting place for some of Hollywood's greatest stars.

these beautiful gardens. The restoration and renaissance cost $7 million. In the cathedral mausoleum Rudolph Valentino is joined by Harvey Wilcox, Peter Lorre, Eleanor Powell, and Peter Finch. Actress Joan Hackett still makes people smile; her gravestone reads "Go away—I'm sleeping."

A memorial celebration is held at the Valentino crypt every August 23 at 12:10 P.M.—the date and time he died.

Inset: Rudolph Valentino's memorial is located in the cathedral mausoleum.

Left: This picturesque cemetery has been featured in several movies and TV shows, including *L.A. Story* and *Charmed.*

RUDOLPH VALENTINO'S FUNERAL

August 23, 1926: "The day that Hollywood died." A mobile emergency room was set up to deal with swooning flappers when more than 100,000 mourners paid tribute to Rudolph Valentino, "the World's Greatest Lover," who died in New York at the age of thirty-one. The Sicilian-born Valentino had starred in *Four Horsemen of the Apocalypse* and *The Sheik* and had become the greatest silent screen star of all time. There was mass hysteria at his funeral service at the Church of the Good Shepherd in Beverly Hills, and thousands stood in stunned silence when he was carried to his final resting place at the Hollywood Cemetery. Shortly after his interment, a mysterious lady in black began making silent sojourns to his crypt. Today's "lady in black" Karie Bible carries on the tradition and gives guided tours.

Above: Established in 1899, the cemetery was originally a hundred-acre park.

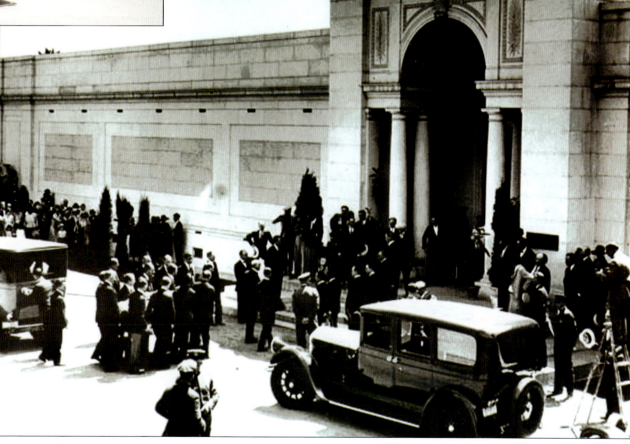

Right: When Rudolph Valentino died in 1926 at the age of thirty-one, ten thousand people came to pay their respects.

HOLLYWOOD GROWING UP

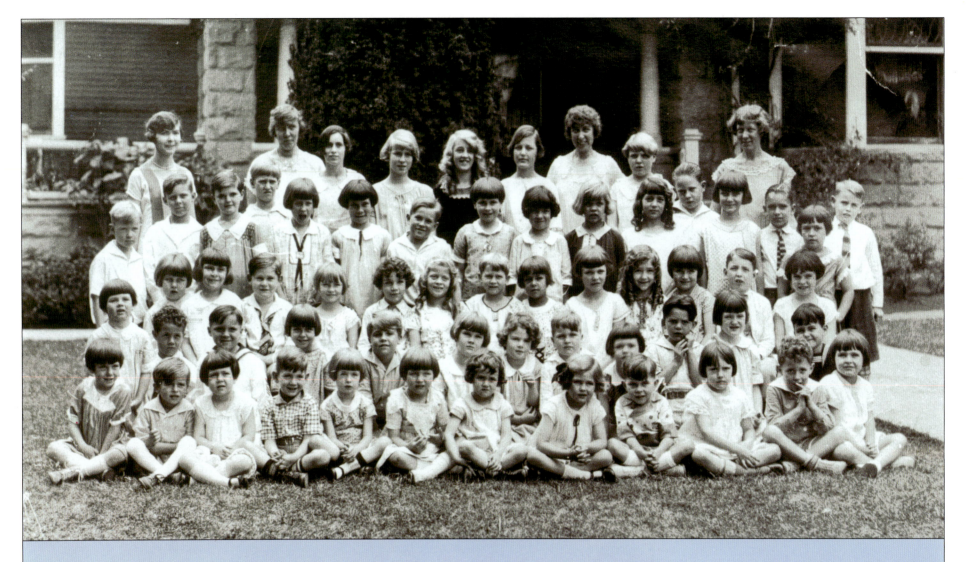

As this young town grew, so did its population. Church schools were built in early downtown Los Angeles, but as the Hollywood area developed, the education of the children had to be addressed. Throughout the 1800s, the closest school for children in Hollywood was the one-room Cienega School on Pico Boulevard near La Brea. This was a long walk for the children. The Cahuenga School District was formed in 1876 to address this matter and by 1881, the Pass School District came into being. They established small schools in local communities. The ladies of the Woman's Club of Hollywood rallied around and got the Hollywood Union High School established. As full-length motion pictures blossomed, many of the movie stars were transplants from the East Coast, especially New York. With the arrival of their children, there was an even greater need for schooling, specifically in Hollywood, and a demand for private schooling. Gradually, Hollywood's own school system developed, meeting the needs for this new and specialized industry town.

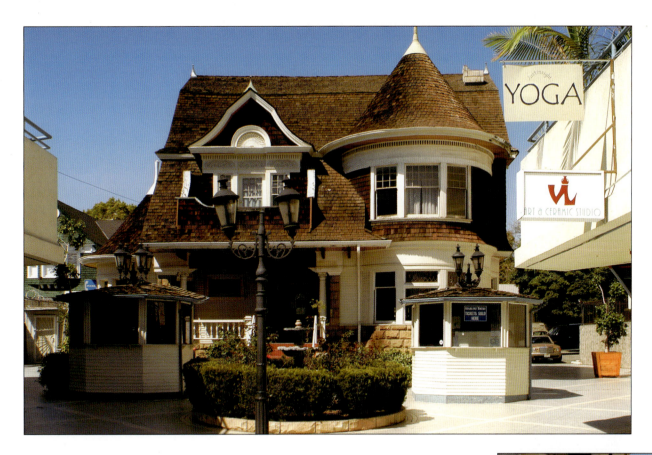

Far Left: The teachers (the Misses Janes) and their students are seen here in front of the house in 1926.

Left: Janes House has been preserved, and the front yard now contains shops and studios.

THE MISSES JANES SCHOOL

This Victorian cottage was built at 6541 Hollywood Boulevard in 1903, when Herman and Mary Janes bought it for their son and their three daughters, Carrie, Mable, and Grace. In 1911, Mrs. Janes helped her daughters open a kindergarten and junior school in their home. Highly respected, the Janeses educated the children of the new Hollywood: De Mille, Chaplin, Jesse Lasky, and Richard Arlen. They believed in the virtues of fresh air, so the women held most of the classes in the leafy back garden.

The school closed in 1926. As their home began to decay, they were forced to rent out their front yard to street vendors and for parking. They took in lodgers. By then the local area was in decline. Carrie, the last of the sisters, died in 1982. But fortunately their longtime lodger Guy Miller fought for the preservation and restoration of the old house. Preserved intact, Janes House is the only remaining Victorian house along Hollywood Boulevard. Previously a tourist office, it currently houses the Hollywood Farmers Market offices. The front yard is lined with gift and sandwich shops.

Above: An archway has been built, announcing "Janes House."

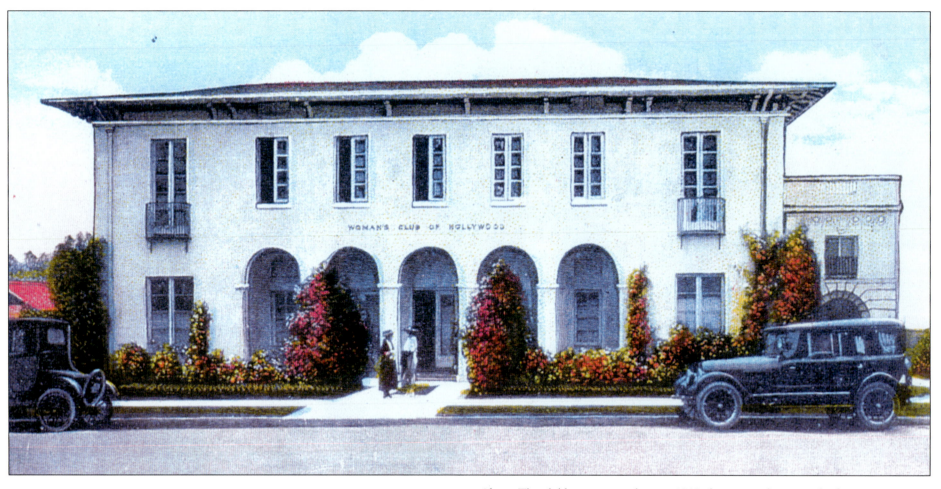

Above: The clubhouse is seen here in 1919, five years after it was built.

WOMAN'S CLUB OF HOLLYWOOD

The Woman's Club of Hollywood was organized in 1905, and their first goal was to build Hollywood a library. Members were often wives of prominent businessmen and celebrities. Daeida Wilcox-Beveridge donated land on Ivar Avenue and Hollywood Boulevard, and the library, built with funds they raised, opened February 8, 1906. The women managed the library until 1908, when they donated it to the city. The women were also active in starting the Hollywood Hospital and the now world-famous Hollywood Bowl. In 1914 they built their own clubhouse on Hollywood at La Brea. Their weekly meetings included music, literature, home economics, public affairs, and celebrity luncheons with

the likes of Gary Cooper, Joan Crawford, and Mary Pickford. They organized outings and parties for local children. After World War II they moved to a new clubhouse at 1749 La Brea Avenue, site of the Hollywood School for Girls. Today, as it approaches its one-hundredth anniversary, the Woman's Club is still making contributions that affect the quality of life in Hollywood.

Right: Among other good works, the Woman's Club organized events for children. Here a group of Hollywood youngsters waits to greet Charlie Chaplin at their party in 1918.

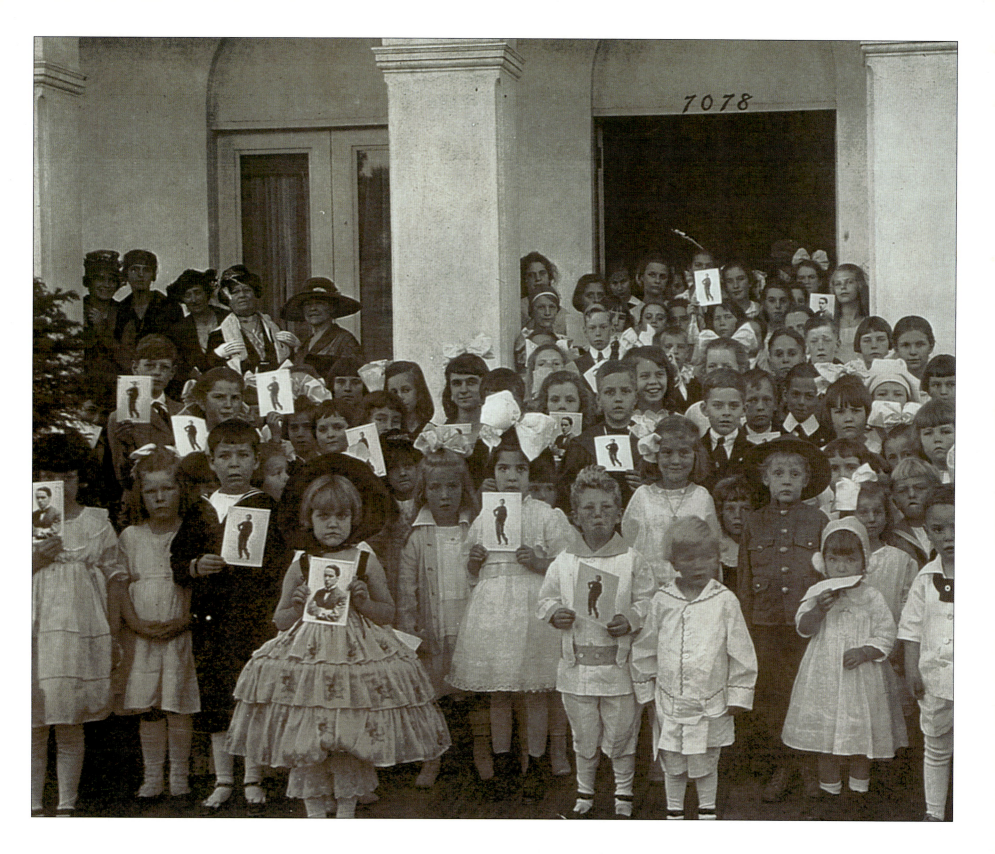

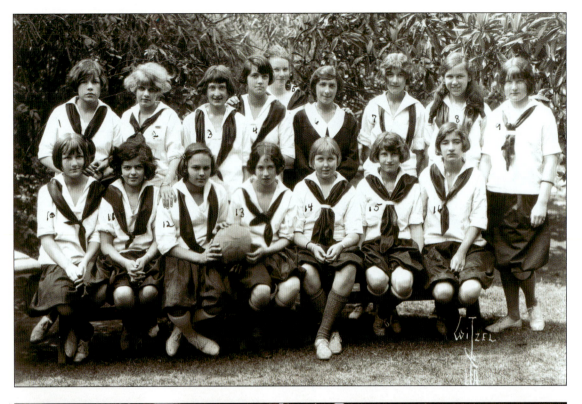

HOLLYWOOD SCHOOL FOR GIRLS

The founders of the Hollywood School for Girls, founded in 1908, believed that girls should be as well educated as boys. Initially the only private school in Hollywood, it enrolled many children of celebrities: Cecilia De Mille, L. B. Mayer's daughters Irene and Edith, and Catherine Toberman. It also had pupils who would go on to become celebrities: Agnes de Mille, Douglas Fairbanks Jr. (who was embarrassed at being at a girl's school), Jesse Lasky Jr. (who had been expelled from Misses Janes), Mary Anita Loos (the first woman screenwriter), and Jane Peters (later known as Carole Lombard). One of the biggest future stars was Harlean Carpenter, later known as Jean Harlow.

Today the original house—then known as the Shakespeare House, because Shakespearean actor Charles Laughton taught here—is all that is left of the school. It is now called the Hospitality House, and it is still used for acting classes. The school resides on property now owned by the Woman's Club of Hollywood.

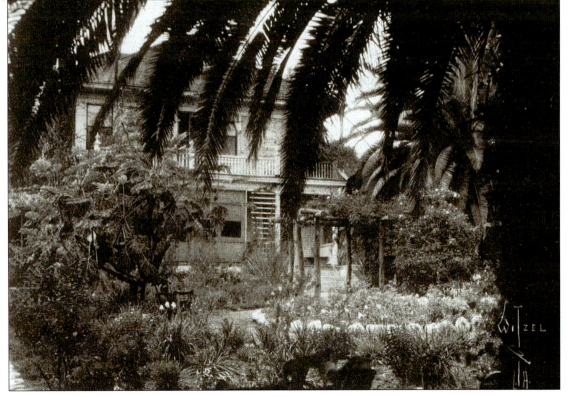

Above Left: Harlean Carpenter was an eighth-grade pupil of the Hollywood School for Girls in 1924. She later took the name Jean Harlow. She is in the top row, second from the left.

Left: A shot through the trees of the Hollywood School for Girls taken in 1924.

Above: The property is now slightly dilapidated but is still used for acting classes.

Left: Jean Harlow is seen here putting her handprints in cement at Grauman's Chinese Theatre in 1933. She put three pennies for luck in the cement by her handprints. She was twenty-two years old, she was wealthy, she was famous. She was only to live for four more years.

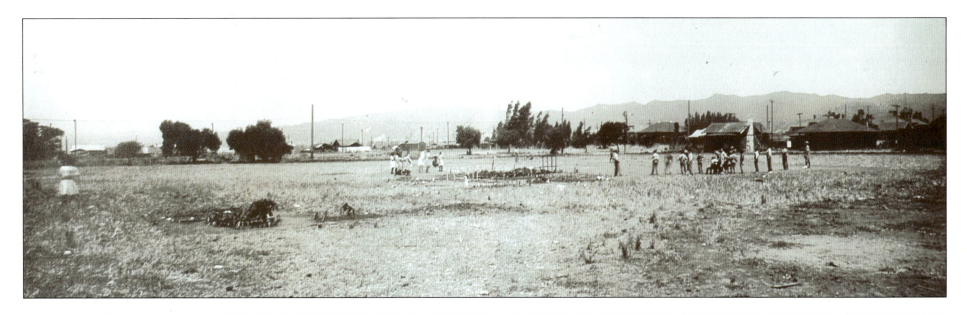

Above: The land for the original Los Angeles Orphans Home Society before the home was built. It was donated by Cornelius Cole, who believed the children needed fresh country air.

Far Right: After earthquake damage, the old house was replaced by this new redbrick one in 1972.

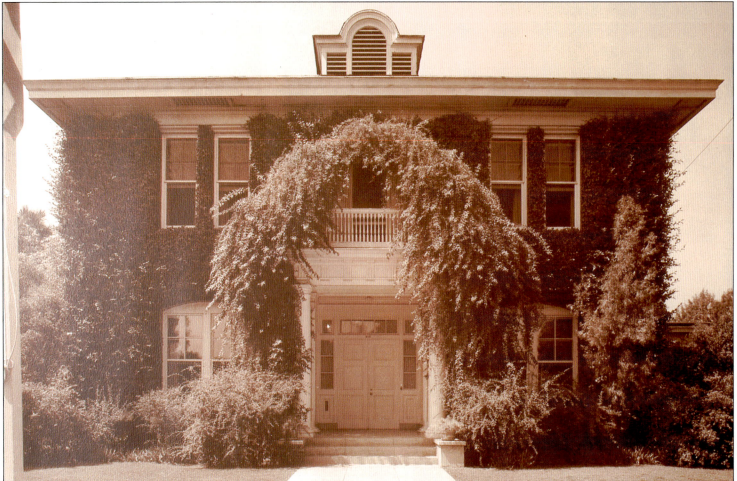

Right: Part of the original Los Angeles Orphans Home complex.

HOLLYGROVE

Originally called the Los Angeles Orphans Home Society, today's Hollygrove was founded in 1880. Located downtown, the new home was built at 815 North El Centro Avenue in 1911. Just yards from Paramount Studios, the land was donated by Senator Cornelius Cole, a local landowner. The brick buildings, set on five acres of gardens and playgrounds, had 105 children "sheltered, cared for, loved, and trained in neatness, obedience, and consideration for others." Over time the needs of the surrounding community changed and in 1952 the organization responded by beginning to concentrate its resources on caring for and treating emotionally troubled children from abusive environments.

Renamed Hollygrove in 1957, more than 15,000 children have now benefited from the services the organization has provided since 1880.

Hollygrove is still home to children from six to thirteen years old. The emphasis is on healing their emotional wounds and building their self-esteem. An important program is the Special Friends mentoring program for volunteers. Hollygrove is a nonprofit organization receiving public and private funding. Locals, including the L.A. Firefighters and Hancock Park Garden Club, have generously supported the children's home. Hollygrove has recently finished building its own library.

Children from Hollygrove have grown up to have successful careers in many professions. One shy, quiet, kind little girl, who first came here in 1937, had a dream of becoming a star. She'd look out the

orphanage's windows and gaze out at Paramount Studios and the Hollywood sign. This girl was Norma Jean Baker (née Mortenson), who later changed her name to Marilyn Monroe. Norma Jean never knew her father and her mother suffered from mental illness, which meant that childhood was difficult for the little girl, with long periods spent away from home. As she grew up, modeling jobs led to acting gigs and soon her dreams were realized. She went on to form a close relationship with Clark Gable—the man she once fantasized was her father—while filming *The Misfits* (Gable died soon after shooting finished). She and Jane Russell are seen here, having their hand and footprints marked in cement for posterity at Grauman's Chinese Theatre. Monroe had just costarred with Russell in the film *Gentlemen Prefer Blondes*.

Above: Marilyn Monroe as a toddler.

Right and Far Right: Marilyn Monroe and Jane Russell outside Grauman's Chinese Theatre.

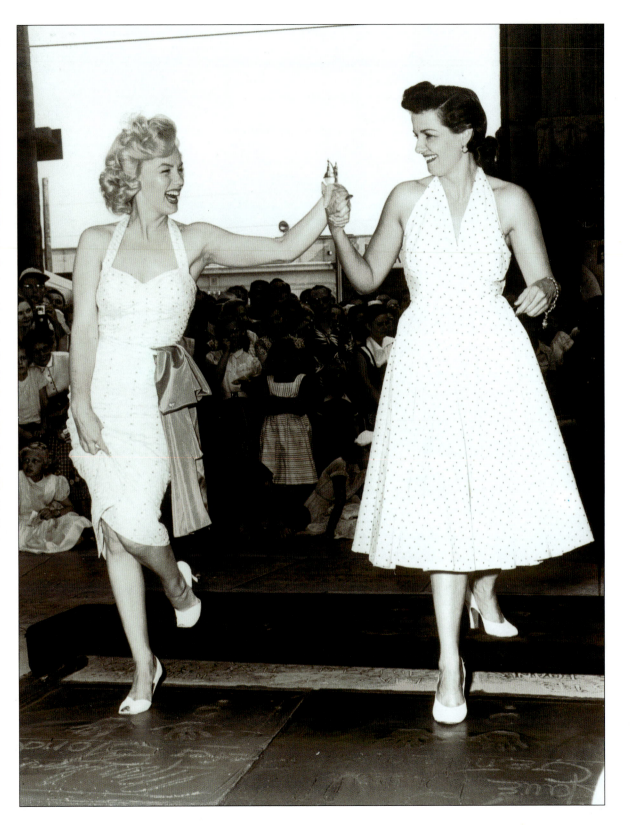

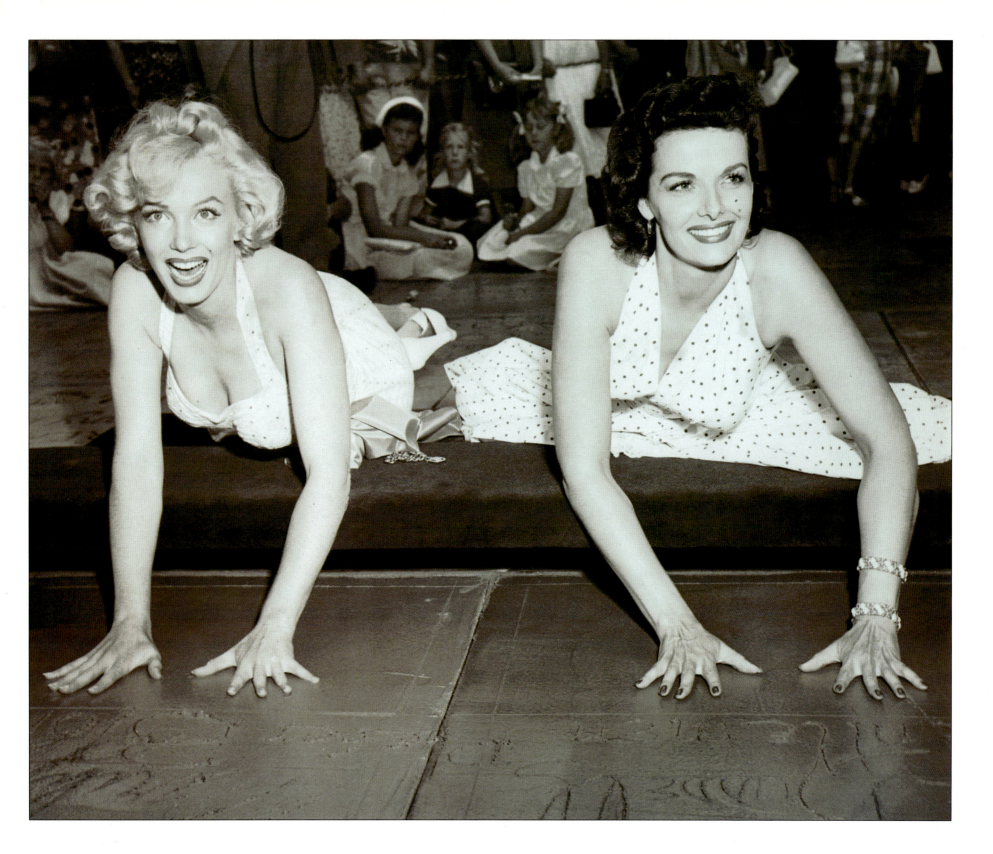

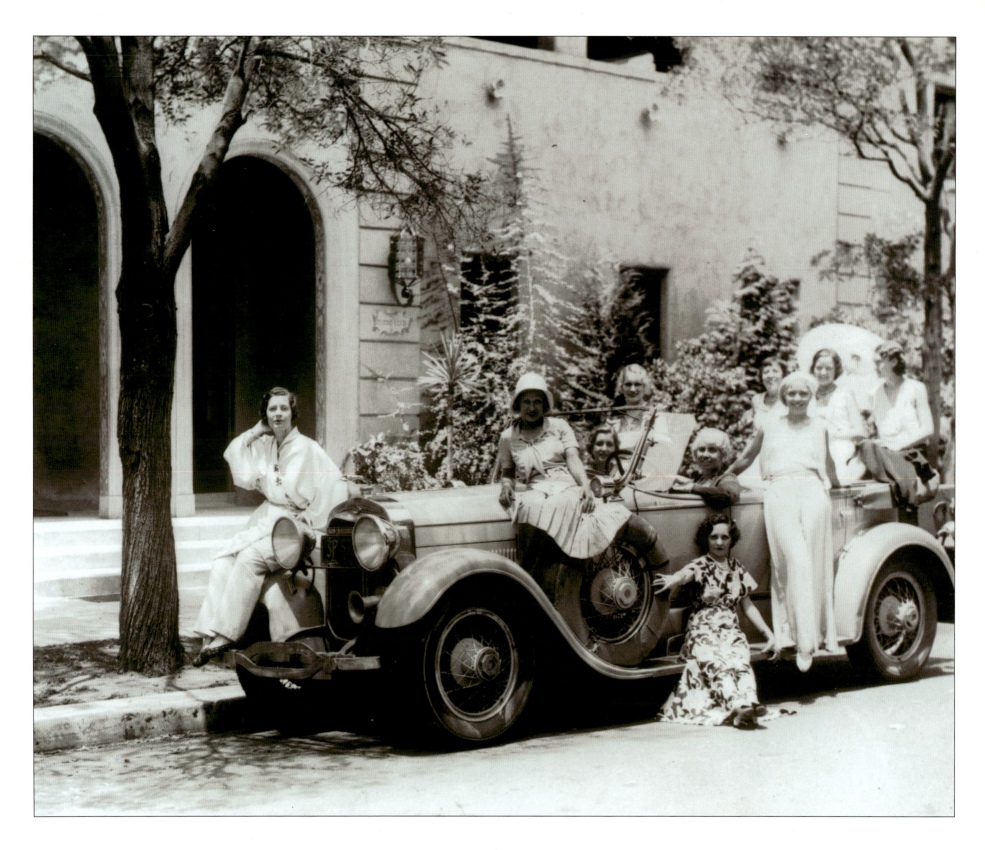

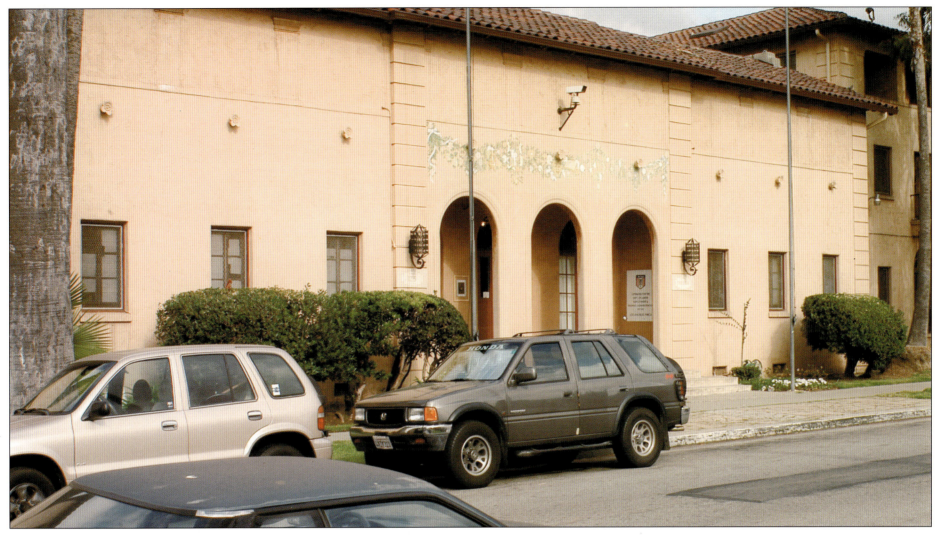

Above: The building that once housed aspiring actresses is now a job training center.

HOLLYWOOD STUDIO CLUB

As the movie industry grew, young girls from all over the country came to Hollywood to seek their fame and fortune. Concerned for their welfare, the Hollywood Woman's Club and the YWCA established the Hollywood Studio Club at 6129 Carlos Street in 1916. By 1925, they had their own building at 1215 Lodi Place. Donations came from the major studios and stars like Gloria Swanson, Harold Lloyd, Howard Hughes, and Mary Pickford. The rules were strict, but the atmosphere was homelike and the rent was low and came with two meals a day. Famous alumnae of the Studio Club include Marilyn Monroe, Rita Moreno, Kim Novak, Dorothy Malone, Nancy Kwan, Zasu Pitts, and Myrna Loy.

The Studio Club was a haven for young girls seeking stardom. But with the decline in the large studios and their stables of performers, the need for it waned. Finally in 1975 the Studio Club ceased operation when the city advised the YWCA the building did not meet new fire-safety standards and could not be used for a residence. Today it is used as a job training center, operated for the Department of Labor by the YWCA.

Left: Young movie hopefuls posing in front of the new Studio Club in 1934.

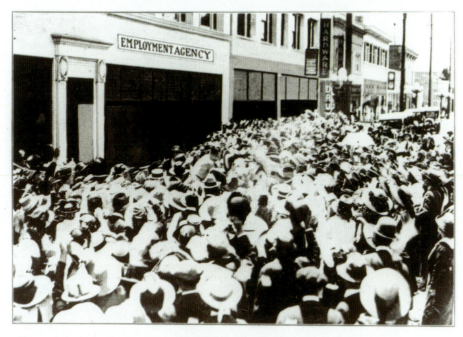

STREET SCENE IN HOLLYWOOD

EMPLOYMENT AGENCY

Thousands buck the line on every call issued for a few movie picture extras. This is a sample of the customary massed assault on the employment bureaus resulting from an ad for a very few men and women to work in an insignificant scene. The wage is meagre for a day or night of hard work.

Don't Try To Break Into The Movies
IN HOLLYWOOD

Until You Have Obtained Full, Frank and Dependable Information

FROM THE

HOLLYWOOD CHAMBER OF COMMERCE
(Hollywood's Great Community Organization)

It May Save Disappointments

Out of 100,000 Persons Who Started at the Bottom of the Screen's Ladder of Fame

ONLY FIVE REACHED THE TOP

DON'T TRY TO BREAK INTO THE MOVIES

By 1921 Hollywood had become a magnet for those seeking fame and fortune. Most were happy to break into the movies as an extra. So many hopefuls were converging on Tinseltown every day that in 1922 the chamber of commerce was forced to take out this advertisement (*left*) as a warning. The exploitation of casual labor, especially the film extras, was addressed by the Will Hays Commission. By 1926 the Central Casting Company had been established to regulate Hollywood extras. Producers would book their extras through Central Casting, which was a free service to all the struggling players.

HOLLYWOOD PROFESSIONAL SCHOOL

Many child actors in early Hollywood had no opportunity for formal education. In 1920 the academic department of the Hollywood Conservatory of the Performing Arts was founded. This became the Hollywood Professional School at 5400 Hollywood Boulevard, established to offer an "academic foundation to professional students actively engaged in motion pictures." Owner Gladys Lyttel recognized that the young stars were unable to attend traditional school hours. At HPS, the classes ran from 8:45 A.M. to 12:45 P.M. and covered a full curriculum. This was not a "stage" school. Arrangements were made for the students to continue their courses on film locations. The early alumni included a young Judy Garland, Mickey Rooney (and his sons), Betty Grable, Donald O'Connor, Connie Stevens, Eric Toberman, and Mitzi Gaynor. The figure-skating world found this the ideal educational setup, as it allowed several hours of "ice time" each day. Olympic medalist Peggy Fleming attended HPS, as did Guinness Book of

World Records holder Elaine Ballace. Tuesday Weld wore a mink coat to class—and smoked! Brenda Lee wrote a song about her time there. Once a month would be "Aud Call," when the whole school would gather in the auditorium and perform whatever they were currently working on. Paul Anka, Brenda Lee, Beach Boy Brian Wilson, Julie London, and Glen Campbell would all perform on the bare stage. Elvis Presley dated a first-year student, so he would turn up at the school each day. Natalie Wood would hang out with her sister Lana's friends when Lana was an HPS student. Other HPS alumni include Ryan and brother Kevin O'Neal (then Tatum and Griffin followed), Barbara Parkins, Peggy Lipton, Michelle Phillips, Melanie Griffith, the *Brady Bunch* kids, several Mouseketeers, Val Kilmer, Linda Blair, and Sue Lyon. The school closed in 1985 and was demolished after the 1994 earthquake. Today it is an empty lot on the corner of Hollywood and Serrano.

Below: Students gather outside the Hollywood Professional School, circa 1951.

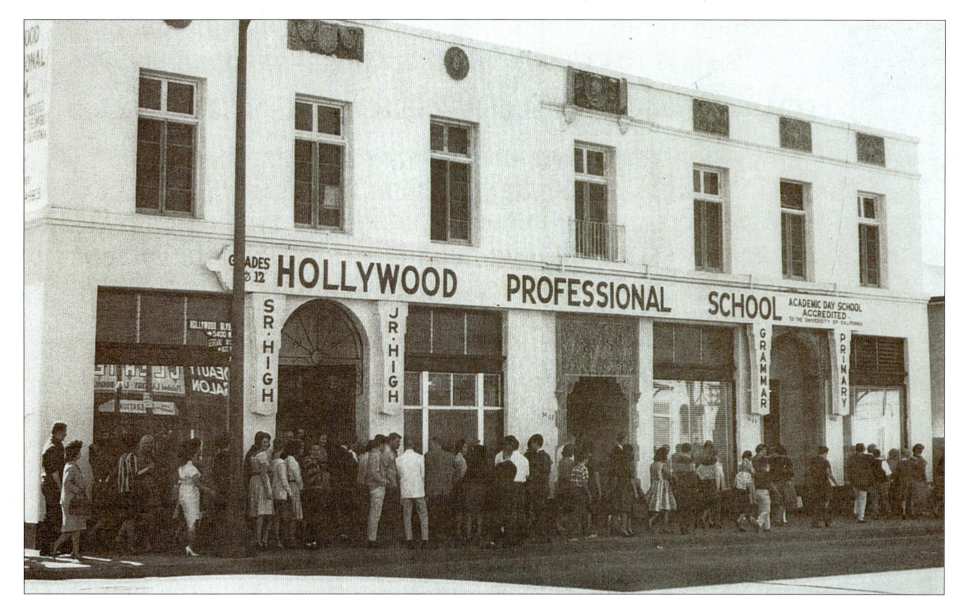

THE STUDIO SYSTEM

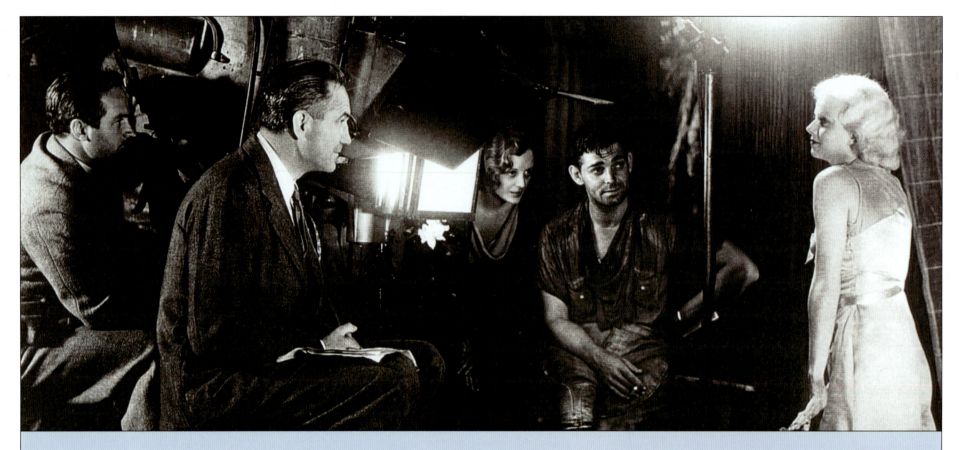

As Hollywood's influence grew, the public became fascinated with the film stars. As the smaller studios merged into larger conglomerates, the producers recognized the value of the movie stars—and they wanted to control them. They put all actors and actresses and some directors and writers under lengthy exclusive contracts. The hungry young actors, anxious to work, leaped at the chance to have guaranteed work and a paycheck each month. The studio system ruled supreme in Hollywood in the golden era of the 1930s and 1940s. Under the careful and iron-gloved guidance of Jack Warner, Harry Cohn, Louis B. Mayer, and the other big studio bosses, the actors were given acting coaching on the studio lots. They also had diction and voice lessons, makeup and hair styling, deportment, and dance and singing instruction. Everything was taken care of. They were told how to dress and behave in public and where they could and could not be seen; thus the public's image of

these young stars would never be tarnished. Publicity campaigns were launched to introduce them to the world and their careers were carefully planned and executed. Film roles were specifically written for their screen alter egos. The world saw the glamorous Hollywood stars at premieres, the best parties, restaurants and nightclubs, and charity functions. While some enjoyed the comfort of all this caring attention, others wanted to be free to play different types of roles and to make their own career decisions. Their "owner" was also free to loan the actor out to another studio. If a contract player wanted a different type of part or refused a role, he was put on suspension that extended the length of his contract. Today these long contracts are a thing of the past. Now actors vying for recognition and profitable careers are free to work where they want, wear what they want, and say and do what they want.

THE STARS

The teaming of legends Jean Harlow and Clark Gable was electric in this 1932 melodrama set on a rubber plantation (*left*). *Red Dust*, originally a Broadway play, was remade in 1953 as *Mogambo*. It again starred Clark Gable, but he was teamed this time with Ava Gardner and Grace Kelly. Victor Fleming went on to direct classic films such as *The Wizard of Oz* and *Gone With the Wind*.

Louis B. Mayer's MGM Studios was one of the most powerful players in the studio system. In this image (*right*), Clark Gable, with the young Mickey Rooney and Judy Garland, welcomes teenager Shirley Temple to MGM after years under contract to Twentieth Century Fox.

Left: A scene between two of the most famous contract players. Clark Gable cues lines off camera to Jean Harlow as director Victor Fleming watches.

Right: Clark Gable, Shirley Temple, Mickey Rooney, and Judy Garland. Temple joined MGM in 1941; her first film for them was *Kathleen,* a box office flop.

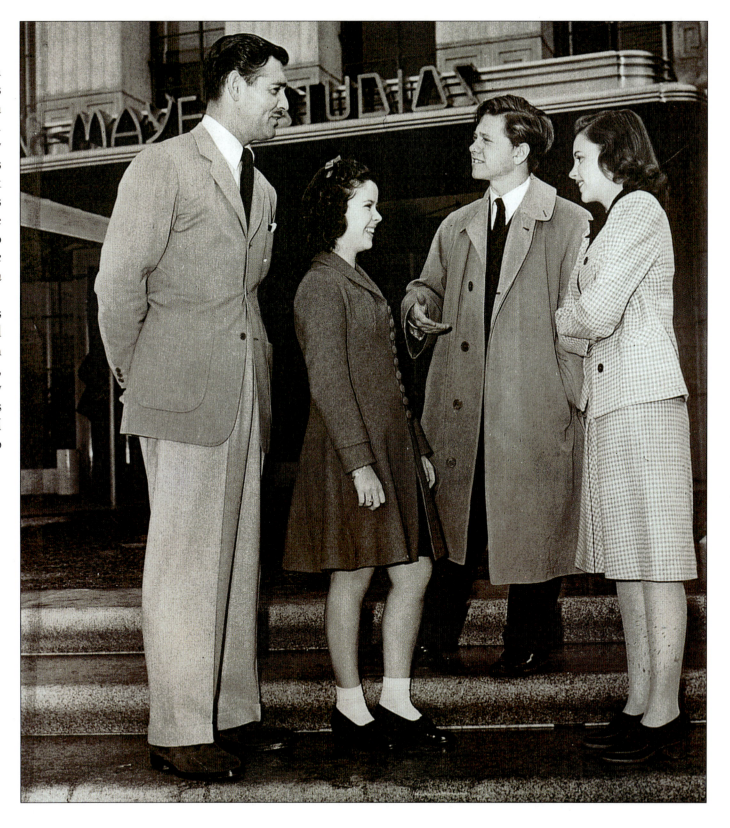

PUBLICITY

In 1939 the Hollywood contract players—both stars and nonstars—dutifully took to the road to publicize the studios' latest offerings. They all did as the studio bosses told them. En route to Kansas City can be seen Gilbert Roland, Priscilla Lane, Errol Flynn, John Garfield, Rosemary Lane, Wayne Morris, John Payne, Hoot Gibson, Buck Jones, Humphrey Bogart, and Frances Robinson, among others.

Below: The stars of *Dodge City*, about to board the publicity train to Kansas. Note Errol Flynn in the center of the picture.

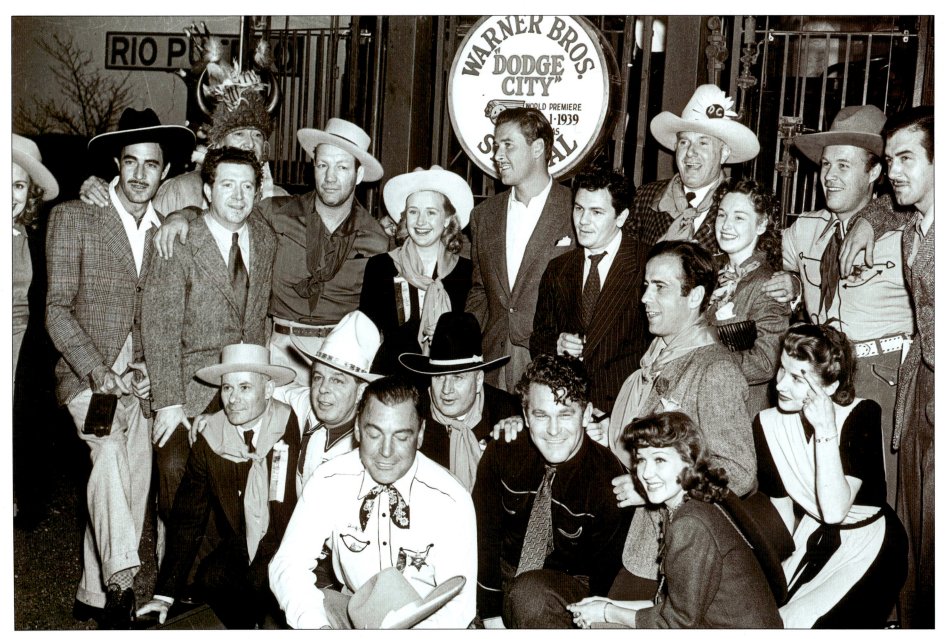

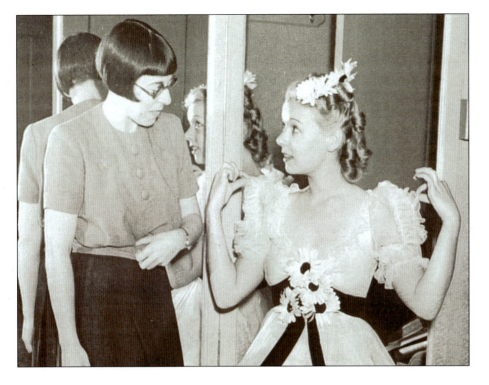

BEHIND THE SCENES

In the 1920s, the Hollywood School for Girls had a young language teacher named Edith Spare, later called Edith Head. Asked to teach art classes as well as French, she studied at night at the Otis Art Institute and later at Chouinard. Edith was encouraged by fellow students to apply for a summer job at Paramount in the costume design department. In the twenty years she spent under contract at Paramount Studios, Edith Head became arguably the most famous costume designer in Hollywood. Her designs were seen in *The Heiress, All About Eve, To Catch a Thief, Funny Face, The Sting,* and over 500 more motion pictures. The most honored woman in Academy Award history, Head was nominated thirty-five times and won eight Oscars. On February 25, 2003, Edith Head's image appeared on a stamp to honor those behind the scenes in Hollywood.

THE DIRECTOR

The lugubrious voice, the famous profile, and the name are synonymous with suspense films with a touch of black humor. Alfred Hitchcock began in London with Paramount's Famous Players-Lasky Productions. His directorial debut was in 1925 with *The Pleasure Garden,* though his Hollywood directorial debut came in 1940 with *Rebecca,* starring Laurence Olivier and Joan Fontaine. Nearly thirty more movies followed, establishing Alfred Hitchcock as the master of suspense and terror. Under contract to Selznick Pictures, he was loaned out to Universal to direct *Saboteur* (1942). In 1954, Hitchcock's agent, MCA, set up a contract with Paramount, where he directed *Rear Window.* His Universal contract began in 1955. For the next ten years he gave us the television series *Alfred Hitchcock Presents,* in which his rotund profile was always the opening shot. Known for his sense of humor, Hitchcock made walk-on appearances in his movies. He scared everyone out of their showers with his 1960 thriller, *Psycho.* Nominated for five Oscars, in 1967 Hitchcock was given the Irving Thalberg Award for his extraordinary body of work.

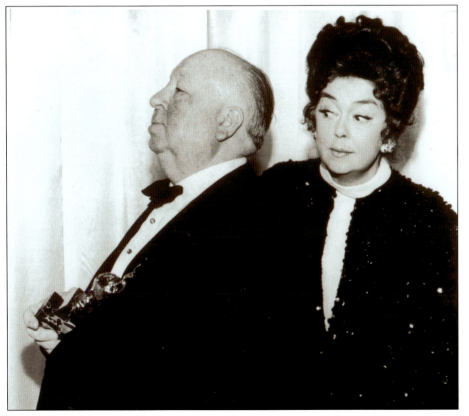

Above Left: Edith Head, seen here with starlet Phyllis Welch in 1930.

Below Left: Alfred Hitchcock with Rosalind Russell as he receives the De Mille Award in 1972.

WHERE THEY LIVED

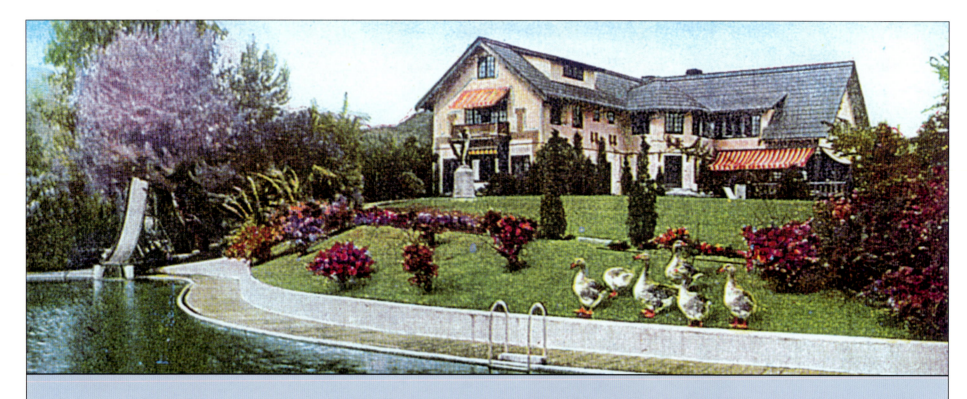

Between 1910 and 1920 the population of Hollywood increased from 5,000 to 36,000. As hopeful actors, directors, and writers flocked to Hollywood, the demand for modestly priced accommodation soared. The Hollywood Hills offered the most sought after locations for the lavish castles and palaces of the wealthy. On the flatlands, people built elegant mansions on the pepper tree–lined boulevards. Tall apartment buildings, grander than any luxury hotel, accommodated the wealthy. In complete contrast, struggling young actors and actresses were living in low-rent boarding houses. Many of these bore signs that said "No dogs or actors allowed." As stars such as Mary Pickford and Charlie Chaplin became extremely wealthy, they left Hollywood behind them and moved west. First stop: Beverly Hills. Many of the older stars continued to occupy their opulent Beverly Hills and Bel Air mansions. Lucille Ball, George Burns, Glenn Ford, Rita Hayworth, and Jimmy Stewart were longtime Beverly Hills residents. Some stars, like Bob Hope, went north to Burbank and Toluca Lake, where the film

and television studios had become established. Marilyn Monroe, Judy Garland, Dorothy Dandridge, Bette Davis, and Rock Hudson all favored West Hollywood. As the decades flew by, other movie folks moved further west. Barbara Stanwyck, Ronald Colman, and Gloria Swanson moved to the beach. Santa Monica and Venice are still magnets for the connoisseurs of cool and Malibu remains the ultimate in status. Tom Hanks, Larry Hagman, Barbra Streisand, and Mel Gibson live surf-side today. Now 75 percent of Hollywood residents live in rented apartments. Many of the working Hollywood actors are residents of the San Fernando Valley or West Hollywood. To protect their privacy, some have bought houses that are tucked away in the Hollywood Hills. With stalkers and paparazzi an ever-present threat, the big stars in their glorious mansions keep well hidden from prying eyes behind ten-foot walls and iron gates.

Above: Pickfair, the home of Mary Pickford and Douglas Fairbanks, became one of the most famous homes in the country.

PICKFAIR

When America's sweetheart Mary Pickford married Douglas Fairbanks, they bought their dream home in Beverly Hills at 1143 Summit Drive. Pickfair was a 1918 hunting lodge that they remodeled into their perfect palace, complete with swans on the lake and a swimming pool. When the couple divorced in 1936, Mary Pickford remained in the forty-two-room house and her new husband, Buddy Rogers, moved in. After her death in 1971, the house was sold to Jerry Buss, owner of the Los Angeles Lakers. He later sold Pickfair and despite protestations from preservationists, the house was subsequently demolished and a new residence built in its place.

VALENTINO'S HOME

Above Hollywood Boulevard in an area called Whitley Heights were some of the most beautiful Mediterranean-style homes. One such home was that of silent screen star Rudolph Valentino at 6776 Wedgewood Place. Purchased in 1924, the eight-room house with servants' quarters had a beautifully landscaped, terraced garden with Italian cypress trees and green lawns. When Rudolph and his second wife, Natasha Rambova, moved in, they decided to make some changes. Mrs. Valentino loved shocking pink, so the decor became pink, gray, and black. Valentino loved to tango, so they put a black marble floor down in the foyer. Rudolph loved this house but Natasha wanted to live in Beverly Hills. A year later they bought Falcon's Lair in Beverly Hills. He spent only a few months there before his untimely death. The house was later demolished to make way for the Hollywood Freeway.

Below: Rudolph Valentino lived here in Whitley Heights.

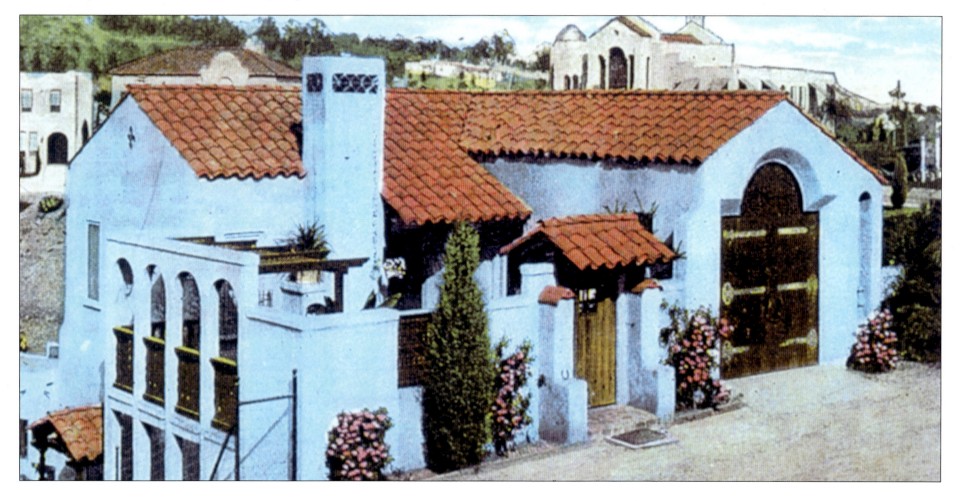

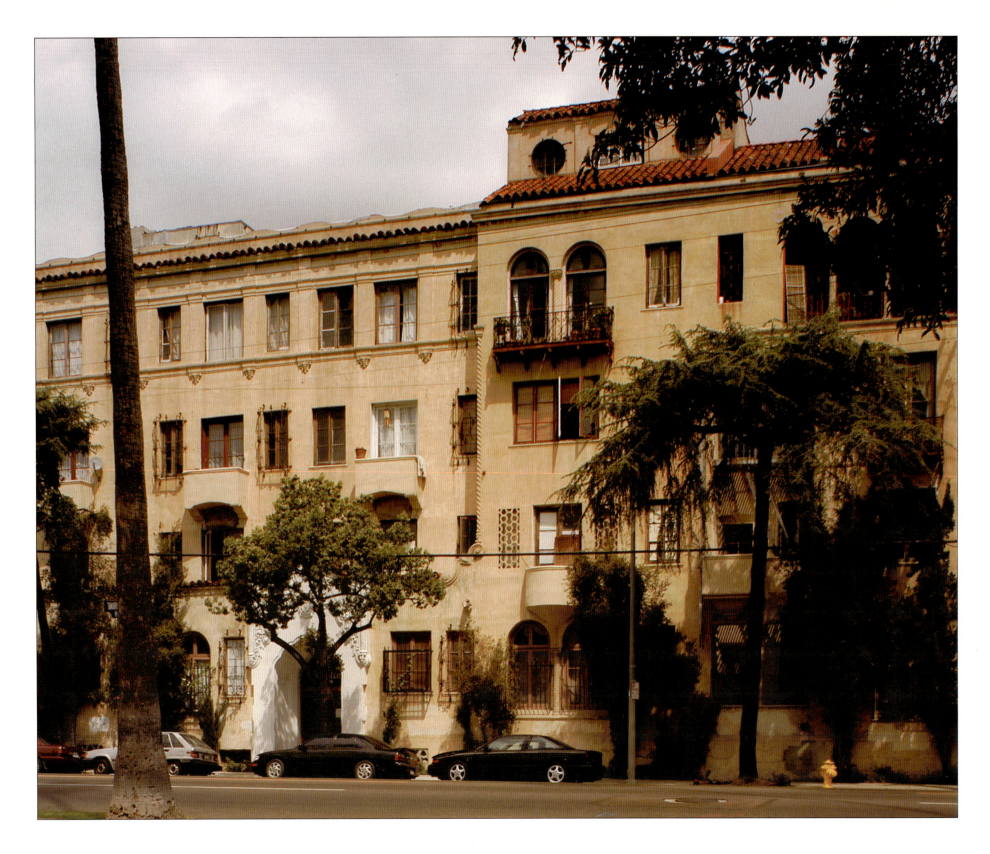

VILLA CARLOTTA

The Villa Carlotta, on Franklin Avenue near Beachwood Canyon, was built in 1927 by Eleanor Ince, widow of pioneer film producer Thomas Ince. The four-story, forty-eight-room Italian Palazzo–style building was originally a hotel for actors. Advanced for its day, the villa had elaborate soundproofing and a ventilation system. Hollywood gossip columnist Louella Parsons lived there and was married in the lobby. Guests at her wedding included Buster Keaton and Norma Talmadge. Marion Davies, Edward G. Robinson, and George Cukor also lived at the Carlotta. Over the years the building has deteriorated, but has not lost any of its charm. The Spanish-style decor in the foyer has survived the years, as has the original furniture, although it's now chained to the floor. Currently it's divided into apartments, and it feels like it's still home to many of the spirits of yesterday.

Left: The Villa Carlotta still survives today, but it is now an apartment building.

Above: The Ravenswood building is still an apartment block, catering to the rental market in West Hollywood.

RAVENSWOOD

This grand old apartment building at 570 North Rossmore was home to Mae West from 1930 until her death in 1980. The buxom, blonde, "Come up and see me sometime" star lived here in the penthouse with her pet monkey, Wooly.

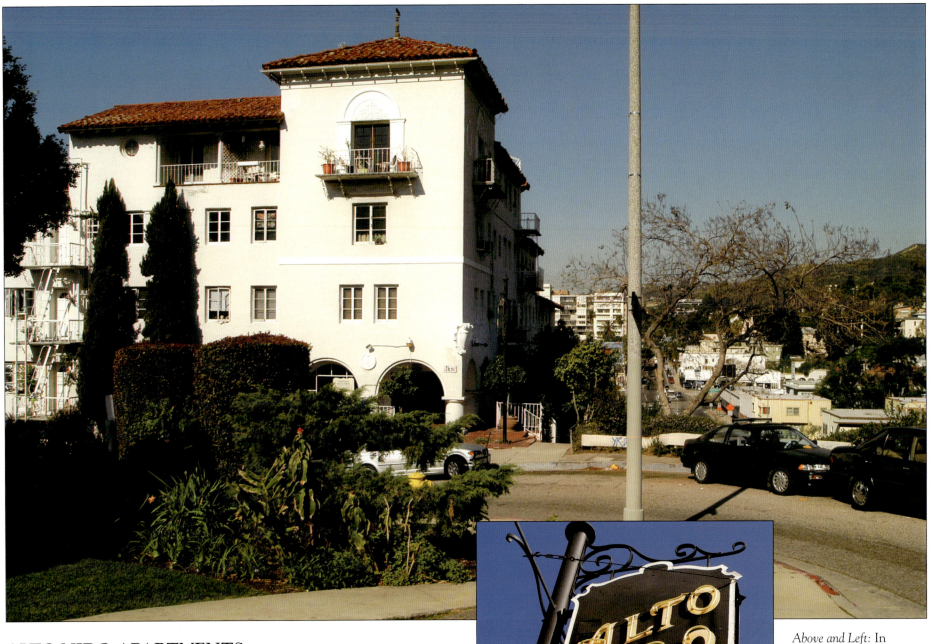

ALTO NIDO APARTMENTS

Right at the end of Ivar Avenue, the Alto Nido at 1851 North Ivar is a beautiful old Spanish-style apartment building. Popular with the film industry in the 1930s, it became famous for being the home of 1947 murder victim Elizabeth Short, the "Black Dahlia," and for being used in the 1950 film *Sunset Boulevard*. Today it's been carefully restored and is still a classic apartment building.

Above and Left: In Sunset Boulevard, William Holden, as screenwriter Joe Gillis, lived here in the Alto Nido apartments.

CHATEAU MARMONT HOTEL

In 1926 Fred Horowitz returned from France with a dream. On February 2, 1929, his Chateau Marmont apartment house opened for business. However, following the Depression, Horowitz sold it to British-born Vitagraph producer Albert Smith, who renamed it the Chateau Marmont Hotel in 1931. It was a private haven for Hollywood's elite. Greta Garbo signed in as Harriet Brown—and was left alone. Jean Harlow liaised here with Clark Gable—on her honeymoon with someone else. Humphrey Bogart and Errol Flynn also hung out at the Marmont. Columbia boss Harry Cohn famously told his young stars William Holden and Glenn Ford, "If you must get into trouble, do it at the Marmont." This is where John Belushi died in 1982. Now under new ownership, the Chateau Marmont hums discreetly on. With its gothic arches and heavy beamed ceilings, the hotel has aged gracefully, with the help of a recent careful face-lift. These days the guests are the new breed of stars: Robert De Niro, Jack Nicholson, Leonardo DiCaprio, Sandra Bullock, and Sting. If they misbehave, no one will tell. It's the Marmont.

Above and Left: The Chateau Marmont is an oasis of charm nestled in the hills above Sunset Boulevard.

WHITLEY HEIGHTS

In 1901 Hobart J. Whitley bought land just north of Franklin Avenue and east of Highland Avenue to develop as a residential tract. It became Whitley Heights, an elegant neighborhood designed to look like an Italian hilltop village. This was where Rudolph Valentino's house stood on Wedgewood Place and where Charlie Chaplin also lived. Their neighbors included Norma Talmadge, Ethel Barrymore, Bette Davis, Joan Crawford, and Jeanette MacDonald. The Whitley family lived at 1720 Whitley Avenue.

Much of this delightful area was lost to the Hollywood Freeway construction, including the Valentino house and the old music pavilion. But there still remains a glimmer of how beautiful old Hollywood was in those days.

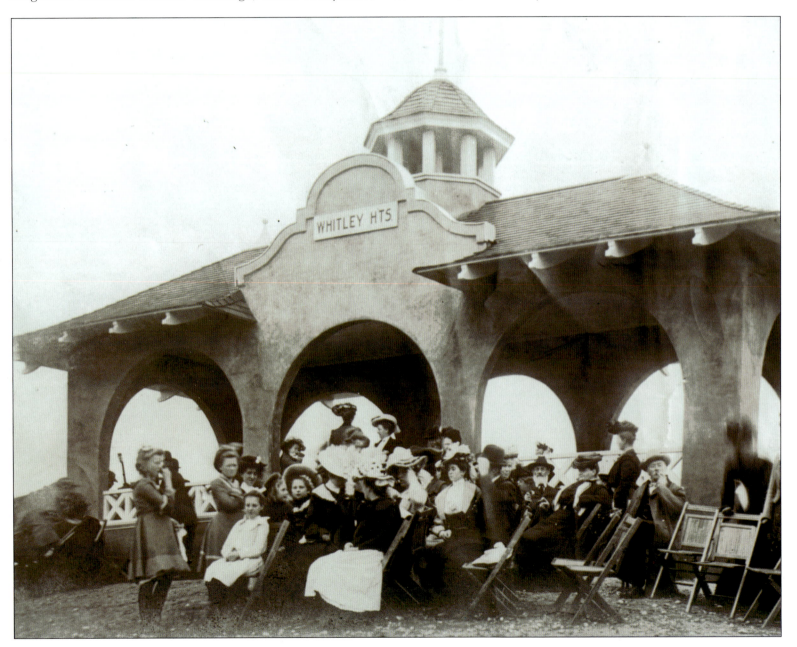

Left: The music pavilion at Whitley Heights photographed in 1903. It was destroyed to make way for the Hollywood Freeway.

Right: The site of Whitley Heights has since been used in movies such as John Schlesinger's 1975 *The Day of the Locust.*

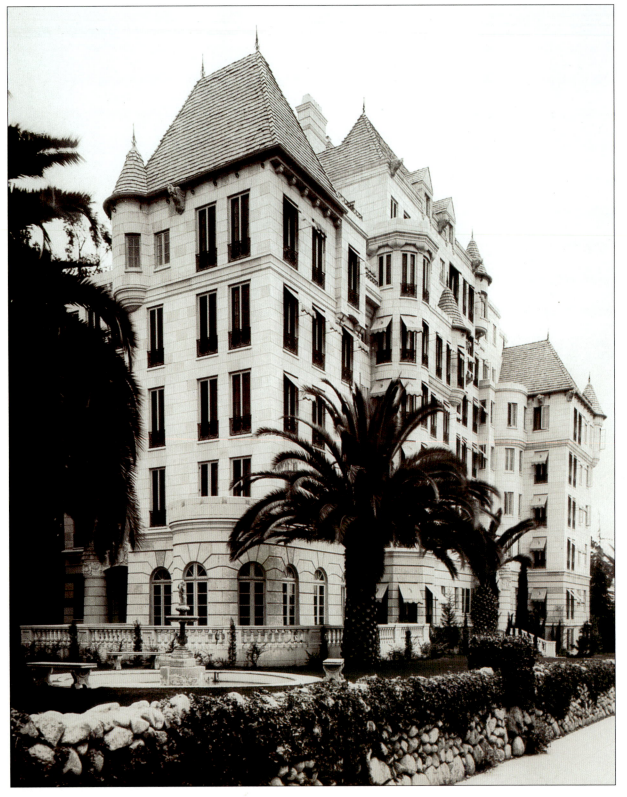

CHATEAU ELYSEE

Completed in 1929 by the widow of film pioneer Thomas Ince, the Chateau Elysee was a secluded hideaway in Hollywood. A French Norman–style chateau with seventy-seven luxury apartments, it was surrounded by beautifully manicured gardens. The seven-story castle had a grass moat, drawbridge entrances, and panoramic views of the city. During Eleanor Ince's ownership, some of Hollywood's most prominent citizens were full- or part-time residents. Many New York–based entertainers kept residences at the Elysee: Clark Gable and Carole Lombard lived here, George Burns and Gracie Allen had room 609, Ginger Rogers and her mother were in room 705, Humphrey Bogart occupied 603, and Edward G. Robinson was in 216. By the time Ince sold the property in 1943, most of the celebrity guests had moved to Beverly Hills and Bel Air. In 1951 it became Fifield Manor, a home for retired actors.

The property was sold in 1973 to the Church of Scientology. Declared a Historical Landmark in 1987, nearly one million man-hours went into the careful restoration of this amazing structure. The impressive rococo lobby has been restored to its former glory and the Manor Hotel (also now called the Scientology Celebrity Centre) has been redone in rococo and French country styles. More than 7,000 new plants have been added to the beautifully manicured grounds. The ninety-year-old palm trees still tower around the property where some of the other trees have stood for 200 years.

Left: Influential Hollywood producer Thomas Ince died in 1924, five years before his grand apartment building was opened.

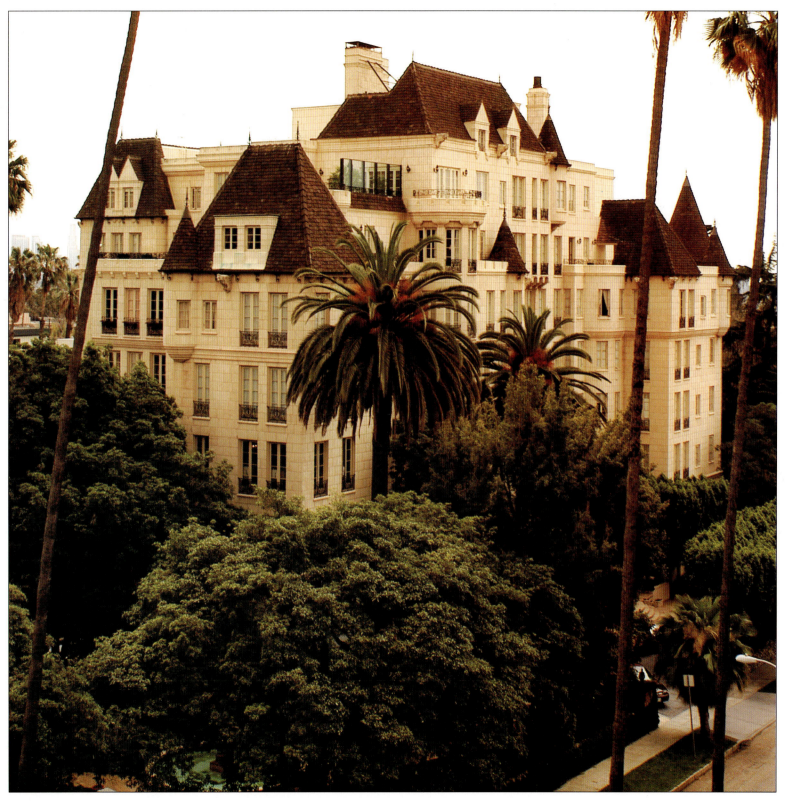

Left: The Chateau Elysee now belongs to the Church of Scientology.

THE HOLLYWOOD HOTEL

The Hollywood Hotel, on the northwest corner of Hollywood and Highland, was a large, quiet, country resort, nestled amid the lemon groves, when it opened in 1903. George Hoover built it for land prospectors, and in 1907 he sold the 144-room hotel to Mira Hershey of the chocolate family. The movie colony started to flock here. Pola Negri, Douglas Fairbanks, Lon Chaney, and Norma Shearer dined and danced here; Rudolph Valentino married and honeymooned at the Hotel Hollywood—its original name. In the crystal-chandeliered ballroom, the owner painted gold stars on the ceiling with names of the stars who dined there regularly, a practice that would lead to the famous Hollywood Walk of Fame. The hotel was demolished in 1956 and was replaced by a bank.

On the site now is the $615 million Hollywood and Highland complex, a development intended to restore this section of Hollywood to its former glory, with stores, restaurants, and a staircase leading to the Babylon Court, designed with replicas of the elephants and motifs from D. W. Griffith's famous *Intolerance* set. The Kodak Theatre is the new home of the Academy Awards and has twenty-six spectacular Oscar photos on display in the lobby. The theater hosts many other events, such as the American Ballet Theatre and charity benefits.

Below: The Hollywood Hotel in 1903, when it first opened. Valentino was refused a room on his wedding night until he produced a marriage license.

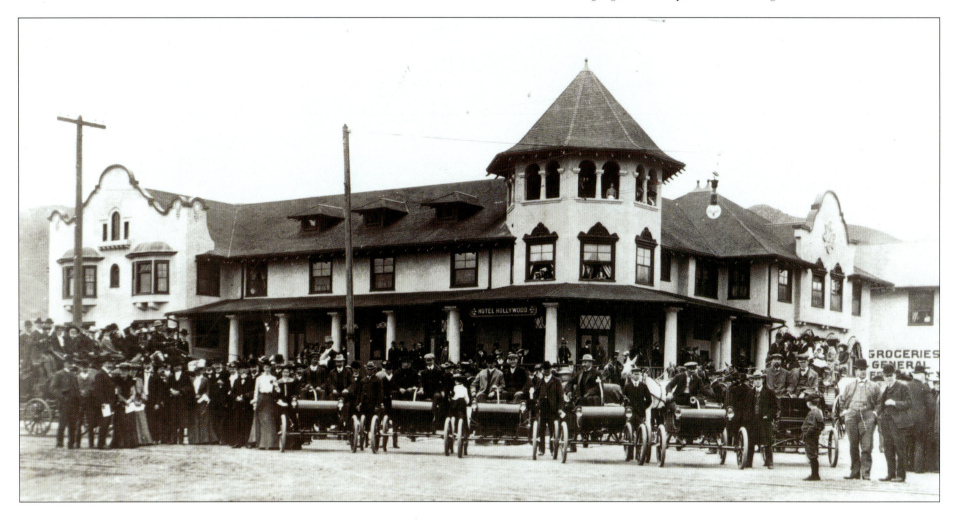

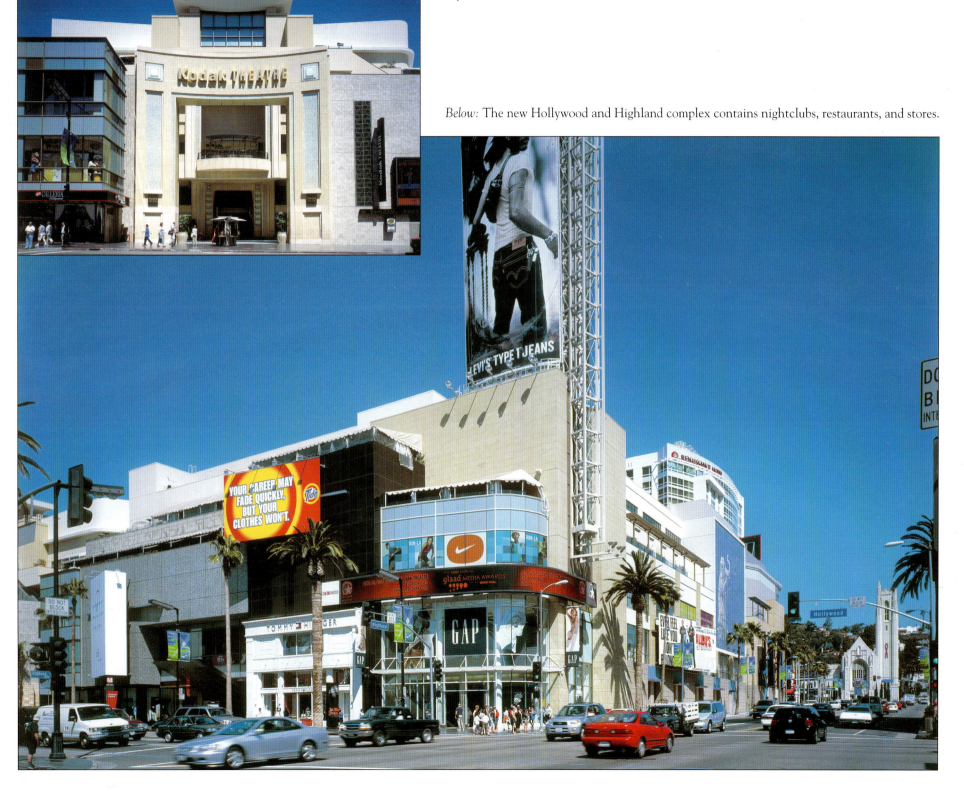

Left: The Kodak Theatre is the new home of the Oscars.

Below: The new Hollywood and Highland complex contains nightclubs, restaurants, and stores.

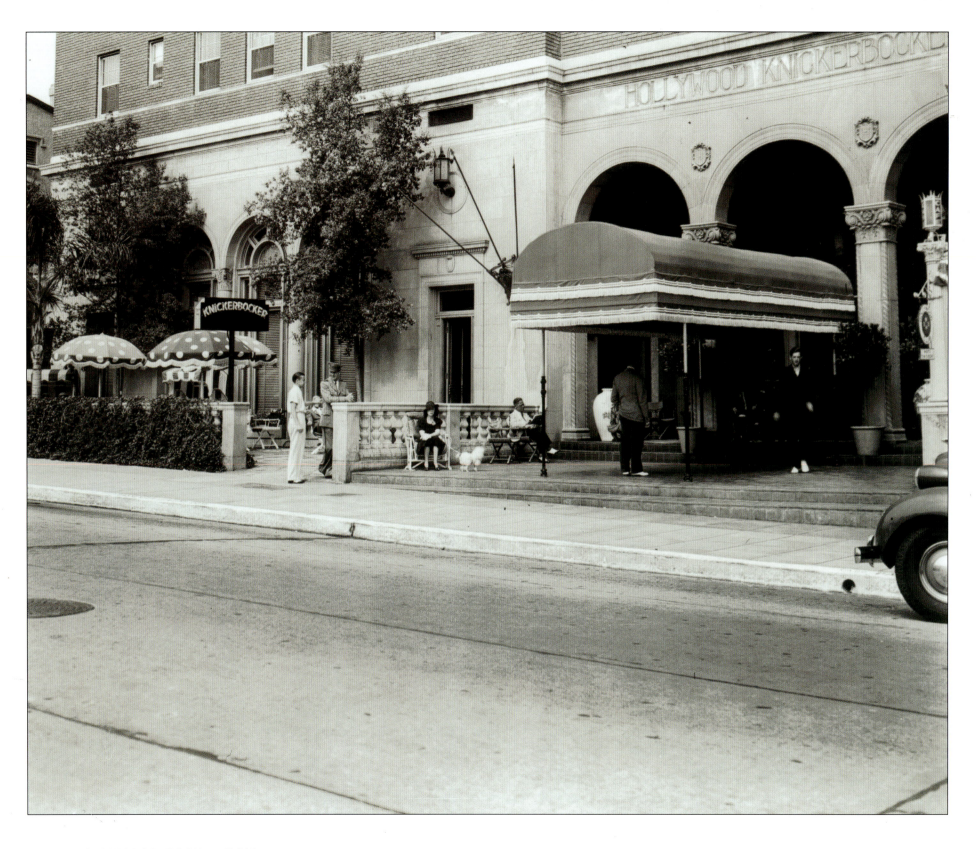

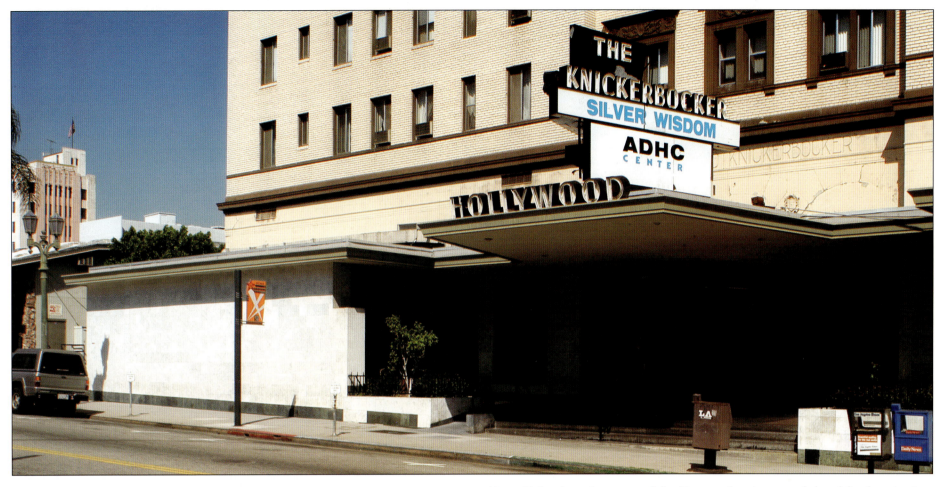

Above: Today the only remnant left of its past glory is a crystal chandelier hanging in the sparse lobby.

THE KNICKERBOCKER HOTEL

Built as a luxury apartment house in 1925, the Knickerbocker Hotel at 1714 North Ivar, played a key role in Hollywood's glory days. Rudolph Valentino tangoed in the Lido Room, and Lana Turner, Laurel and Hardy, and Barbara Stanwyck lived there. D. W. Griffith died of a stroke in the lobby of the Knickerbocker on July 21, 1948. Frances Farmer was arrested here in 1942. Marilyn Monroe and Joe DiMaggio had trysts here. Elvis Presley lived in room 1016, during the filming of *Love Me Tender,* and Houdini's widow, Bess, tried to communicate with him by conducting a séance on the roof.

The Knickerbocker then became a retirement home with a locked security gate. The hotel had become run-down, and the ground floor bar area was shuttered for twenty-five years. In 1993 Max Fisher opened an upscale, nostalgic café called the All-Star Theatre Café and Speakeasy in this famous bar. Bringing back the glamour of the roaring twenties, it was hugely popular with young Hollywood figures such as Leonardo DiCaprio and Sandra Bullock. It was used for film locations and studio wrap parties. Recently forced to move, the All-Star Café is now located at the Vogue Theatre at 6675 Hollywood Boulevard, next to the Musso & Frank Grill. At the Knickerbocker site, you'll now find a Russian café.

Left: The Knickerbocker Hotel during its glory days in the 1930s.

ROOSEVELT HOTEL

This lavish twelve-story Spanish Colonial hotel was built in 1926 by "Mr. Hollywood," the developer C. E. Toberman. It was financed by prominent Hollywood figures such as Mary Pickford, Louis B. Mayer, and Douglas Fairbanks, among others, to house visiting East Coast moviemakers. In his early days a young David Niven lived in the servants' quarters, Mary Martin sang at the hotel's nightclub, Cinegrill, and Errol Flynn made hooch in the barbershop during Prohibition. For five dollars a night, Clark Gable and Carole Lombard occupied the penthouse. Shirley Temple and Bill "Bojangles" Robinson practiced tap dancing on the ornately tiled lobby stairs. Marilyn Monroe did her first modeling job by the pool and Montgomery Clift lived in room 928 while making *From Here to Eternity*. The first Academy Awards banquet was held in the Blossom Room on May 16, 1929.

The Roosevelt, the oldest continuously operating hotel in Hollywood, has been featured in many films and is undergoing a multimillion-dollar renovation. The exquisite Spanish tile and ornate ceilings, columns, and balconies in the main lobby are a feast for the eyes. In the heart of bustling Hollywood, the Roosevelt is a tranquil Mediterranean oasis. Today the spirits of both Marilyn Monroe and Montgomery Clift are said to still haunt the hotel.

Right: The Roosevelt Hotel in 1927. Two years later, the first Oscars ceremony was held here.

Opposite Page: The modern exterior and interior of the Roosevelt Hotel. The legendary Cinegrill nightclub has recently reopened as an exclusive 120-seat cabaret. The statue of Charlie Chaplin is situated by the front door of the hotel.

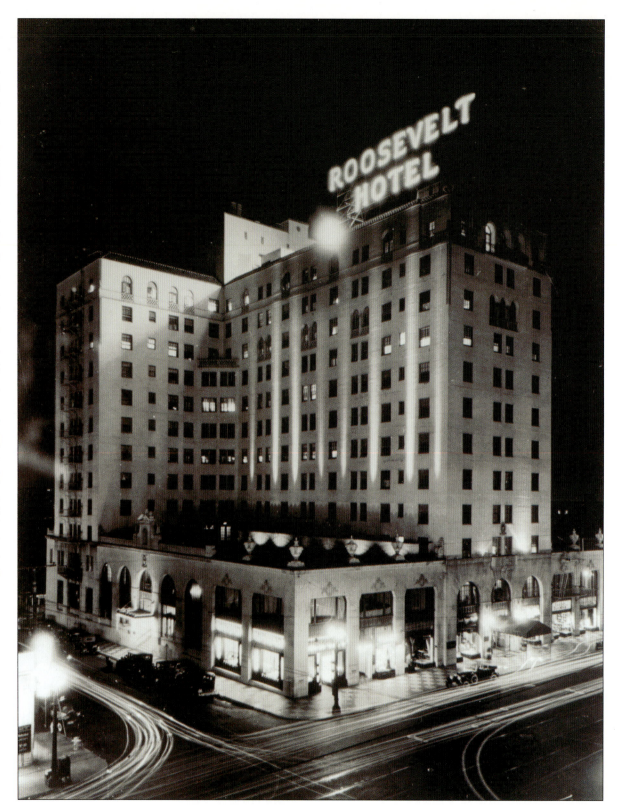

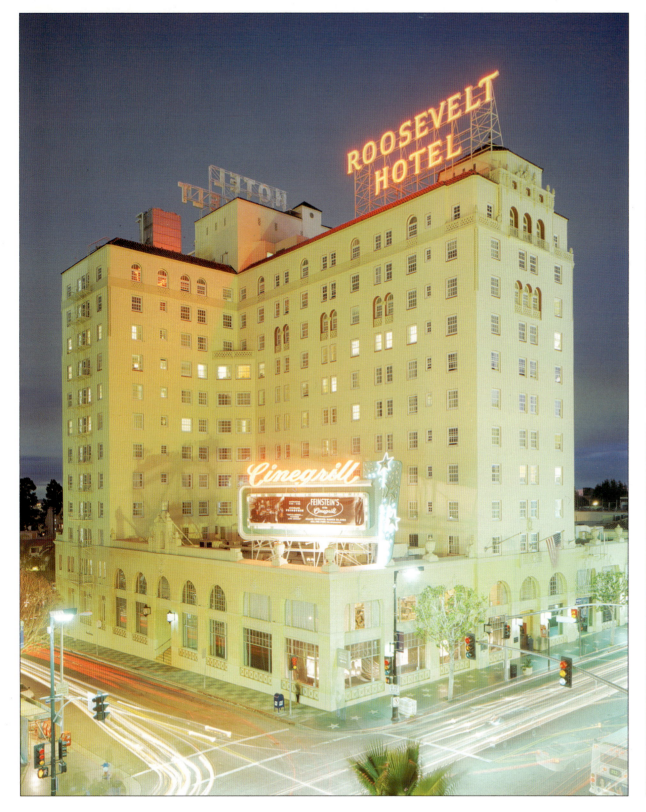

THE GARDEN COURT APARTMENTS

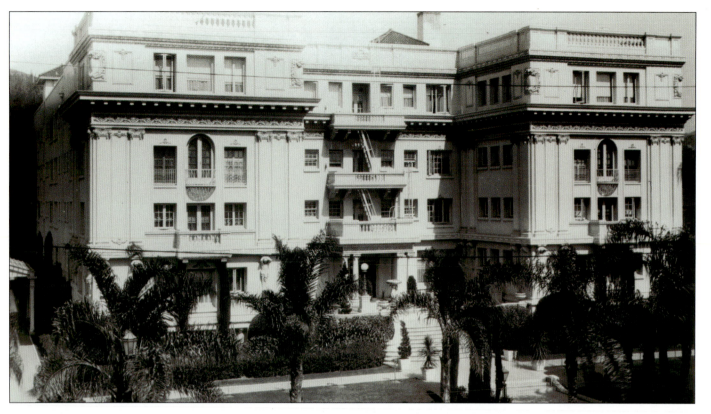

Built in 1919, the Garden Court Apartments at 7021 Hollywood Boulevard were built in Italian Renaissance style. It was the first modern luxury residential hotel built to accommodate the burgeoning film industry. Boasting Oriental rugs and baby grand pianos in every suite, the Garden Court had two lavish ballrooms, tennis courts, a pool, and a fountain in front. Hollywood luminaries who lived there included Mack Sennett, Louis B. Mayer, Lillian Gish, Mae Murray and John Barrymore.

As the local area declined, so did the Garden Court Apartments. In its last years, it was home to the American School of Dance. Finally abandoned, it was taken over by squatters and became known as "Hotel Hell." Movie legend Debbie Reynolds led a fierce battle to preserve the grand old building, but commerce won. It was demolished in 1985 and replaced with the Hollywood Galaxy movie theater complex and a Hollywood props museum.

Above Left: The Garden Court Apartments in 1926.

Below Left: The props museum entrance is located under the canopy—the exact spot of the steps of the old Garden Court Apartments.

THE GARDEN OF ALLAH

At 8150 Sunset Boulevard, the Garden of Allah filled the block from Crescent Heights to Havenhurst. Built in 1921 by wealthy Russian actress Alla Nazimova, it was a complex of villas surrounding an enormous swimming pool. Nazimova opened the garden with a lavish eighteen-hour party and stately dinner. The center of Hollywood's social life in the 1930s and 1940s, Garden residents included Ava Gardner, Frank Sinatra, Errol Flynn, Clara Bow, David Niven, the Marx brothers, Tallulah Bankhead, and Humphrey Bogart. Nazimova lost all the money she had invested in the Garden in the Depression. After her death in 1945, the garden continued as a sanctuary for Hollywood celebrities until it fell out of favor.

Joni Mitchell wrote a song, "Big Yellow Taxi," in which she sang about paving paradise and putting up a parking lot. She was referring to the Garden of Allah, which was sold to Lytton Savings and Loan in 1950. They demolished the colorful playground and built the parking lot mentioned in the song. It's still there today—along with a bank and an assortment of stores and restaurants. It's just across the road from the Chateau Marmont.

Above: The Garden of Allah attracted many celebrity residents. Fans would often wait outside on the sidewalk to glimpse a movie star.

Right: The Garden of Allah was demolished and replaced by this concrete lot.

LEISURE TIME IN HOLLYWOOD

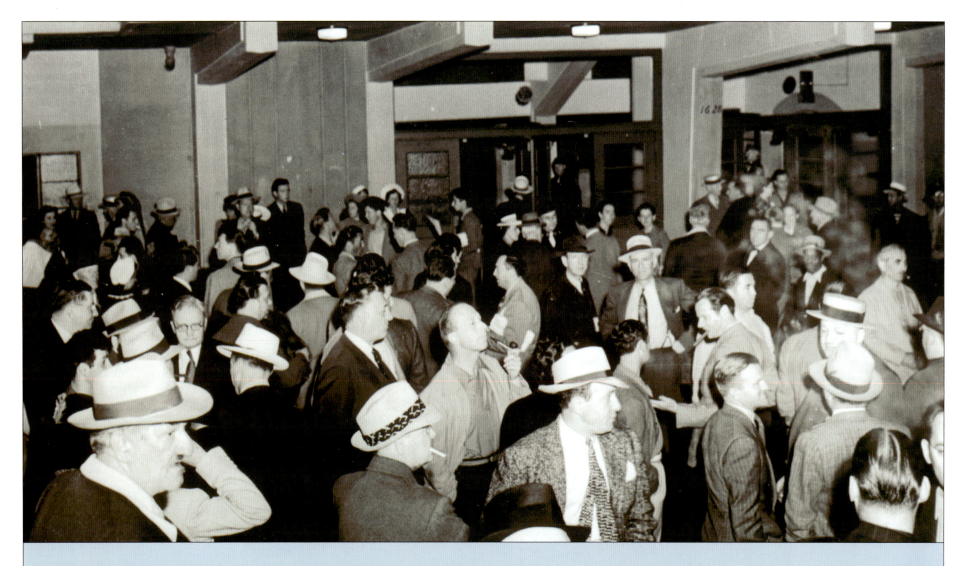

When filmmakers first arrived in this city of dreams, filled with ambition and determination, they worked long, hard hours to establish themselves in a neophyte business. Gradually, filmmakers, as well as writers, actors, and all the technicians, settled into a comfortable existence. Now they had the money and some time to enjoy their life in Hollywood. Those wealthy enough acquired their own airplanes and airfields. Others took up more down-to-earth pursuits. As the movie industry took shape in Hollywood, the town developers created some of the most fanciful arenas for entertainment, be it sportive or musical. It was in the 1920s and 1930s that some of the world's most elaborate and exotic theaters were built in Hollywood. These were a fitting tribute to the celluloid entertainment that the talent in Hollywood was producing. In little more than a decade, Hollywood had created six ornately beautiful theaters, two athletic stadiums, a boxing arena, and what would become a world-famous open-air music venue.

HOLLYWOOD LEGION STADIUM

In need of a recreational facility, Hollywood found a site at 1628 El Centro, just south of Hollywood Boulevard. The Hollywood post of the American Legion bought the property in 1919. By 1923 they had built a 6,000-seat boxing arena that quickly became famous. Some of the best championship boxing matches took place here. The Marx brothers would appear regularly, jumping into the ring to clown around. Al Jolson and his wife Ruby Keeler were front-row regulars; Mae West gifted her favorite boxers with wristwatches. Lou Costello, the Three Stooges, and Claudette Colbert were constantly part of this unlikely mix of Hollywood stars side by side with bootleggers, gangsters, and gamblers. After years of abandonment, this site is once again filled with the athletically minded. It is currently the home of a popular health and fitness club.

Left: Seen here in 1940, the Hollywood Legion Stadium was the site of some of the best championship boxing matches.

Below: After years of abandonment, the stadium was replaced by a fitness club.

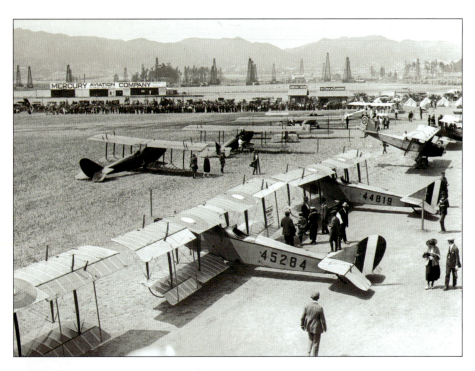

CHAPLIN AIRFIELD

Charlie Chaplin enjoyed the fruits of his success in Hollywood. He also built his mother a house, helped his family establish businesses, and invested in airplanes. The Chaplin Aircraft Corporation was founded in 1919 by Charlie's brother Syd Chaplin. On the southwest corner of Wilshire Boulevard and Crescent Avenue (now Fairfax), the Chaplin Airfield had a fleet of the newest two-passenger airplanes, advertising short observation flights: a fifty-mile run over beach, harbor, and city. They offered a course "in flying tutelage by expert pilots." Syd Chaplin pioneered the first air services from Los Angeles to Catalina Island.

Left: The Chaplin Aircraft Corporation is seen here in 1920.

Below: Wilshire Boulevard is now a busy thoroughfare, minus the airfield.

DE MILLE AIRFIELD

In 1919 celebrated movie director Cecil B. De Mille founded the Mercury Aviation Company and the De Mille Airfield on the northwest corner of Wilshire and Fairfax Boulevards, right next to the Chaplin Airfield. Mercury was one of the first American airlines to carry air freight and commercial passengers on scheduled runs. They proudly boasted that they never had one injury. In August 1920, Mercury Aviation's first Junkers JL-6 plane was delivered by World War I flying ace Eddie Rickenbacker to De Mille Airfield. De Mille discontinued operations of Mercury Aviation in 1921 and sold the assets to Rogers Airport Corporation.

In 1910 there were 319,198 people living in the city of Los Angeles, which included Hollywood. Today there are approximately five million Los Angeles city residents. More people require more amenities and so the airfields are long gone, replaced by banks, apartment buildings, and stores.

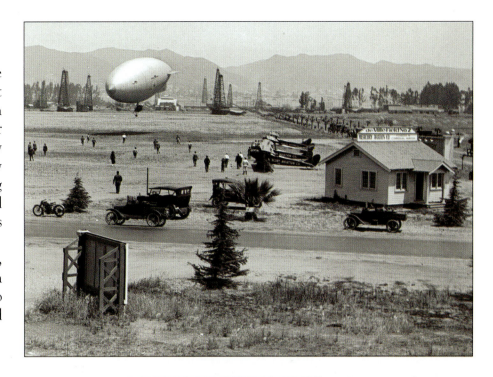

Above: De Mille Airfield in 1920. In the background the Goodyear Pony Blimp is about to land. Note the oil wells in the distance.

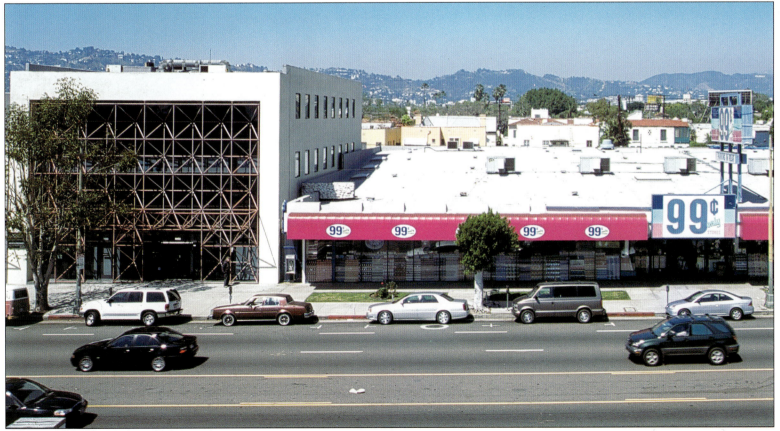

Left: The airfields are long gone in this heavily populated area.

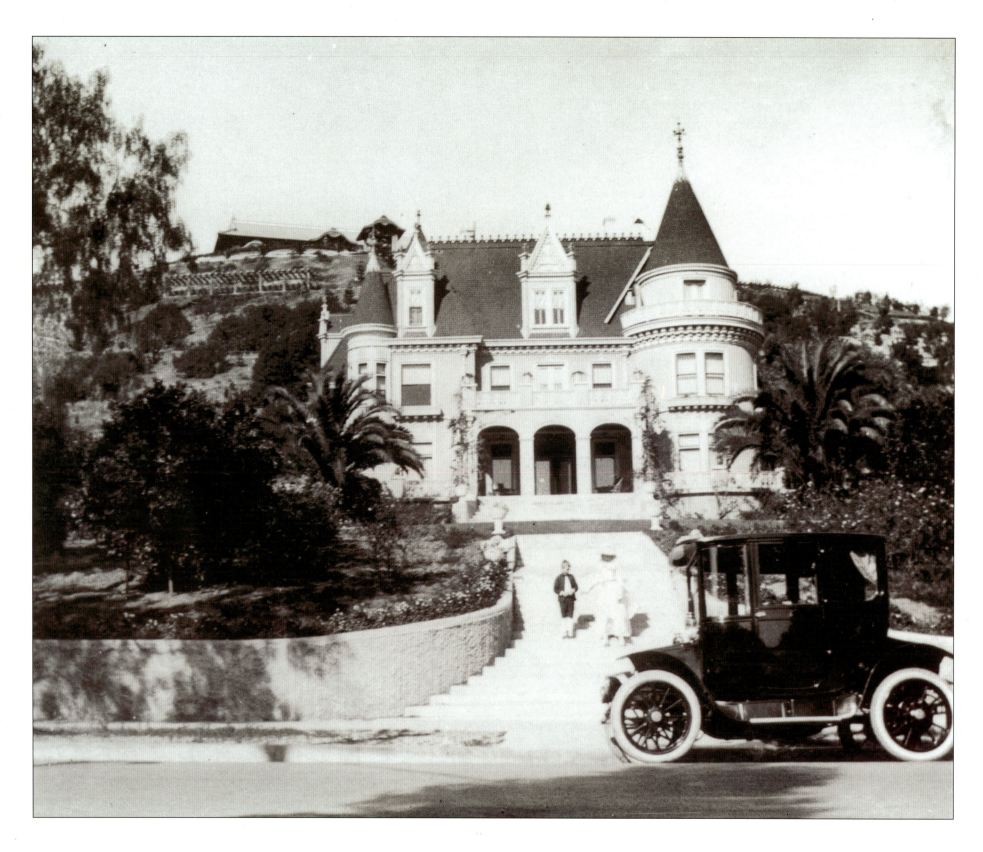

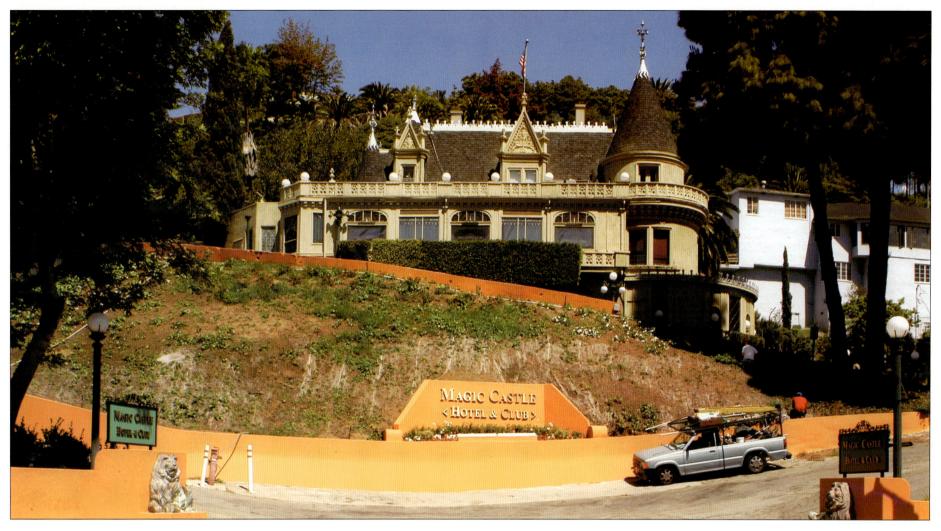

Above: The Magic Castle is now a famous private club with over 5,000 members.

MAGIC CASTLE

Built by philanthropist Rollin B. Lane for $12,000 in 1909 in the midst of orange groves, the three-story, seventeen-room Victorian Gothic house at 7001 Franklin Avenue at the head of Orange Drive was christened Holly Chateau by Mrs. Lane, who spent the rest of her life there. Tom Glover then bought it and leased it to brothers Milt and Bill Larson in 1961. They restored and renovated this intriguing house, then opened it as the Magic Castle. This is the world headquarters of the Academy of Magical Arts, founded by Milt Larson. The promise was "to encourage and promote interest in the art of magic."

Today, with a wonderful new face-lift, the Magic Castle is as busy as ever. The famous private club has over 5,000 members and is a mecca for magicians and celebrities from all over the world. Cary Grant was on the board of directors. Once inside the mysterious house, members enjoy the Parlor of Prestidigitation, the Palace of Mystery, the Close Up gallery, and a gourmet restaurant. In keeping with the elegant Victorian decor, there is a strict dress code and reservations are essential.

Left: Built in 1909, the house was originally called Holly Chateau.

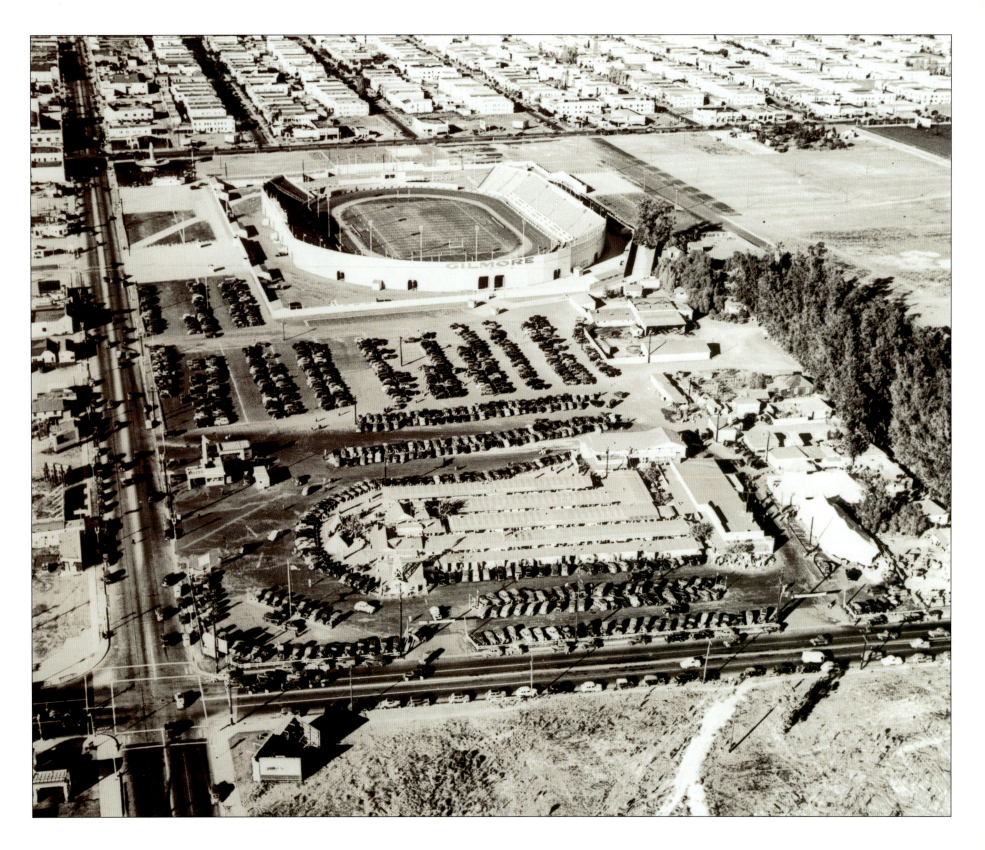

GILMORE ISLAND

When Illinois farmer Arthur Fremont Gilmore was drilling for water for his cattle in 1900, he struck oil on his land at Third and Fairfax. In 1905, the dairy was gone and Gilmore oil was gushing. By 1914 Gilmore's corner of L.A. was known as "Gilmore Island." Arthur's son Earl created a vast gasoline and oil distribution network and invented "gas-a-terias," self-service stations. Meanwhile, in 1934, a group of farmers pulled their trucks onto empty land at the corner of Third and Fairfax and displayed their produce from their trucks. The idea caught on, the crowds came and strolled around the displays, and the Farmers Market became an institution. Back at the oil wells, sports-loving Arthur built Gilmore Stadium just north of the market. The 18,000-seat stadium was home to the Bulldogs, L.A.'s first professional football team. The stadium was also used for boxing matches, dog shows, an Esther Williams aquatic show, circuses, rodeos, and midget car racing. Arthur's son Earl built a racetrack on Gilmore Island. His love of cars would lead him later to sponsor winning cars at the Indianapolis 500. In 1987, E. B. Gilmore was elected to the Indianapolis Motor Speedway Hall of Fame.

GILMORE FIELD

Gilmore Field was constructed in 1938 in the northeast part of Gilmore Island. It was built to accommodate the Hollywood Stars, a Pacific Coast League baseball team. The club was owned by Bing Crosby, Barbara Stanwyck, Walt Disney, Cecil B. De Mille, and Gary Cooper. Generations of Angelenos watched the Stars play at this intimate venue, helping to persuade the Brooklyn Dodgers, in 1957, to move west. Semiprofessional football was also played on the former dairy farm. Later there was a much-loved drive-in movie theater here.

Left: An aerial view of Gilmore Island showing the Gilmore Stadium, which finally closed in 1950.

Below: Gilmore Field was home to the Hollywood Stars baseball team.

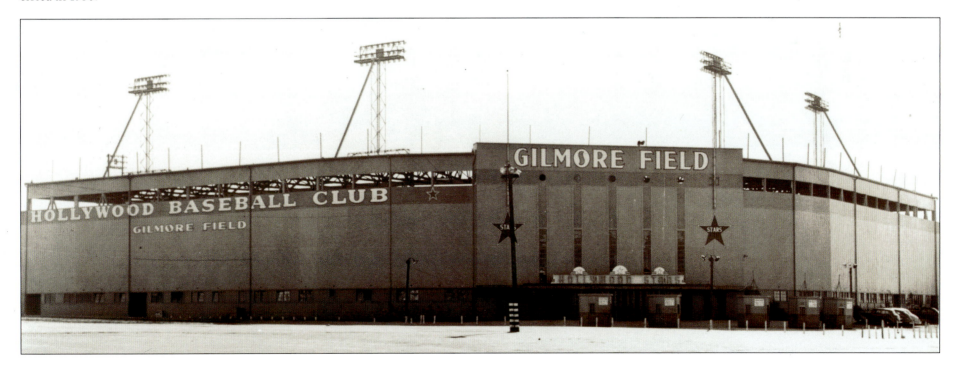

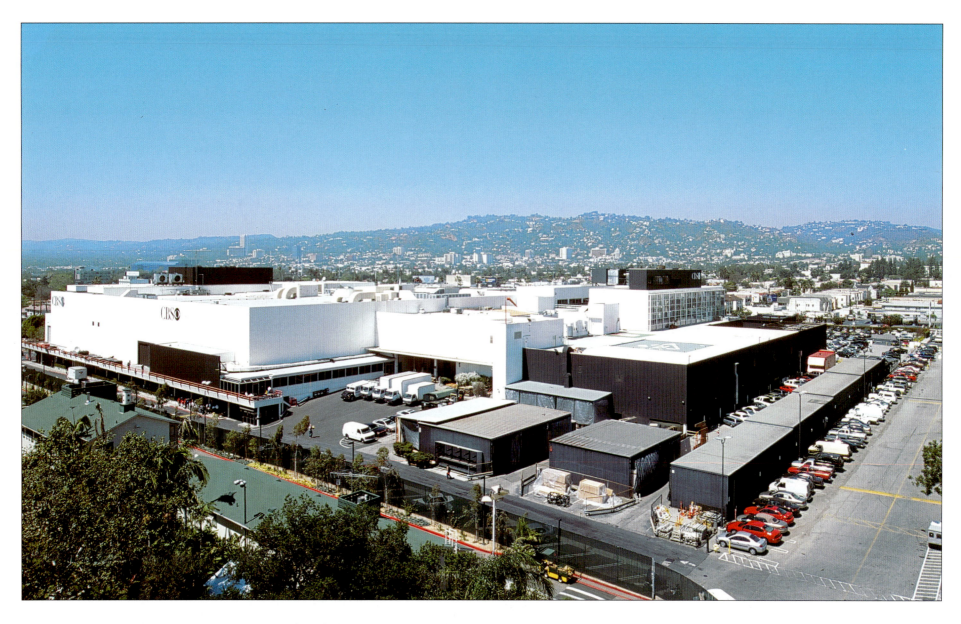

Today CBS Television City, just north of the Farmers Market, occupies the Gilmore Stadium site. Since 1952 CBS has filmed a myriad of television shows here, including *The Twilight Zone*, *The Merv Griffin Show*, *The Carol Burnett Show*, *The Young and the Restless*, and *Hollywood Squares*. Other CBS shows include *The Guardian* and *Everybody Loves Raymond*. In 1999 Viacom (Paramount's parent company) bought the CBS network in, what was then, the largest merger in media industry.

The old Farmers Market on Gilmore Island recently had a massive four-year renovation, which transformed the property into an elegant shopping center called the Grove. Stylish restaurants and stores surround the quaint "town square," which features a fishpond, a grass area, and a luxurious new theater complex, complete with 1920s-style uniformed staff wearing pillbox hats and white gloves. This is just steps away from the site of the old Gilmore drive-in theater. A vintage trolley takes visitors around the new Grove. The original Farmers Market still stands where it always has and linking the two is the famous 1941 clock tower, inscribed with a tribute to Gilmore Island founders: "An Idea."

Above: CBS Television City now occupies the Gilmore Stadium site.

Below and Right: The Farmers Market has been transformed and renovated into a shopping center known as the Grove. The famous 1941 clock tower still stands.

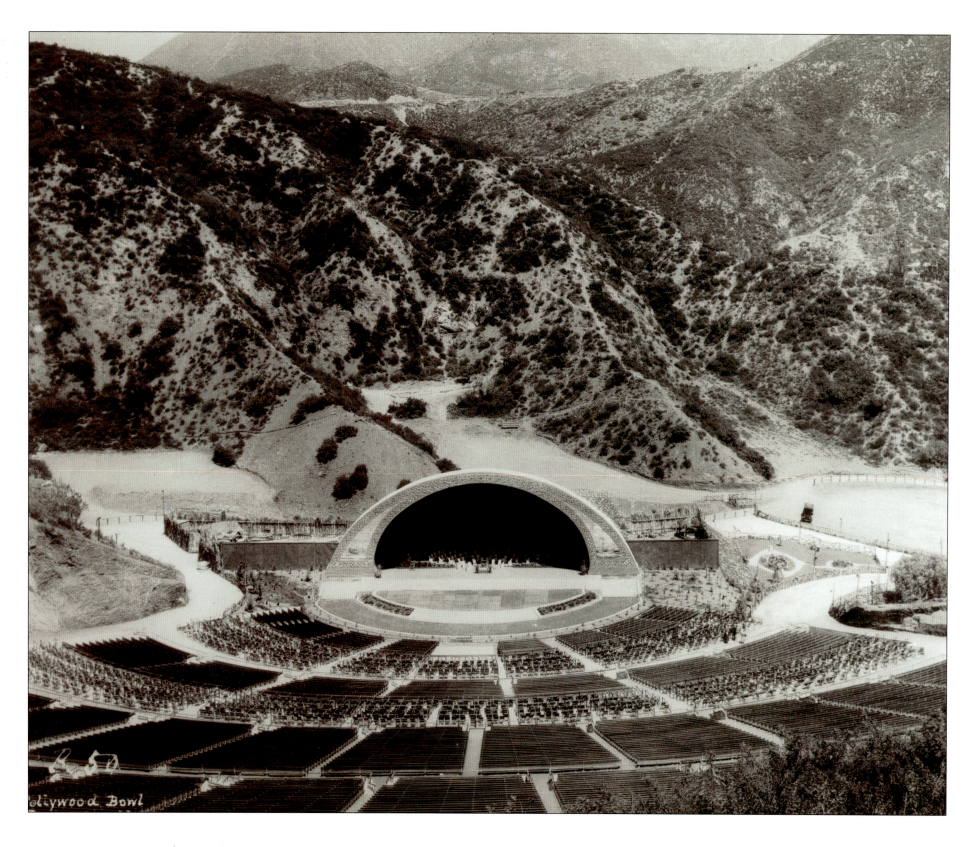

Hollywood Bowl

HOLLYWOOD BOWL

When Christine Stevenson, heiress to the Pittsburgh Paint fortune, arrived in Hollywood in 1918, she wanted to present religious plays and outdoor theatrical performances. She chose Daisy Dell, where the Hollywood Bowl now sits. Stevenson established the Theater Alliance, and with developer C. E. Toberman's help, she bought the land for $49,000 in 1919. In 1920 the Theater Alliance was replaced by the Community Park and Art Association, which took over ownership of Daisy Dell.

Enter Artie Mason Carter, who was supervising musical performances in the Dell. Carter, the "arch-dreamer and master-builder of the Hollywood Bowl," created fund-raising schemes and publicity. She told whomever would listen of "this outdoor gathering place where people can hear symphonies under the stars." The name came in 1920 when conductor Hugo Kirchhofer declared: "It's like a big bowl—a Hollywood bowl!" Hollywood Bowl's first Easter sunrise service was March 21, 1921.

The "Symphonies Under the Stars" concerts cost twenty-five cents. In 1926 a large "shell" was erected. Lloyd Wright (son of Frank Lloyd Wright) designed shells for the Hollywood Bowl in 1927, which were then replaced in 1929 by a sturdier steel shell.

The Hollywood Bowl was featured in the 1937 version of *A Star is Born* with Janet Gaynor and Frederic March, and in many other films since then. The legendary artists that have graced the famous stage include Igor Stravinksy, Frank Sinatra, Barbra Streisand, Luciano Pavarotti, Ella Fitzgerald, the Beatles, and Judy Garland.

The Hollywood Bowl today looks much as it did in the beginning. Careful maintenance keeps its architectural integrity, and much has been done to renovate the facilities and the grounds. From Leonard Bernstein to Bobby McFerrin, from the Playboy Jazz Festivals to Paul McCartney, such is the rich assortment of wonderful music that emanates from the magical home of "Symphonies Under the Stars."

Left: Lloyd Wright designed shells for the Hollywood Bowl in 1927.

Below: The Hollywood Bowl looks today as it did when first constructed, thanks to careful maintenance and renovation.

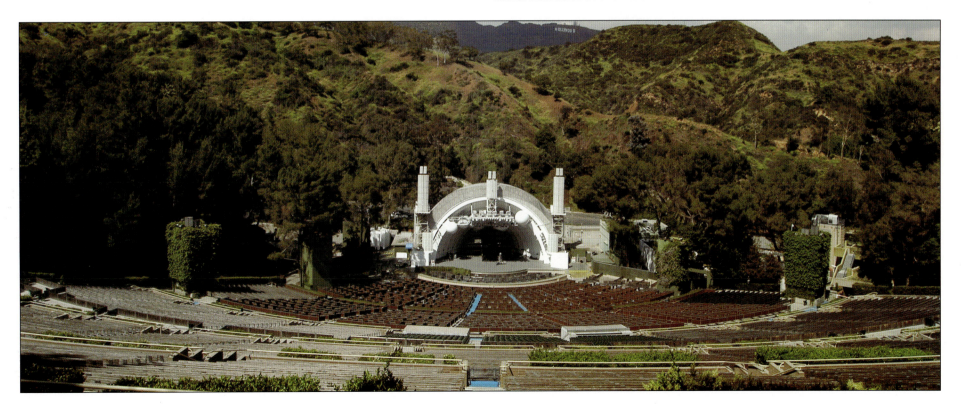

HOLLYWOOD AND HIGHLAND

In the mid 1920s, the intersection at Hollywood Boulevard and Highland Avenue was the hub of the area, mainly due to the Hollywood Hotel. The oldest theater in Hollywood was located here. Built in 1913 as the Idle Hour Theatre, it was remodeled and renamed the Hollywood Theatre.

Hollywood and Highland is still one of the busiest crossroads in the city. The former Hollywood Theatre is now the Guinness World of Records Museum.

Above Right: This photograph was taken from the Hollywood Hotel in the mid-1920s and shows the intersection at Hollywood Boulevard and Highland Avenue. The building behind the traffic policeman is the C. E. Toberman Building and to the left of that is the Hollywood Theatre.

Right: Today the intersection is just as busy, with the Guinness World of Records Museum replacing the former Hollywood Theatre. To the right is the Ripley's Believe It or Not Museum.

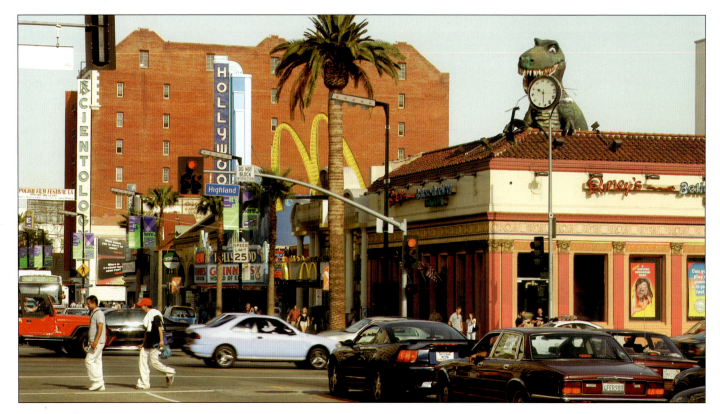

THE MUSIC BOX THEATRE

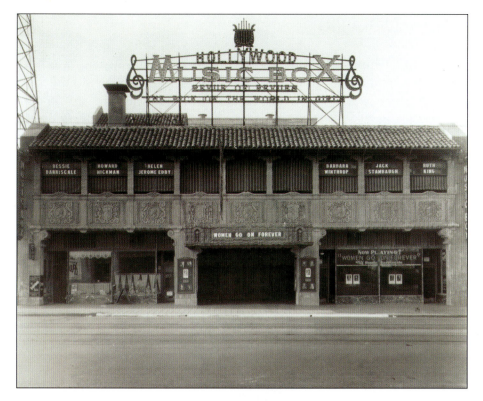

Above: The Music Box Theatre in 1931.

In October 1926 the Hollywood Music Box Theatre opened at 6126 Hollywood Boulevard. It ran elaborate shows with Fanny Brice and other musical stars. A year later, legitimate theater replaced the musicals, with *Dracula*, starring Bela Lugosi, and *Chicago*, featuring Clark Gable. In 1936 the Music Box Theatre was home to radio broadcasts of popular live radio dramas featuring Marlene Dietrich, Joan Crawford, James Cagney, and Al Jolson. Returning to traditional stage productions, *Life with Father* played here in 1942. The name of the theater was changed to the Guild in 1945 and then to the Fox, as motion pictures proved more popular at this theater. In 1985 it became the Henry Fonda Theatre as a tribute to the actor who enjoyed success on stage with productions of *Mister Roberts* and *The Caine Mutiny Court Martial,* as well as his better-known career in film, with movies such as *12 Angry Men.*

Now this theater is called the Henry Fonda Music Box Theatre. The People's Choice awards, Country Music Awards, and the Grammy nominee parties have all been held here. The venue has also been host to concerts by Tori Amos, Cyndi Lauper, and Sandra Bernhard.

Right: Today the theater is still going strong and is also used as a stage concert venue.

Right and Below: In 1923 the first movie to show at the Vista was *Tips*, starring Baby Peggy.

VISTA THEATRE

The Vista Theatre was built in 1923 as a vaudeville house called the Bard's Theatre, taking its name from a local showman who built four theaters with exotic Egyptian themes. It stands on the site of the towering Babylon set from D. W. Griffith's 1916 epic *Intolerance*. In October 1923, it debuted as a movie house with the premiere of *Tips*, starring child star Baby Peggy. The movie cost ten cents and candy was five cents. On Sunday there were four vaudeville acts before the movie. Eccentric film director Ed Wood had an office upstairs at the Vista. In

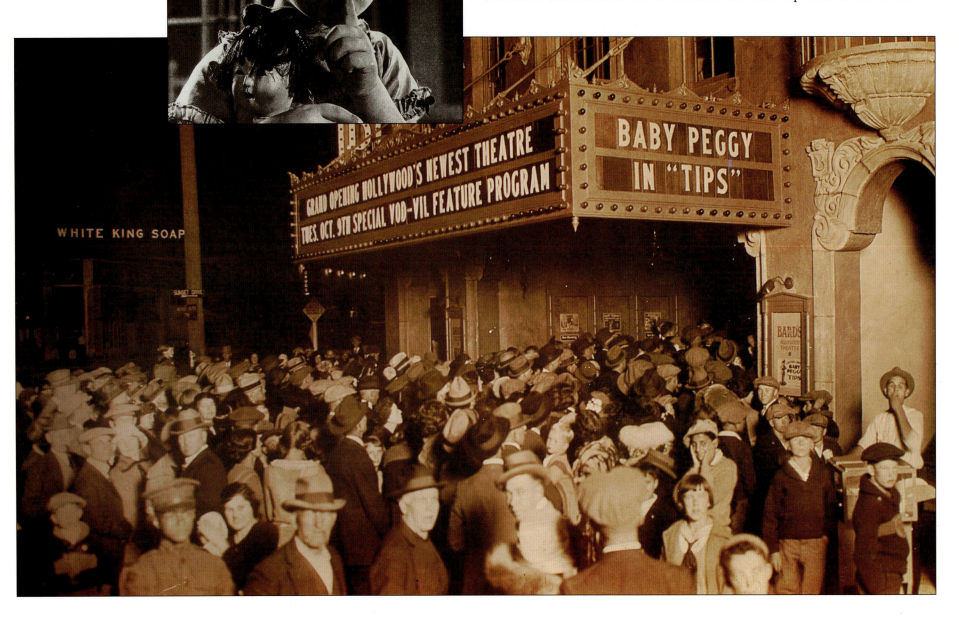

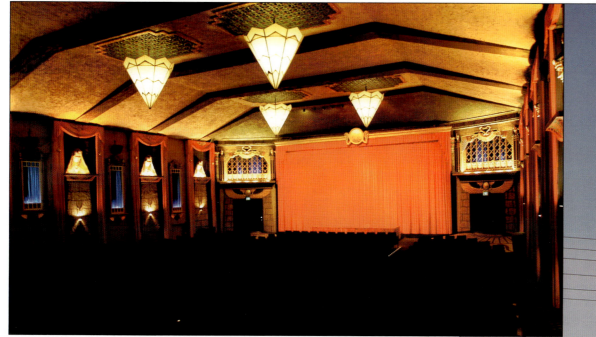

Right and Above: The Vista has now been beautifully renovated.

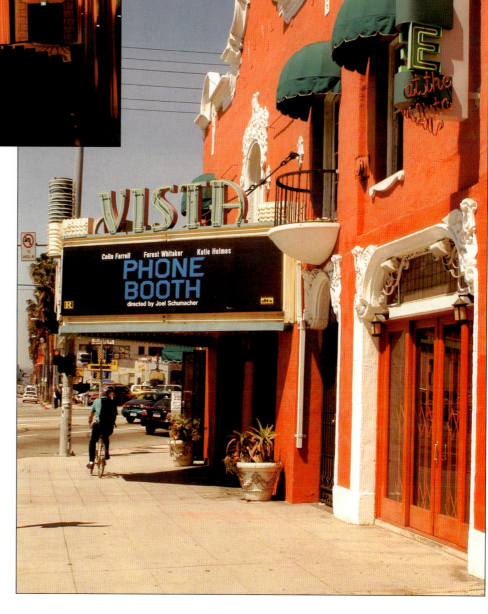

the 1950s the building, as with the surrounding neighborhood, became run down. In the 1960s and 1970s the Vista ran adult movies.

Film enthusiasts realized the historical importance of this bijou cinema and it has recently been beautifully restored. There are now celebrity handprints in the entranceway, the Egyptian interior has been carefully renovated, and there are fewer seats, more legroom, and a revamped sound system. The Vista shows classic and first-run films. It remains a favorite with some of the biggest show-business names, who enjoy anonymity here.

GRAUMAN'S CHINESE THEATRE

Once developer C. E. Toberman had persuaded Sid Grauman and his father to relocate to Hollywood, they built some of Hollywood's most notable landmarks together. Grauman's Chinese Theatre—the most famous and instantly recognizable—opened on May 18, 1927, with the premiere of Cecil B. De Mille's *The King of Kings*. It was said to be the grandest opening ever, with hundreds of fans clamoring for autographs from the bejeweled stars. Grauman and Toberman had produced the most exotic theater; the Chinese front is

Below and Right: Grauman's Chinese Theatre in 1930.

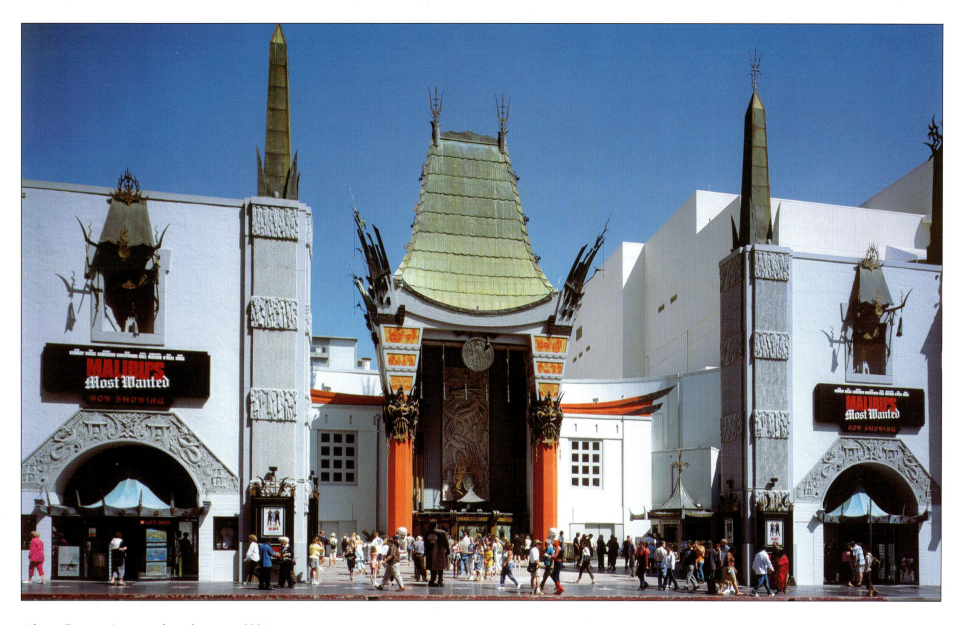

Above: Grauman's regained its identity in 2001.

ninety feet high and the bronze roof is held aloft by two gigantic columns, between which is a carved stone dragon. Giant Foo dogs guard the entrance.

On November 9, 2001, Grauman's Chinese Theatre reopened after an extensive $2 million renovation and upgrade. Almost eighty years after it opened, it now has some of the most technologically advanced projection and sound equipment. The large, dramatic lobby boasts ornate Chinese murals and chandeliers. The projection booth was moved back upstairs to its original location after it was moved downstairs in 1958. It was renamed Mann's Chinese after Ted Mann purchased it in 1973, but when the theater was acquired by a partnership of Warner Brothers and Paramount in 2000, they restored its original name. Grauman's Chinese Theatre reopened with the premiere of *Harry Potter and the Sorcerer's Stone*.

MOROCCO PREMIERE AT GRAUMAN'S CHINESE THEATRE

Grauman's Chinese Theatre, which has hosted more premieres than any other theater in Hollywood, was known for its lavish openings. This 1930 gala premiere of *Morocco* shows the many fans who had patiently waited for hours to get a glimpse of their favorite movie star. *Morocco*, directed by Josef Von Sternberg, was Marlene Dietrich's American debut.

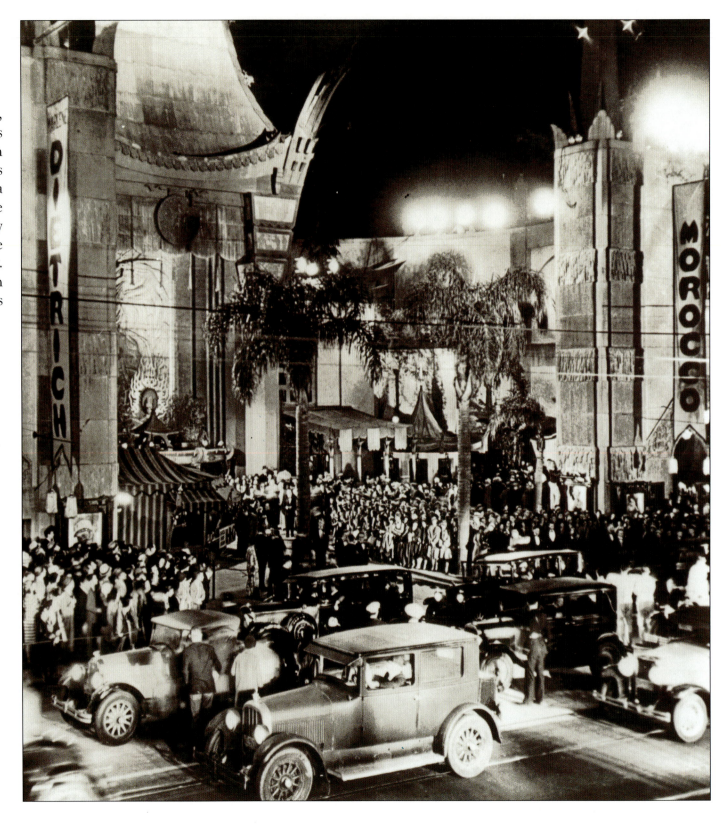

Right: The premiere for *Morocco*, the movie that transformed Marlene Dietrich into an international star. By 1939 she had become a U.S. citizen.

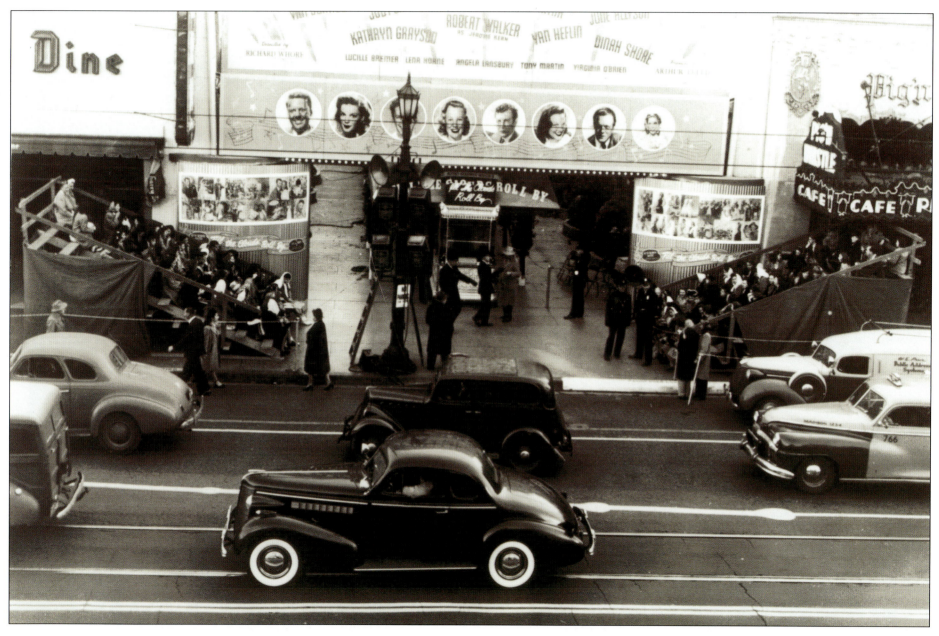

TILL THE CLOUDS ROLL BY PREMIERE AT THE EGYPTIAN THEATRE

Above: The premiere of *Till the Clouds Roll By*, starring Judy Garland, in 1946. The film was directed by Vincente Minnelli.

Till the Clouds Roll By premiered at the Egyptian Theatre in 1946. Major theaters would set up bleacher seats for the comfort of the waiting fans. When the Egyptian Theatre opened in October 1922, it was to be the host of the very first movie premiere—*Robin Hood*, starring Douglas Fairbanks. Sid Grauman staged an elaborate gala with red carpet, bright lights, and lots of movie stars. The Hollywood Egyptian Orchestra played *Aida* as the overture. Today much of the formality has gone from premieres, but the glamour remains.

EGYPTIAN THEATRE AND PIG'N WHISTLE

Charles Toberman developed the Egyptian Theatre with impresario Sid Grauman. Tutankhamen's tomb had just been discovered in Egypt, and an Egyptian craze was sweeping America. The theater, at 6712 Hollywood Boulevard, cost $800,000 to build. Props from the current movie would be displayed in the forecourt. Four massive columns marked the entry and an actor in Egyptian costume marched back and forth on the roof announcing the next showing.

Girls in harem costumes showed patrons to their seats.

Closed in 1992, the Egyptian reopened in 1998 following a $15 million renovation. The American Cinemateque (a nonprofit arts

Below: The Egyptian Theatre was the site of the Hollywood premiere of Douglas Fairbanks's *Robin Hood.*

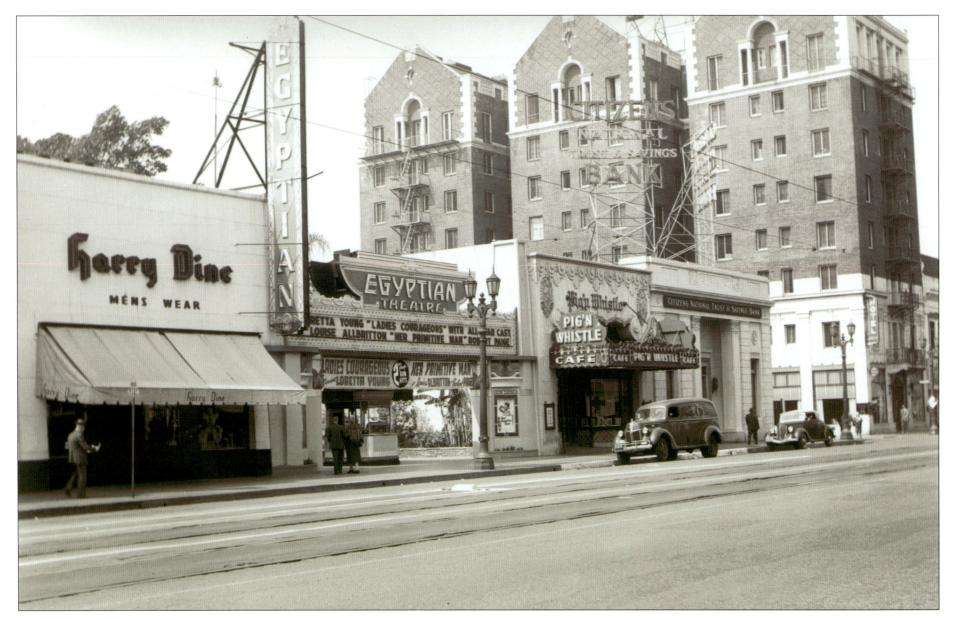

organization) purchased the theater from the city for a dollar with the provision that it be restored to its former grandeur as a movie theater and add programs on filmmaking. Behind-the-scenes tours are available and a documentary, *Forever Hollywood*, was made about the theater.

The Pig'n Whistle opened in July 1927 next to the Egyptian Theatre. Theaters in those days did not have concession stands, so the family-style restaurant, with a soda fountain and candy counter in the front, became very popular with moviegoers. Shirley Temple, Spencer Tracy, and a young Judy Garland were among the celebrities who enjoyed the atmosphere and the sundaes. The restaurant closed in 1949, but reopened in March 2001 on the same site with much of the interior faithfully restored. The soda fountain is gone, but there is a patio café on the boulevard.

Below: The Pig'n Whistle next to the new Egyptian Theatre today.

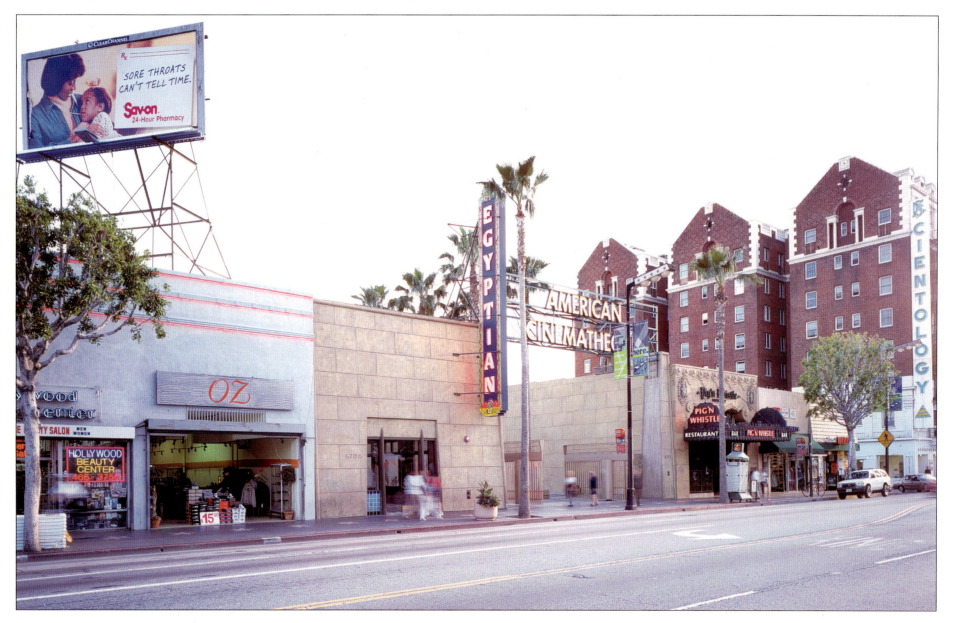

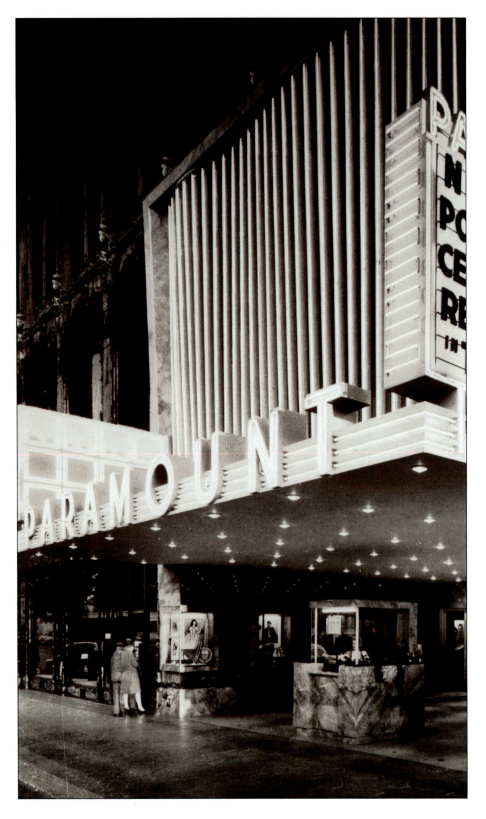

EL CAPITAN

The El Capitan on Hollywood Boulevard, west of Highland, opened on May 3, 1926. This was the second collaboration between Charles "Mr. Hollywood" Toberman and Sid Grauman. Opened one year before Grauman's Chinese Theatre, the El Capitan was a live theater and its first show was the French *Charlot's Revue*, starring Gertrude Lawrence and Jack Buchanan. In the next decade, over 120 live plays were presented at the El Capitan, with stars such as Clark Gable, Buster Keaton, and Joan Fontaine. Switching to the movies, the El Capitan premiered Orson Welles's masterpiece *Citizen Kane* in 1942. The El Capitan closed shortly afterward and reopened as the Hollywood Paramount. Despite its success, the Paramount changed hands often in the next few years.

In 1989, the Walt Disney Company joined with Pacific Theatres to restore this historical theater. They returned the El Capitan to its former East Indian and Spanish Colonial decor and restored its original name. Today Disney films are premiered here, preceded by a live Disney stage show with singing and dancing.

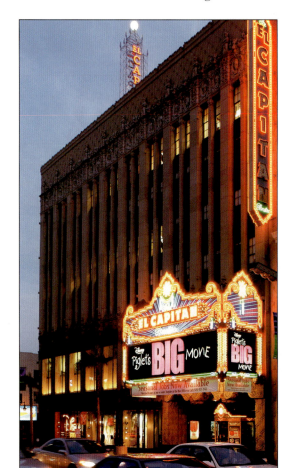

Left: The El Capitan changed to the Paramount. It is seen here in 1942.

Right: The theater is now back to its original name, El Capitan, and is a favorite site for Disney premieres.

THE HOLLYWOOD PALLADIUM

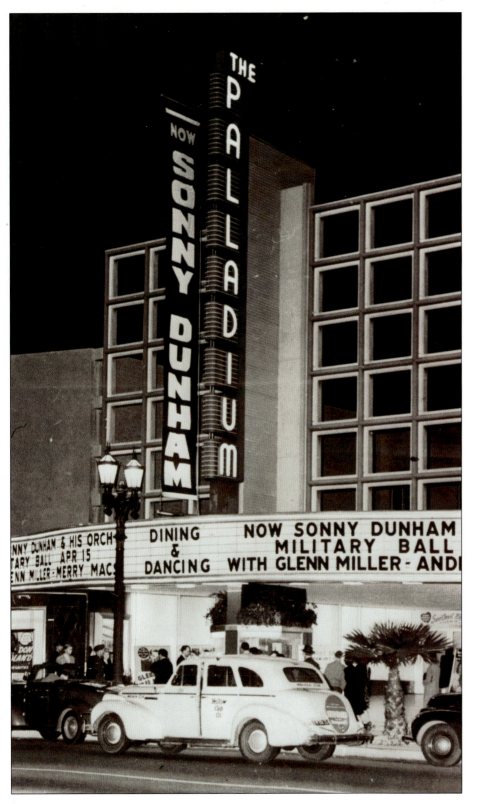

The Hollywood Palladium opened on Sunset Boulevard, between Argyle and El Centro, October 31, 1940, and was a huge success from the beginning. On the opening night, Tommy Dorsey and a little-known crooner named Sinatra entertained several thousand in the enormous ballroom. During its reign, the Hollywood Palladium has entertained more than fifty-eight million guests. Stars like Doris Day, Betty Grable, Rita Hayworth, and Martha Raye were Palladium regulars and were often seen dancing with soldiers in uniform. The Hollywood Palladium allowed uniformed servicemen entrance for fifty cents. Between the Hollywood Canteen and the Palladium, it was a great time to be a soldier on leave. Glenn Miller, Artie Shaw, and Harry James often provided the entertainment. After producer Don Fedder took over management of the Hollywood Palladium in 1961, bandleader Lawrence Welk broadcast his popular weekly television show from there.

The Hollywood Palladium is currently owned by Palladium Investments, Inc., who have renovated and updated this famous venue. Award shows such as the Grammys, the Emmys, and the Country Music Awards have been held here, and the theater has also been used as a filming location for movies such as *The Bodyguard*, and *The Frank Sinatra Story*. The Hollywood Palladium continues to host concerts featuring such musicians as Bob Dylan, Prince, the Rolling Stones, and James Brown.

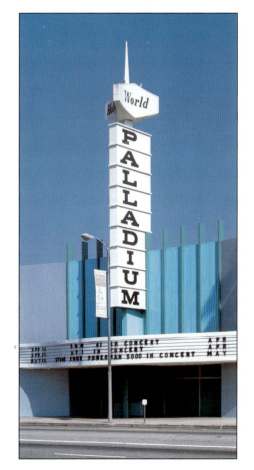

Left: The Hollywood Palladium in 1942, advertising Glenn Miller and the Andrews Sisters.

Right: The Hollywood Palladium still hosts concerts.

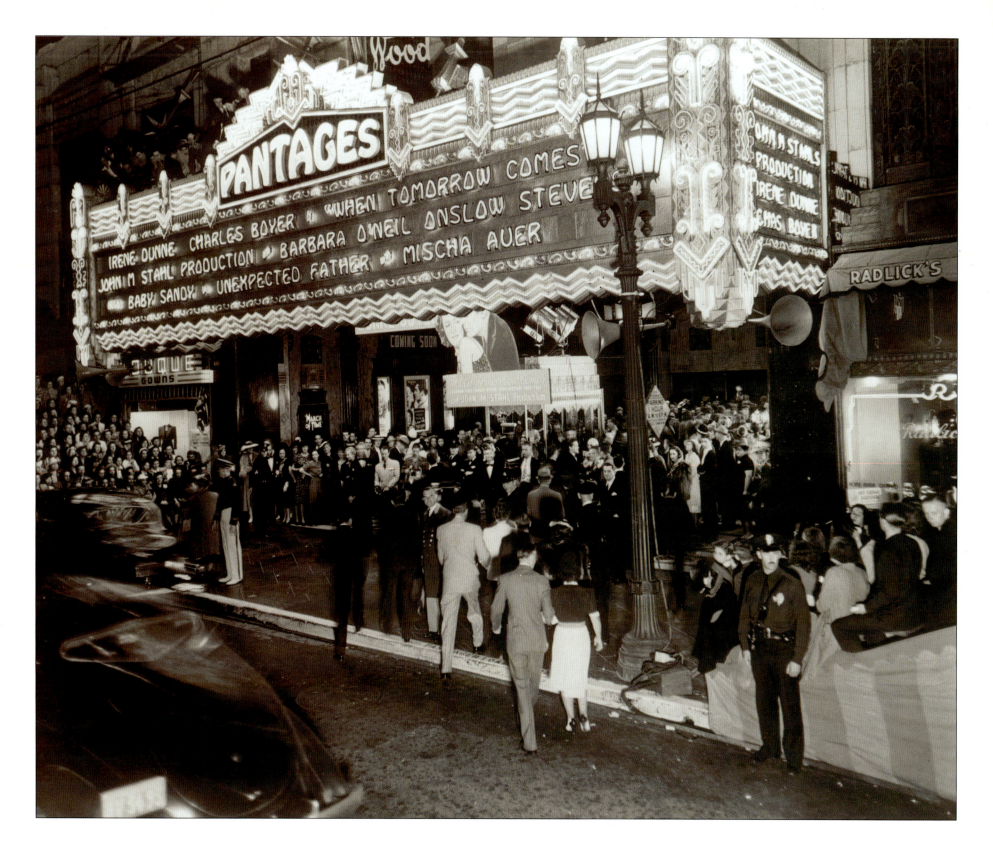

PANTAGES THEATRE

The Pantages Theatre, at 6233 Hollywood Boulevard, opened in 1930 as a movie theater with the premiere of *Florodora Girl,* starring Marion Davies. Designed by Marcus Priteca, this Art Deco theater has a lavish marble and bronze entrance, an elaborate ceiling, and ornate twin staircases. The most ornate of Hollywood's movie houses, with almost 3,000 seats, this was the fourth theater built by legendary impresario Alexander Pantages, at a cost of $1.25 million. The ensuing years saw both live presentations and movies at the Pantages: Leopold Stokowski conducted the Los Angeles Philharmonic for an entire season in 1940. The Academy Awards ceremony was held here from 1949 to 1959.

In 1977 Pacific Theatres joined with the Nederlander Organization as new owners of the Pantages. Starting with the Broadway hit *Bubbling Brown Sugar,* the Pantages has continued to present world-class stage productions, many fresh from Broadway and London. In 2000 nearly $10 million was spent to restore this magnificent place. Mel Brooks's smash *The Producers* opened in 2003 to great critical and popular acclaim.

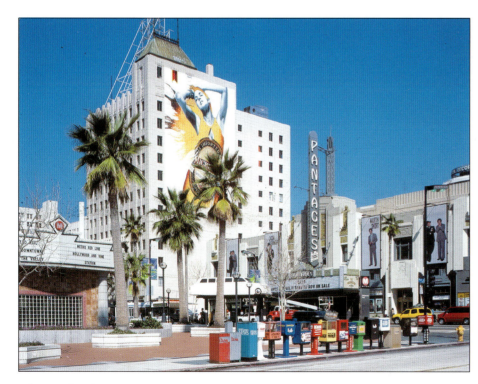

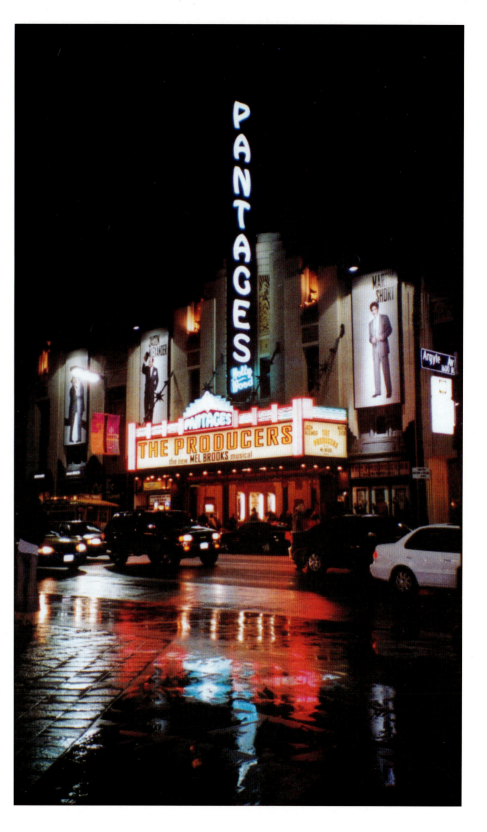

Above and Right: The Pantages is now a live-performance theater.

Left: The premiere of *When Tomorrow Comes* in 1939.

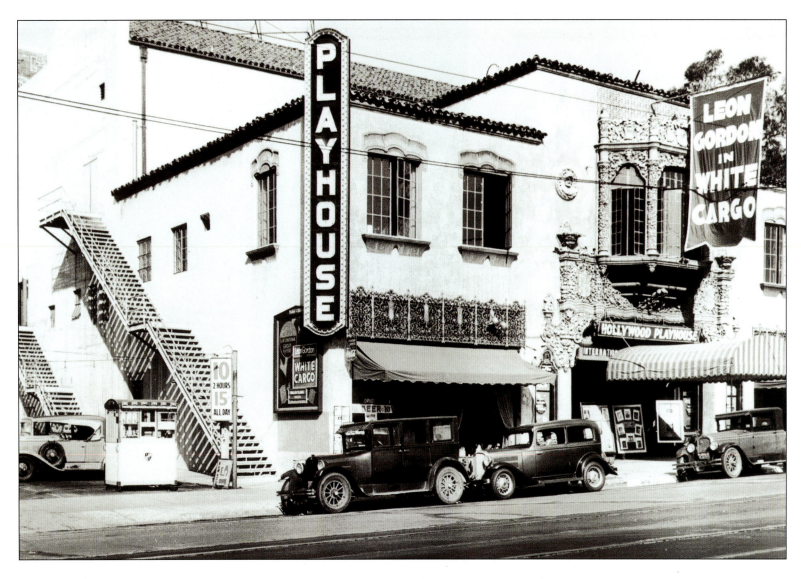

Left: The Playhouse Theatre in 1930.

Right: The Palace is now a nightclub.

THE HOLLYWOOD PLAYHOUSE THEATRE

The Hollywood Playhouse Theatre opened in 1927 at 735 Vine Street. S. H. Woodruff and partners from the nearby Vine Street Theatre presented lavish dramatic productions with star-studded casts that included Fanny Brice and Lucille Ball. In the 1940s, this theater became the El Capitan (the original El Capitan ran as the Paramount). Under this guise it was home to the classic *Ken Murray's Blackouts,* a live burlesque show that ran a record 3,844 performances. In the 1950s, as an NBC television facility, popular shows such as *You Bet Your Life* with Groucho Marx, *Queen for a Day,* and *The Colgate Comedy Hour,* as well as telethons and fundraisers, were broadcast from here. The theater was finally renamed the Hollywood Palace, and in 1964 the ABC television show of the same name featured celebrated guests such as Judy Garland, Bing Crosby, George Burns, Pearl Bailey, and Fred Astaire. Merv Griffin televised his own talk show from here until he moved to his own theater.

Rebuilt as a multimedia facility, the Palace, as it is now called, has become the consummate nightclub and concert venue in the tradition of New York's Studio 54. A place to listen to new bands, dance, and mingle with the stars, the Palace has attracted the likes of Madonna, Prince, and the Rolling Stones.

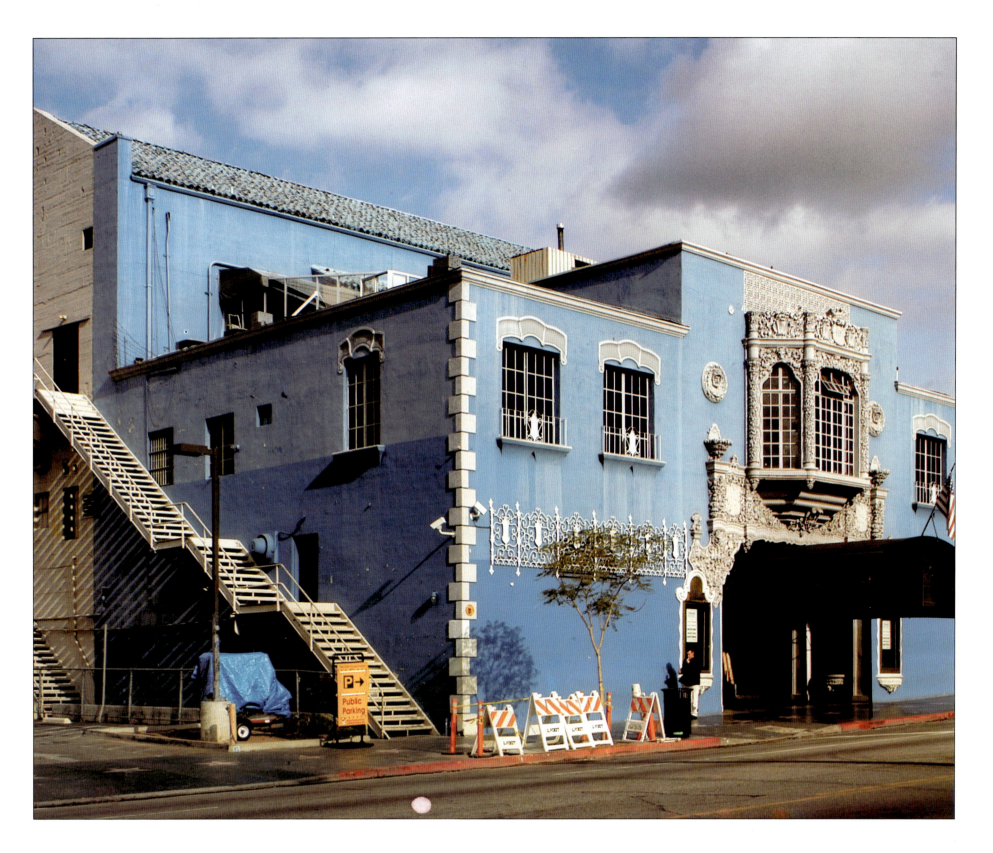

Left: The CBS Radio Playhouse in 1938.

Below: This 1936 photo shows Cecil B. De Mille directing George Raft, June Lang, and Gloria Swanson for a Radio Playhouse broadcast.

THE VINE STREET THEATRE

In 1926, the Wilkes Vine Street Theatre opened at 1615 North Vine Street. Known simply as the Vine Street Theatre, it became the CBS Radio Playhouse in the 1930s and broadcast such hugely popular shows as *the Lux Radio Theatre*. *The Lux Radio Theatre* brought movie stars such as William Holden, Gloria Swanson, and George Raft to radio dramas, complete with full orchestras. In 1954 the theater reverted to stage productions and was renamed the Huntingdon Hartford.

This theater has had, like so many others in Hollywood, many identities. Next it became the James Doolittle Theatre for stage productions. More recently, it was taken over by the Nosotros company and renamed the Ricardo Montalban Theatre. The Ricardo Montalban Foundation premiered the musical biography *Selena* here in 2001. CBS radio station KNX-1070 in Los Angeles currently rebroadcasts many of the original radio dramas.

THE WARNER/PACIFIC THEATRE

The Warner Theatre, at 6423 Hollywood Boulevard, opened on April 26, 1928, with *Glorious Betsy*, starring Delores Costello and Conrad Nagel. The Warner Theatre was designed by the prominent theatrical architect G. Albert Landsburgh. A four-story Italianate beaux arts building, this was the largest theater in Hollywood, with 2,700 seats. It was one of the few Hollywood theaters large enough to convert to Cinerama (a widescreen process introduced in 1956 that used three cameras to create a single image on a specially curved screen that gave moviegoers the illusion of vastness). In 1968 it was purchased by Pacific Theatres and renamed the Pacific Theatre. In the early 1970s, *A Clockwork Orange* played here to packed houses, and *2001: A Space Odyssey* ran for thirty-seven weeks. The theater then underwent a $1 million rehabilitation. The Pacific Theatre has been closed for several years. On rare occasions it is opened for special events or for use as a filming location.

Left: The Warner in 1937. A young Carol Burnett worked as an usherette at the old Warner Theatre—she now has her star on the Walk of Fame right in front.

Below: The theater is now only open for special events.

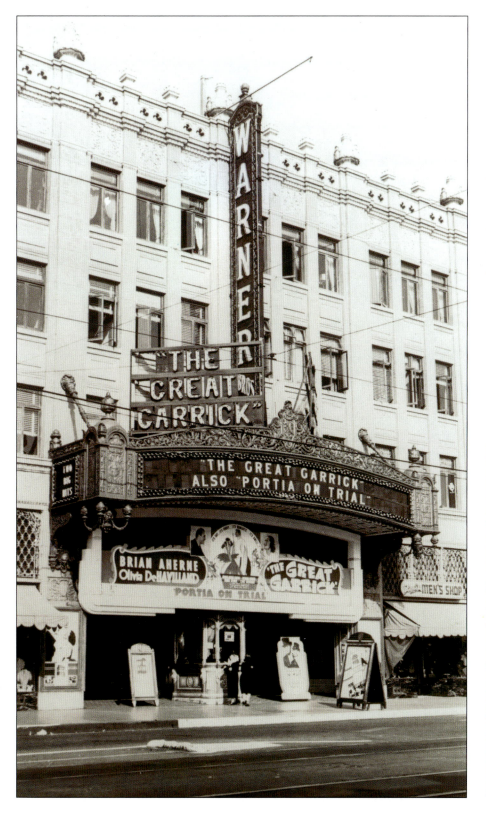

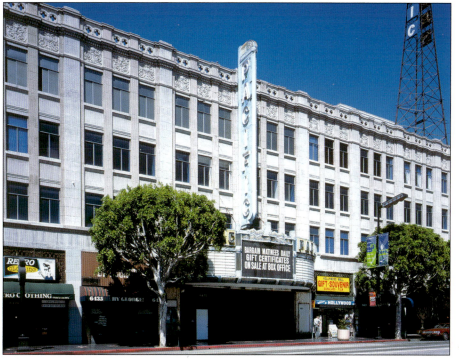

HOLLYWOOD AND VINE

In 1910, in the final act of incorporation back into Los Angeles, Prospect Avenue became Hollywood Boulevard—an effort to preserve the name of the now-lost city for posterity. Vine Street was so named because it was a street that ran through Senator Cornelius Cole's vineyard. The Taft Building on the southeast corner (site of the former Methodist Episcopal Church) was built in 1924 by Hollywood pioneers the Taft family. Providing office space for celebrities such as Will Rogers and Clark Gable, from 1935 to 1945 the Taft housed the Academy of Motion Picture Arts and Sciences. The Gothic Art Deco–style Equitable Building on the northeast corner was built in 1929 and was popular with financial institutions. The Dyas department store was built on the southwest corner in 1927. It was later replaced by the Broadway store.

No one knows why Hollywood and Vine has become such a world-famous symbol of movie glamour. To local residents, it's just another intersection. Except that, on May 29, 2003, this was named Bob Hope Square (*right*), honoring the legendary entertainer's one hundredth birthday, two months before his death.

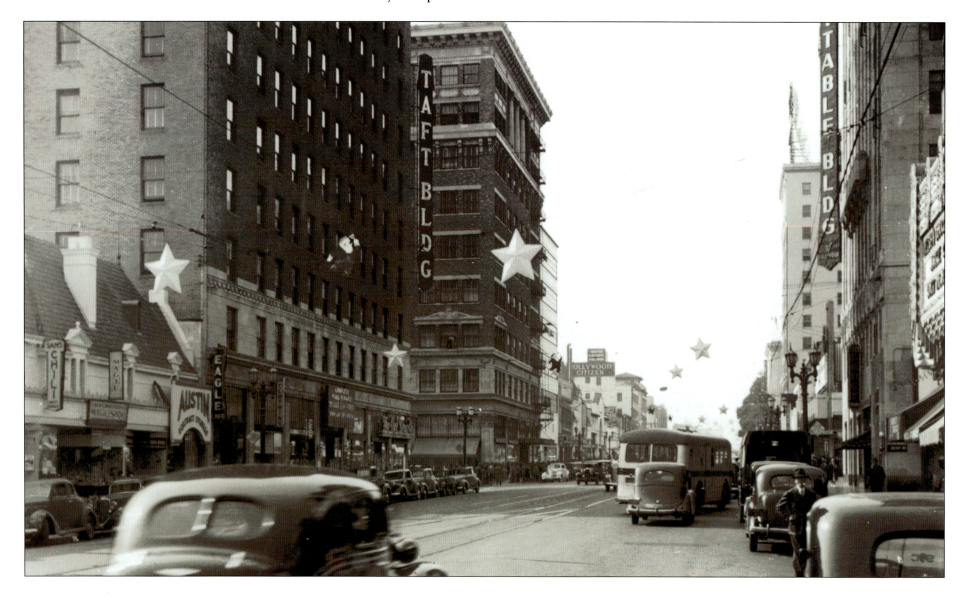

BOB HOPE
SQUARE

Comedian in vaudeville, radio,
movies, and television and
entertainer of overseas U.S. troops.

Dedicated May 2003

Far Left: Looking west, just east of Hollywood and Vine in 1934.

Below and Right: The modern-day view, looking west approaching Hollywood and Vine.

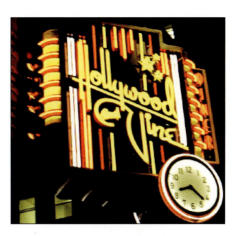

DINING & DANCING

During Prohibition, which started in 1920 and lasted thirteen years, Hollywood built some of its grandest palaces of entertainment. This was also a time when many of the popular restaurants and dance spots opened. There were, of course, the speakeasies, gambling joints, and assorted dens of iniquity, but most of the Hollywood elite dined at the Brown Derby or the Musso & Frank Grill, and danced at the Montmartre Café and the Cocoanut Grove. If the absence of alcohol at these noted establishments bothered the stars, they would make their own arrangements for a disguised "special delivery" to their table. Tea dances were also very popular during these years. When Prohibition ended, Hollywood celebrated with the opening of some of the most glamorous nightspots in history. At nightclubs such as Ciro's, the Mocambo, and Café Trocadero, the rich and famous dined and then danced until dawn while champagne flowed freely.

Back then glamour and formality went hand in hand. Men would wear tuxedos or suits, and women wore elegant evening gowns, gloves, and lots of sparkling jewelry. But times have changed. The dress is informal and a lot more comfortable. You'll not find many clubs where you can dance to the big band sound, but you will find an eclectic array of clubs where you can dance or just sit back and enjoy the music. As they say, the beat goes on.

MONTMARTRE CAFÉ

Eddie Brandstatter opened the Montmartre Café in December 1922. Located on the second floor of the C. E. Toberman Building, at 6757 Hollywood Boulevard, the supper club offered entertainment, dancing, and fine cuisine. Joan Crawford is rumored to have won a Charleston contest here and an unknown Bing Crosby was hired to sing. The stars flocked to the Montmartre night and day; the luncheon was very popular, especially on Wednesdays, when it was set up specifically for the film folks. Fans would line up on the street and in the lobby to catch a glimpse. Bebe Daniels, Marion Davies, Mabel Normand, John Barrymore, Winston Churchill, and Fatty Arbuckle all signed the guest books. The café closed in 1929 and in the 1970s the Lee Strasberg Theatre Institute was housed here. Today there is no sign of the glamorous life of the Montmartre, just an office block.

Right: Montmartre Café—Hollywood's first nightclub. Its motto was "Where everyone goes to see and be seen." Patrons included Charlie Chaplin, Rudolph Valentino, and Gloria Swanson.

Left and Below: The Musso & Frank Grill is Hollywood's oldest restaurant. Regular visitors included F. Scott Fitzgerald and Frank Sinatra.

MUSSO & FRANK GRILL

The Musso & Frank Grill was opened in 1919 by John Musso and Frank Toulet at 6667 Hollywood Boulevard. They sold it six years later to Joseph Carissimi and John Mosso, who added the building next door in 1937. It is now the oldest running restaurant in Hollywood. The literati, including William Faulkner, Dashiell Hammett, and Ernest Hemingway, would rendezvous here at what they called the "Algonquin Round Table West." Raymond Burr, Charlie Chaplin, Humphrey Bogart, and a host of celebrities through the ages occupied the red leather booths, while notorious gossip columnists Louella Parsons and Hedda Hopper conducted interviews here.

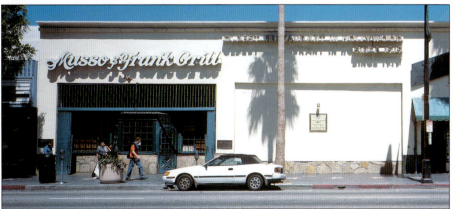

After more than eighty years in operation, the Musso & Frank Grill appears to have hardly changed. The decor is dark wood, with red-leather booths, much like an old gentlemen's club, and the food is as good as ever: Irish stew, steaks, and hearty sandwiches. It is still as busy as it must have been in Hollywood's heyday, but is now frequented by a mix of businessmen and tourists, with a sprinkling of celebrities and writers.

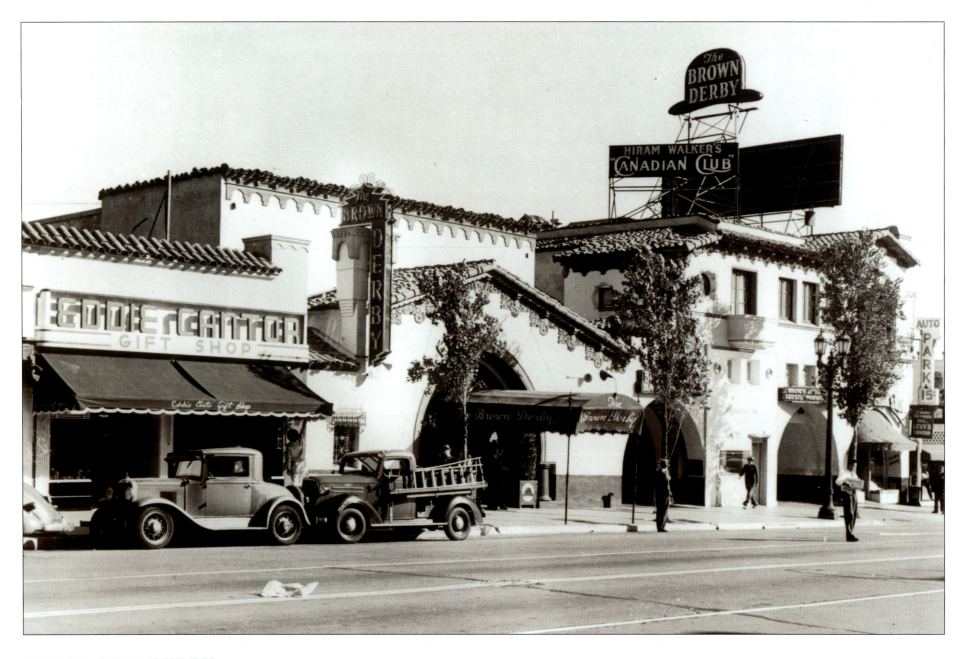

THE BROWN DERBY

On Valentine's Day 1929, Herbert Somborn (Gloria Swanson's husband) opened the Brown Derby on Vine Street in a rambling Spanish structure owned by Cecil B. De Mille. (The original hat-shaped Derby was on Wilshire.) This Hollywood Brown Derby was an immediate success; the food was simple and good and the stars piled in for lunch and dinner. Eddie Vitch's cartoons of the celebrity guests soon covered the walls.

After Somborn's death in 1934, Robert Cobb, inventor of the Cobb salad, became the owner. Regulars included George Burns, Gracie Allen, George Raft, Cary Grant, and Barbara Stanwyck; just about every big Hollywood name was there at some point. Actors, writers, and producers had themselves paged for telephone calls while dining to make themselves seem more important. Clark Gable proposed to Carole

Lombard here in booth 54. Later, the Derby would attract the newer Hollywood: Kim Novak, Ernest Borgnine, and Steve McQueen.

In the late 1970s the Vine Street Brown Derby was given a face-lift. The stars and the public kept coming for a while, but it finally closed in 1985. The building was damaged by fire in 1988, and after further damage in the 1994 earthquake, it was demolished. Today there's just a parking lot on the site of what was a great Hollywood eatery.

Left and Above: The Brown Derby on Vine Street became the place where movie stars, celebrities of all types, and the rich and powerful gathered. Sadly, it was demolished in 1994, though the site is commemorated by a Historic Site marker (inset).

FORMOSA CAFÉ

The red-painted Formosa opened in 1925 as Jack's Steak House—until Jack lost the restaurant in a poker game in 1939 to Jimmy Bernstein. That's when it became the Formosa Café—so called because of its location at 7156 Santa Monica Boulevard at Formosa Avenue. It was built on the site of the huge Maid Marion castle in Douglas Fairbanks's *Robin Hood* of 1922, and in the 1940s a Red Line trolley car was added in the back. All the stars working at the United Artists studios next door ate here, including Humphrey Bogart, Clark Gable, Roy Rogers, and Tyrone Power. When Sam Goldwyn bought another studio nearby, even more stars rolled in. John Wayne (when finishing *The Alamo*) would spend so much time here that one night after work he fell asleep in his booth. He was too large for anyone to move, so they left him, and the next morning when the staff came in, they found him in the kitchen fixing himself breakfast. Lana Turner was a frequent guest with her boyfriend Johnny Stompanato. Bogart sat at the bar, as did Jack Webb, while Jack Benny, Marlon Brando, Grace Kelly, Rock Hudson, Billy Wilder, and James Dean all enjoyed the Chinese-American food. It is reported that Bernstein had to loan the fabulously wealthy Howard Hughes the cab fare home a few times. Elvis Presley and Marilyn Monroe had their own booths, Tony Curtis and Jack Lemmon were also regulars, and Dean Martin and Jerry Lewis were much loved by the staff. The Formosa is now run by the grandson of the original chef and co-owner, Lem Quon.

In the early 1990s, a back patio and a roof deck were added for smokers. The neighbors were now called Warner Hollywood Studios. The interior of the legendary Formosa Café reveals its history: Over the bar and on every inch of wall space are photographs that tell the history of this funky little restaurant. The colorful Formosa has been used in

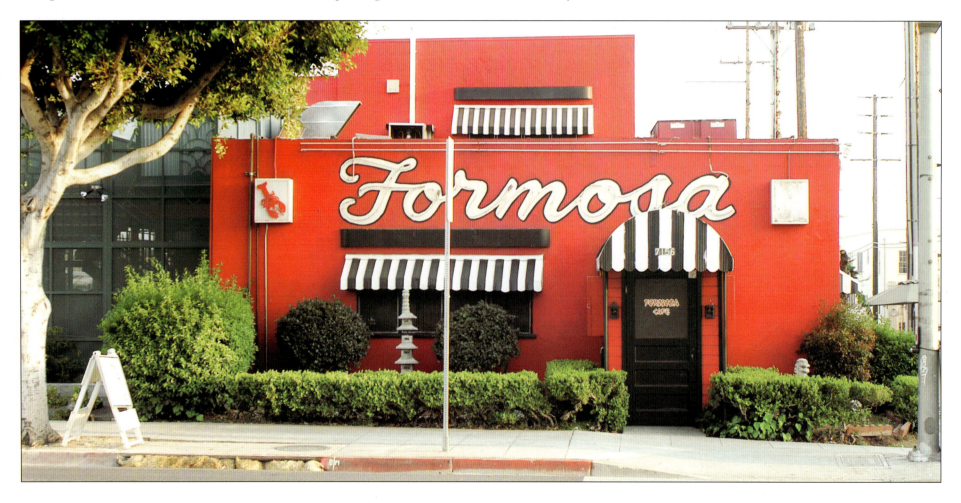

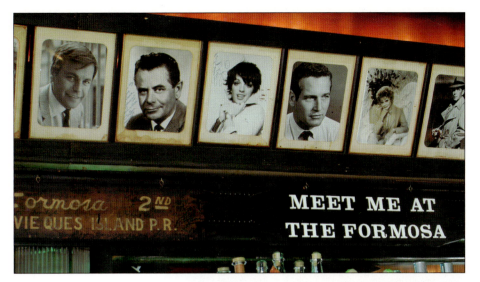

many films: scenes for *L.A. Confidential* and Jim Carrey's *The Majestic* were shot here, as were *Swingers* and *Still Breathing*. Films have their wrap parties here and new stars like Nicholas Cage, Lisa Marie Presley, Matthew Perry, Jodie Foster, Christian Slater, and Johnny Depp are perpetuating the tradition. However, this legacy was almost lost in 1991 when the Formosa's lease ran out. The restaurant, unable to buy the land it sits on, has always been a tenant of the neighboring studio. After decades of loyal service, the Formosa was given ninety days to leave. However, the customers were outraged and rebelled. After picketing and plotting, they finally managed to get a Historic Preservation Order for the old place. The Formosa is still a tenant—the studio is now called the Lot—and there is a multistory shopping plaza being built right behind the café that will provide customers with much-needed parking spaces.

Above and Right: Hundreds of celebrity photos from appreciative customers (personally signed and delivered) adorn the walls of the Formosa.

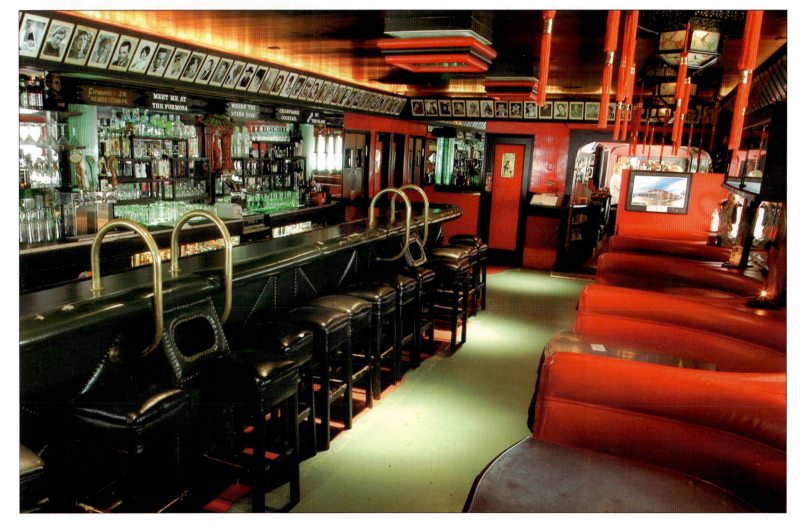

Left: The Formosa is lovingly preserved.

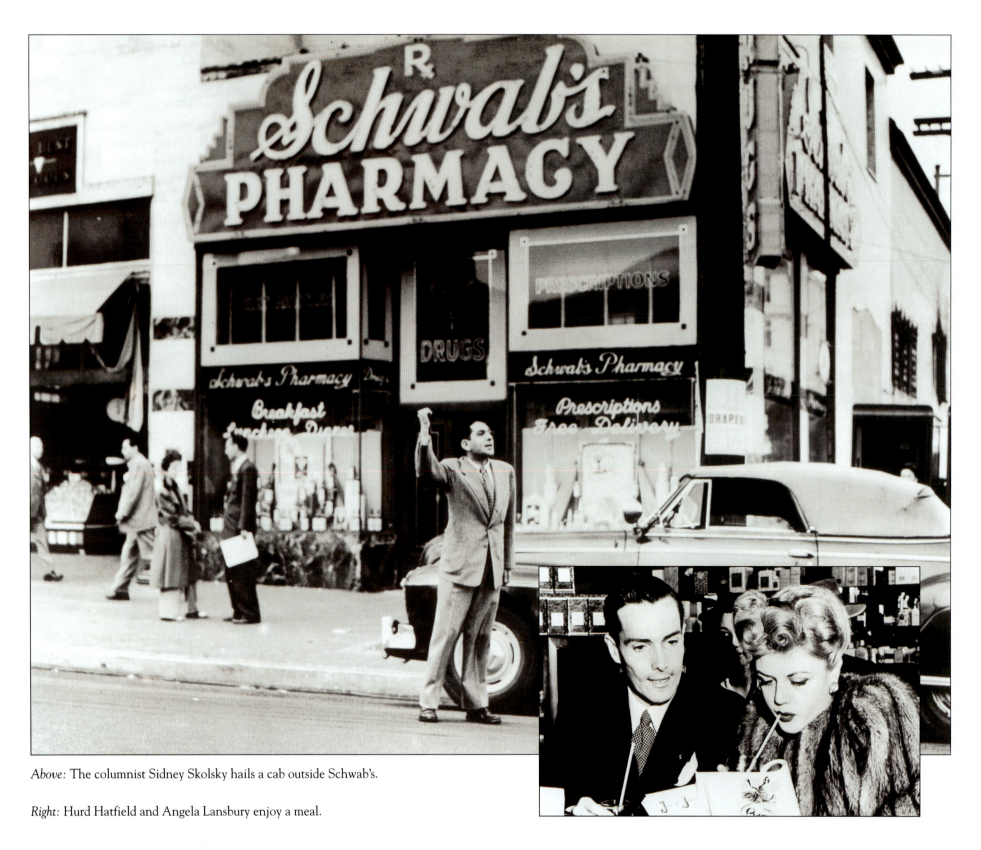

Above: The columnist Sidney Skolsky hails a cab outside Schwab's.

Right: Hurd Hatfield and Angela Lansbury enjoy a meal.

SCHWAB'S PHARMACY

In 1932 the Schwab brothers started a drugstore at 8024 Sunset Boulevard that became a movie business hangout, catering to actors, writers, producers, and industry insiders. It even had a pager and a special phone installed for the growing show-business clientele. Lana Turner was not actually discovered here, but the Marx brothers, Charles Laughton, Cesar Romero, and Judy Garland were regulars. James Dean relaxed here, William Holden (as Joe Gillis) hung out here in *Sunset Boulevard*, and Sidney Skolsky had an office upstairs where he wrote a column called "From a Stool at Schwab's." A unique drugstore, Schwab's sold top-quality cosmetics and the best ice-cream sodas. Charlie Chaplin made his own milk shakes at the famous soda fountain.

Up until 1986 when Schwab's closed, managers, agents, and talent scouts discussed business in the booths. Shelley Winters was there most mornings; Cher, Robert Forster, Sally Kellerman, and Jack Nicholson came, too. Schwab's was torn down in 1988 and replaced with a multistory complex housing movie theaters, stores, and a gym. Today modern stars such as Calista Flockhart, Ben Affleck, Leonardo DiCaprio, and Drew Barrymore have been spotted at the new plaza.

Below: A huge Virgin megastore now occupies the old Schwab's site.

MOCAMBO

On January 3, 1941, Charles Morrison's nightclub, Mocambo, opened at 8588 Sunset Boulevard. It was to be the latest in the Sunset Strip's dance-until-dawn success stories, with colorful decor and huge glassed-in aviaries of live cockatoos, parrots, and other exotic birds. Once again, Hollywood's elite were in attendance: Judy Garland, Janet Leigh, Henry Fonda, Jimmy Stewart, Ray Milland, Franchot Tone, Humphrey Bogart, and Lauren Bacall. Some of the finest performers entertained at the Mocambo, including Billy Daniels, Frank Sinatra, and Lena Horne. Charlie Morrison died in 1958 and the Mocambo closed soon after. The site is now a parking lot.

Below: The fabulous Mocambo on the Sunset Strip.

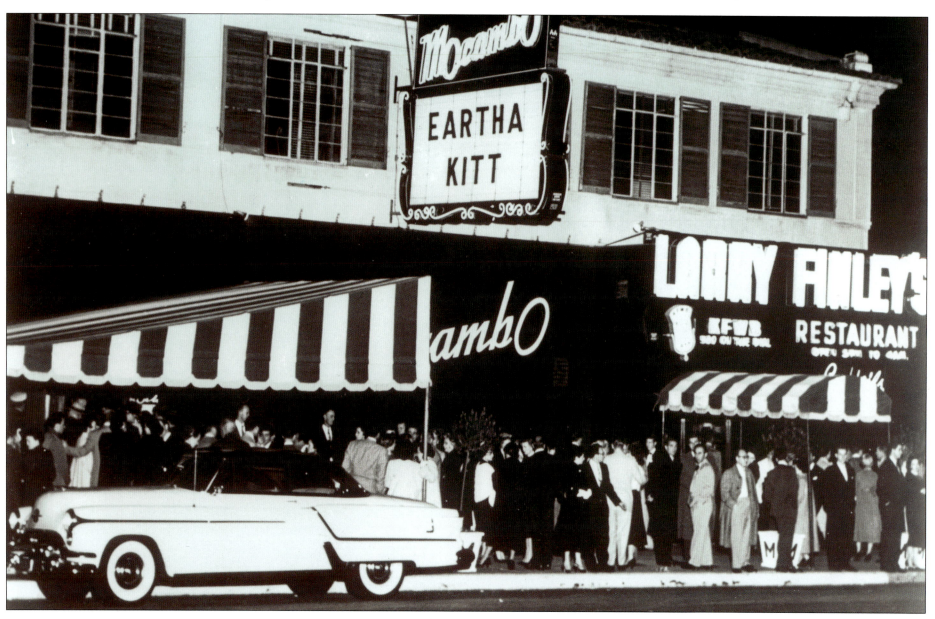

GREENBLATT'S DELI

Founded in 1926, this wonderful old delicatessen has served regular folks and the Hollywood elite for decades. It moved west a few blocks to this Sunset Boulevard location on the corner of Laurel Avenue in 1940. From there it became a Hollywood Landmark, known especially for serving the best turkey sandwiches and chicken noodle soup around. The establishment was also renowned for its extensive wine department, which delivered to all the movie and recording stars living in the Laurel Canyon area. In 1979 Greenblatt's moved next door. Now a hip, upscale deli, it serves the best tasting kosher and hearty American food, with the restaurant upstairs and the deli and impressive wine store below. Brad Pitt and Brendan Fraser are among today's celebs who nosh at this popular watering hole.

Right: The Mediterranean-style building that housed Greenblatt's when it was situated at the corner of Sunset Boulevard and Laurel Avenue.

Below: Greenblatt's home since 1979 has been at 8017 Sunset. The old building is now occupied by the Laugh Factory.

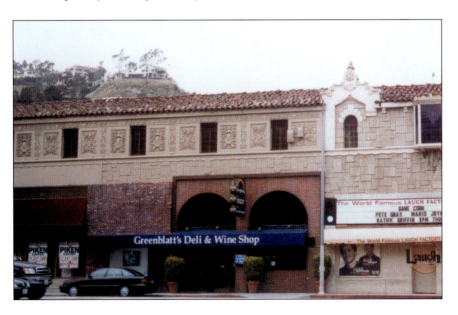

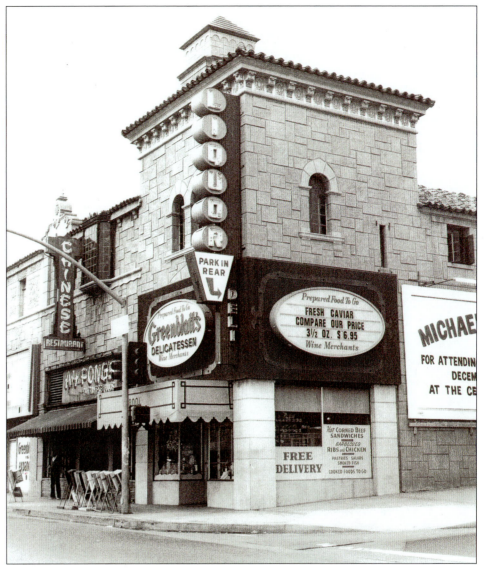

The corner building left vacant by the deli's move was quickly taken over by Jamie Masada, who opened the Laugh Factory there. In the ensuing years the Laugh Factory has become one of Hollywood's most successful comedy outlets, mixing new names with established comics, and has also become a great source of new talent for the Hollywood scouts. Richard Pryor played here, as did Rodney Dangerfield, Mel Brooks, Howie Mandel, Jason Alexander, David Letterman, Eddie Murphy, Martin Lawrence, and the great Robin Williams. Masada gives back to the local community by holding charity events at the Laugh Factory, while at Christmas and Thanksgiving he serves free meals to starving performers in Hollywood.

SARDI'S

Designed in ultramodern metal and frosted glass by Rudolph Schindler, Sardi's opened at 6313 Hollywood Boulevard, near Vine Street, in 1932. The Depression called for a scaling back—even in Hollywood—and the big bands were now gone, as was any lavish entertainment. Breakfast and lunch were the big things at Sardi's, which was the sister of New York's Sardi's. Tom Breneman broadcast his national radio show from here and Maurice Chevalier loved the new restaurant, as did Wallace Beery, Marlene Dietrich, and Joan Crawford. After the golden era melted away, the center of Hollywood changed and adult movie theaters and discount shops moved into the deserted buildings. The site where Sardi's once stood housed a popular dance hall during the 1960s and 1970s, and now has a topless bar, surrounded by adult stores.

Below: The filming of Paramount's aptly named *Hollywood Boulevard*, in front of Sardi's in 1936.

Right: Today an adult club occupies the site.

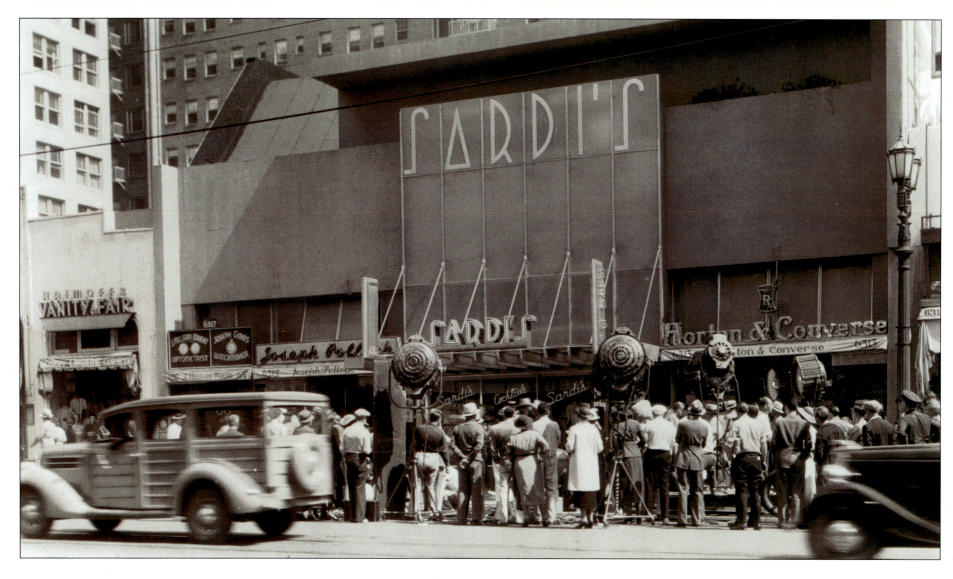

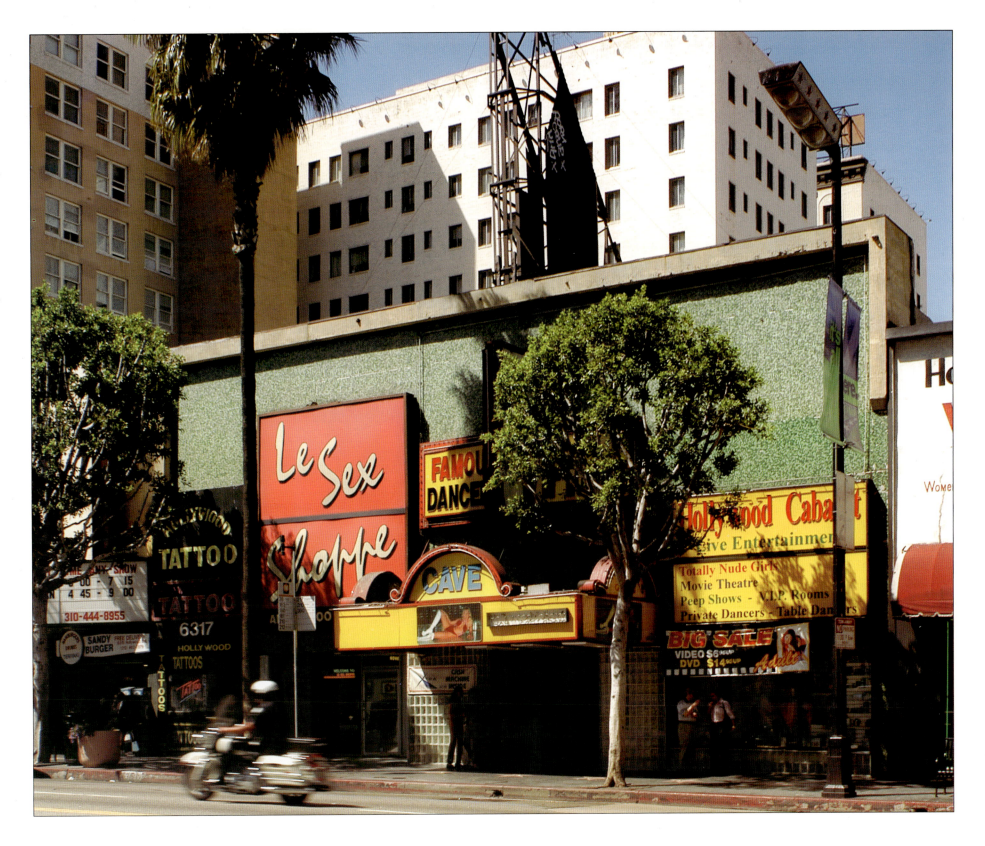

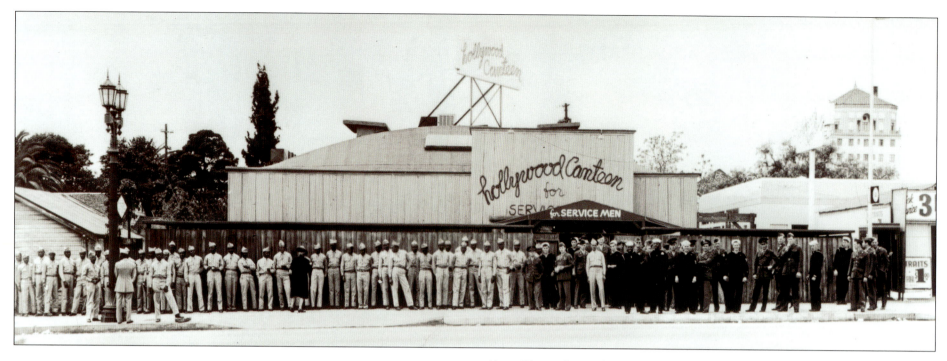

Above: The Hollywood Canteen in 1944.

HOLLYWOOD CANTEEN

During World War II, many military and defense workers spent their leave in Hollywood, and the motion picture stars opened their hearts to them. The Hollywood Canteen, founded by a committee headed by Bette Davis and John Garfield, backed by Dr. Jules Stein, was the most famous of the many services in Hollywood that catered to the soldiers. Davis and Garfield organized studios, unions, and guilds to provide funds and staff—over $6,500 was raised from the opening of *Talk of the Town* at the posh nightclub Ciro's—while materials and talent were also donated to renovate the building. The Hollywood Canteen opened October 3, 1942, in Buddy Fisher's old Hollywood Barn at 1451 Cahuenga, just south of Sunset. Stars paid one hundred dollars a ticket to watch the festivities and a parade of soldiers, sailors, airmen, and marines, with Eddie Cantor as master of ceremonies. The Duke Ellington Orchestra was one of several that played. Over 6,000 stars, writers, directors, producers, agents, and secretaries were registered to work as hosts, kitchen crew, cooks, waiters, and general helpers. Between 7 P.M. and midnight, it took 300 volunteers to operate the Canteen in two shifts. Food and cigarettes were free and glamorous stars like Ginger Rogers, Greer Garson, Loretta Young, Marlene Dietrich, Joan Crawford, Carol Landis, Deanna Durbin, and Betty Grable were hostesses and danced with the service personnel. The male stars waited tables and

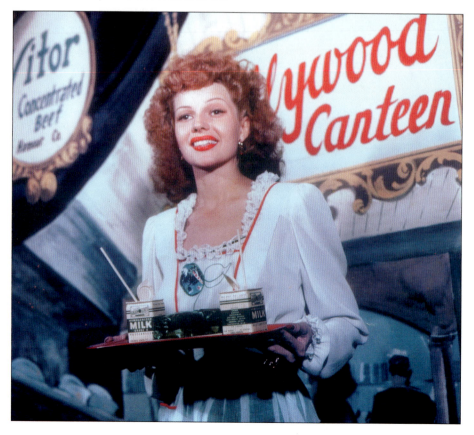

everybody helped in the kitchen. Mickey Rooney, Dinah Shore, Betty Hutton, Rudy Vallee, Nelson Eddy, and Frank Sinatra entertained, while Fred MacMurray, Basil Rathbone, and John Garfield were busboys. Every night for three years the party went on. The last night was November 22, 1945, shortly after the war ended. Bob Hope, Jack Benny, and Jerry Colonna led the closing night show and rather sad farewell.

Today the site of all those wonderful memories of the Hollywood Canteen now houses a parking structure.

Left and Far Left Bottom: Mickey Rooney and Rita Hayworth entertain the troops.

Below: The site of the Hollywood canteen is now occupied by a parking lot.

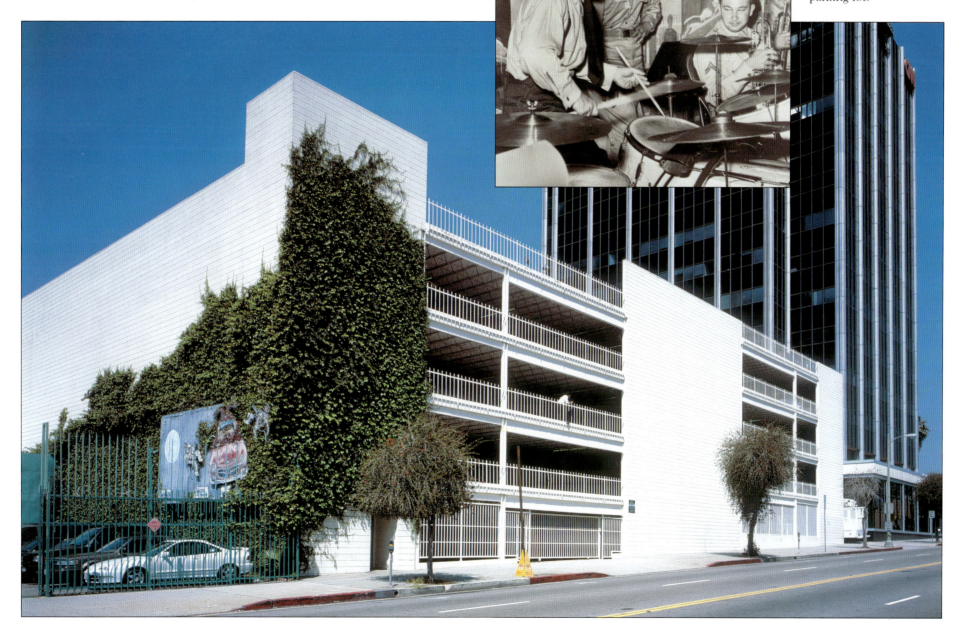

COCOANUT GROVE

When the sprawling 400-room, Italian-style Ambassador Hotel opened on Wilshire Boulevard in 1921, it quickly became the place to be seen. By April 21, the Grand Ballroom had been converted into a nightclub that became world famous: the Cocoanut Grove. Guests enjoyed a tropical grove of several hundred fake palm trees (left over from the filming of Valentino's *The Sheik*) with fake monkeys climbing them. The tables and chairs were bamboo and wicker. This was the height of exotic glamour in the 1920s and the stars lined up to attend and play. Chaplin entertained, Howard Hughes danced the rumba, Judy Garland sang, Sammy Davis wowed them, and Joan Crawford and Carole Lombard were said to have competed for dance trophies here. Pola Negri would

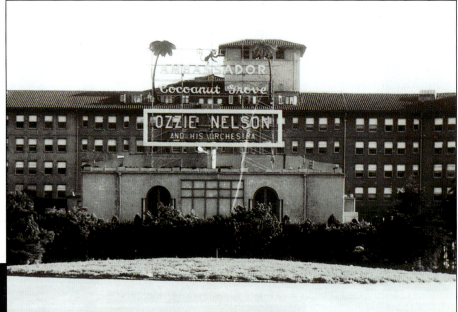

Above: The Cocoanut Grove at the Ambassador Hotel in its heyday. It was nicknamed the "Playground of the Stars."

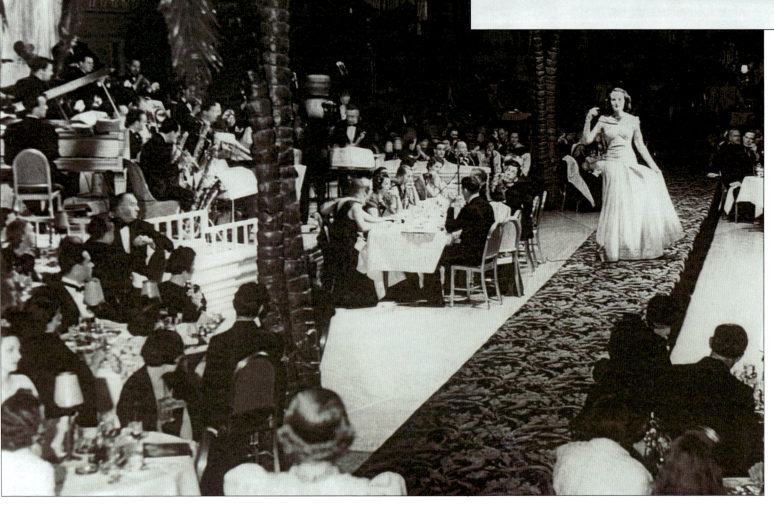

Left: The interior of the Cocoanut Grove, complete with fake palm trees.

walk her pet cheetah on the manicured grounds of the hotel. During the 1930s, six Academy Awards ceremonies and the first Golden Globe Awards dinner were held at the Cocoanut Grove.

The Ambassador later became notorious for a different reason when Robert Kennedy was tragically assassinated here in 1968. More recently it has featured in several films, including *Forrest Gump*, *A Star Is Born*, and *The Graduate*. The Grove closed in 1988 and the Ambassador Hotel followed suit the following year. A battle has since ensued to save and restore the twenty-four-acre grounds. Currently the Los Angeles School District wants to build a new high school on this land.

Right: The neon lights of the nightclub advertise an appearance by Nat King Cole.

Below: The Ambassador Hotel today.

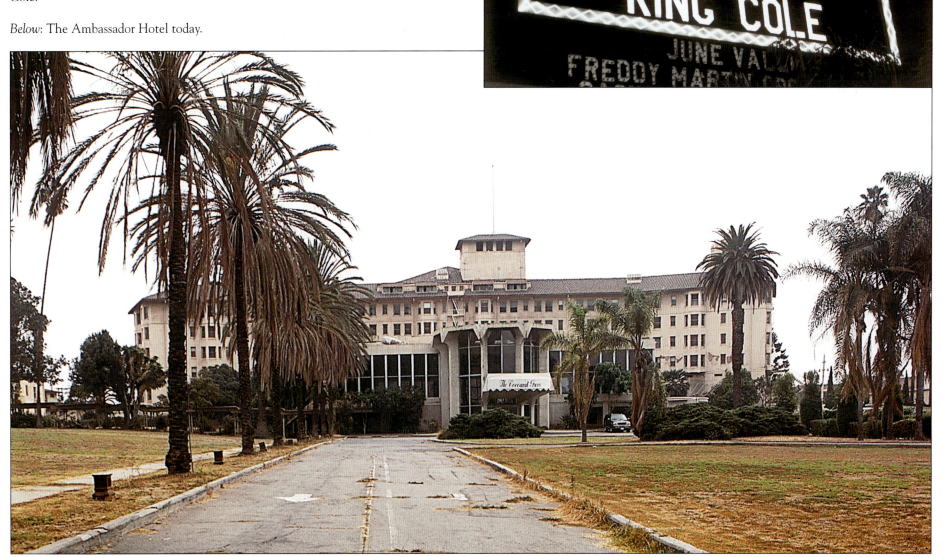

CIRO'S

Entrepreneur Billy Wilkerson opened his latest nightclub, Ciro's, on January 1940, at 8433 Sunset Boulevard on the Sunset Strip. On the site of the old Club Seville, Ciro's had a baroque green, red, and gilt interior and was an instant hit. "Everybody that's anybody will be at Ciro's" ran the ads in the *Hollywood Reporter*. Here, the audience watched Sophie Tucker, Edith Piaf, Billie Holiday, Peggy Lee, Dean Martin, and Jerry Lewis, along with the Emil Coleman Orchestra. Betty Grable, Gary Cooper, Lucille Ball, and Desi Arnaz were regulars before the nightclub closed in the late 1950s.

Frank Sinatra and his wife Nancy celebrated Frank's first Academy

Left: Ronald Reagan and Jane Wyman at Ciro's in 1944.

Below: Ciro's in 1941.

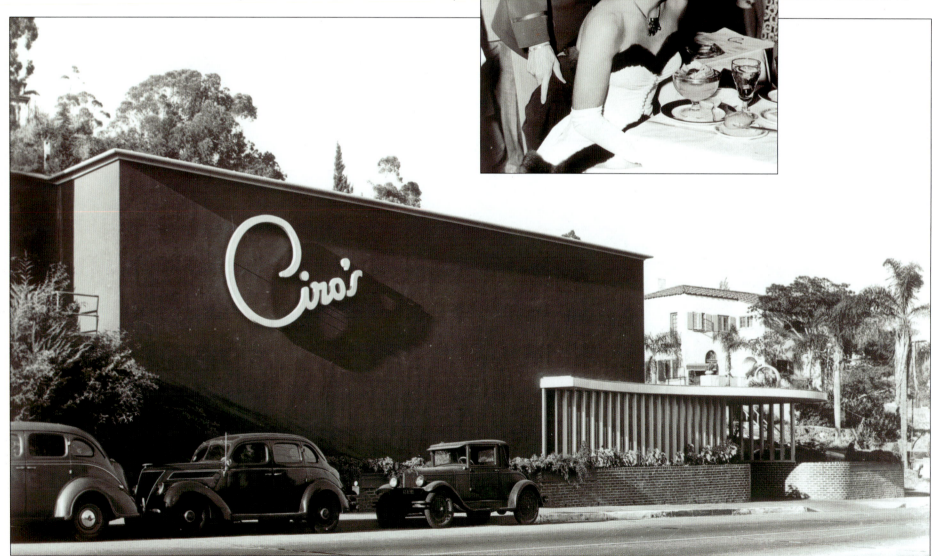

Award win at Ciro's nightclub; he was given an honorary Oscar for *The House I Live In*, a film advocating racial, ethnic, and religious tolerance. Directed by Mervyn Leroy, its theme song was written and performed by Sinatra. Sinatra went on to win an Academy Award for Best Supporting Actor in *From Here to Eternity* in 1953.

The site of the great nightclub now plays host to the Comedy Store, which opened in 1972 when comedian Sammy Shore and his wife Mitzi leased space inside the huge building. Johnny Carson was one of the first comic acts in the ninety-nine-seat theater. By 1973 Mitzi was running operations and was able to buy the building in 1976. She immediately renovated and expanded the club to include a 450-seat main room. Richard Pryor staged his comeback here, and over the years many other comedians have appeared, including David Letterman, Jay Leno, Gary Shandling, Whoopi Goldberg, Eddie Murphy, Michael Keaton, Paul Rodriguez, Elaine Boosler, Roseanne, and George Carlin.

Above Left: Frank and Nancy Sinatra in 1946.

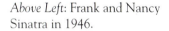

Left: The site is now the Comedy Store.

CAFÉ TROCADERO

Billy Wilkerson (of the *Hollywood Reporter*) opened the Café Trocadero, at 8610 Sunset Boulevard, on September 17, 1934. It was designed as an elegant French café with sidewalk tables; at night there was dancing "to the toe-tingling rhythms" of Phil Ohman's orchestra. David Niven, Ginger Rogers, Jimmy Stewart, Cary Grant, Cesar Romero, Mary Martin, and Martha Raye enjoyed evenings here. Movie premiere parties were often held at the Trocadero and Wilkerson created "Sunday Night Auditions," when new talent could perform before the star-studded audience. Judy Garland, Deanna Durbin, and Jackie Gleason are said to have participated. Scenes from the 1937 version of *A Star Is Born*, starring Janet Gaynor and Frederick March, were shot inside the Trocadero. After Wilkerson sold it in 1938, people said "the Troc" was not the same and its clientele waned before it finally closed in 1946. The site of the legendary nightspot is part of the same parking lot and new construction site as its neighbor, the Mocambo.

Below: Café Trocadero, photographed in 1936. The premiere party for *Gone with the Wind* was held here in 1939.

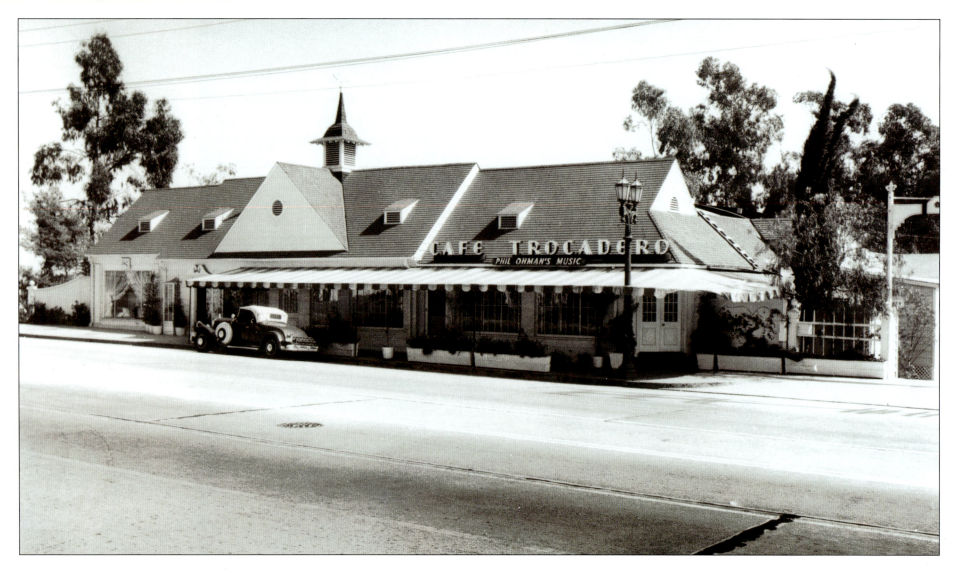

VILLA CAPRI

The Villa Capri—tucked away at 6735 Yucca Street—was one of Hollywood's best restaurants. Joe DiMaggio was one of the owners, as was Frank Sinatra, and the place was run by Pasquale "Patsy" D'Amore. This was certainly a place to be seen; during the early 1950s, celebrities like Lana Turner, Jimmie Van Heusen, Judy Garland, Dean Martin, and Debbie Reynolds enjoyed the home-style Italian food and movie-business newcomers Pier Angelli, Grace Kelly, and Natalie Wood were also regulars, as was James Dean. When Dean was dating the nineteen-year-old Swiss actress Ursula Andress before she rose to James Bond fame, they could often be seen, sometimes barefoot, enjoying a romantic dinner here. But it was said he would complain when Ursula would insist on ordering steak instead of the cheaper spaghetti dinner. During those golden years of the new cinema, the Villa Capri was also frequently used for press parties.

Although the Villa Capri Building still stands, looking much as it did in its heyday, nowadays it houses only offices. Neighboring restaurant Don the Beachcomber has also vanished to become yet another parking lot.

Left: James Dean and Ursula Andress enjoying cake at Patsy D'Amore's going-away party.

Below: The facade of the Villa Capri Building is little changed today, but the villa now houses offices.

and today . . .

THE IVY

Surrounded by a white picket fence, the Ivy, at 113 North Robertson Boulevard, has long been one of Hollywood's premier restaurants. The charming ivy-covered patio and country cottage appearance belie the powerhouse of guests that the Ivy attracts, including Faye Dunaway, Jennifer Lopez, Ben Affleck, Oprah Winfrey, John Travolta, Anjelica Huston, and Steve Martin. Opened in 1980, the Ivy is owned by Lynn von Kersting and chef Richard Irving, who started the famous L.A. Desserts bakery, which still exists on the Ivy property. The flower-filled patio becomes a hive of activity at midday when big agents, producers, executives, and bankable stars come to eat lunch and make deals. In the evening it is a haven where Hollywood legends come to relax.

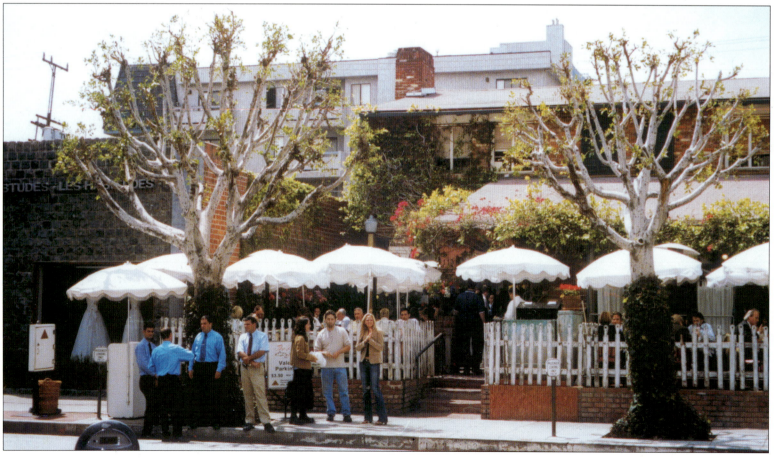

Left and Above: Paparazzi can often be seen in the streets opposite the Ivy, hoping to get a shot of one of the restaurant's famous guests. Regulars include Jennifer Lopez, Sharon Stone, and Madonna.

Above: The interior of Morton's.

MORTON'S

Morton's boasts an impressive list of famous diners, including Tom Cruise, Barbra Streisand, Sidney Poitier, and Arnold Schwarzenegger. On Monday night it is also the hangout for the crème de la crème of Hollywood's power players: Jack Nicholson, Steven Spielberg, David Geffen, Jeffrey Katzenberg, and Warren Beatty. This simple, elegant restaurant, hidden behind a swath of palm trees on the corner of Robertson and Melrose, is an unofficial private club for the seriously important of Hollywood. Originally the site of Tramps, the British legacy favored by Michael Caine, Jackie Collins, and the Brit-pack of the 1970s, Morton's is a family affair. It is now established as a place for Hollywood to meet and make deals and also hosts fabulous parties for those who can afford to rent the restaurant out for an evening. The Vanity Fair post-Oscar party is held here every year and is considered to be the most exclusive in town, with a guest list featuring a host of stars.

Left: The entrance to Morton's, complete with palm trees.

HOUSE OF BLUES

In 1992 the House of Blues Sunset Strip opened its doors at 8430 Sunset Boulevard, changing the Los Angeles music scene forever. It was built on the site of acting legend John Barrymore's estate, which later became the hippie restaurant Butterfields. The House of Blues was founded in Cambridge, Massachusetts, in 1992 as a home for blues music, folk art, and Southern-inspired cuisine and a second venue was soon opened in New Orleans. Founded by *Blues Brothers* star Dan Aykroyd and Isaac Tigret (cofounder of the Hard Rock Café), celebrity investors include Jim Belushi, George Wendt, and Isaac Hayes. The old tin cotton-gin design was based on one in Mississippi where Muddy Waters once worked. Sheets of corrugated tin were shipped from that very site and installed at the West Hollywood site, along with cartons of Mississippi dirt for authenticity. The "visual blues" inside include over a thousand pieces of American folk art on the walls. Hollywood has turned out in force to see this new star in town; Magic Johnson, Robert De Niro, John Lee Hooker, Steven Spielberg, Sylvester Stallone, Madonna, Brad Pitt, Bruce Springsteen, Etta James, Little Richard, Smokey Robinson, James Brown, and Crosby, Stills & Nash have all been here, and many have performed.

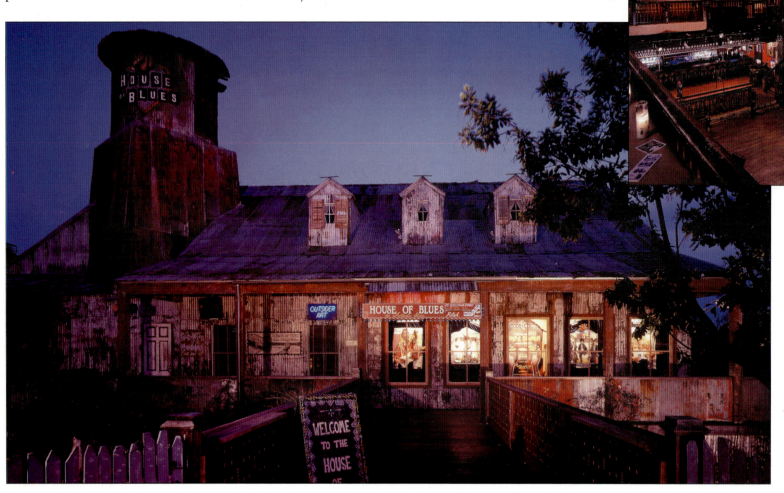

Left and Above: The House of Blues pays homage to the styles of the old South both inside and out.

Above: The decor of Spago is chic and elegant, the perfect setting for the amazing food offered here.

SPAGO

In 1997 Wolfgang Puck's greatly anticipated restaurant, Spago, opened in Beverly Hills, at 176 North Canon Drive, where the famous Bistro Garden used to be. The public was not disappointed. It features glass Italian chandeliers, jewel-colored art glass, and impressive contemporary artwork, in addition to exotic flora, fountains, a lush romantic garden, and ancient olive trees. There is, of course, the signature open-style kitchen. This vision came from Puck's designer-partner Barbara Lazaroff, whose innovative designs have received critical acclaim. Austrian-born Wolfgang Puck has attracted a high-end celebrity crowd since his days as chef at Patrick Terrail's Ma Maison in Hollywood. At the now-closed original Spago in Hollywood, Puck's exotic pizzas became as famous as his guests, which included Joan Collins, Michael Douglas, Michael Caine, and Jack Lemmon. This was where the Oscar party tradition was started by the legendary Swifty Lazaar. At the Beverly Hills Spago, the tradition has been continued by Elton John. He hosted his first Oscar party for his AIDS foundation in 1998. Some of Hollywood's brightest, including Sharon Stone, Robin Williams, Kim Basinger, Natalie Cole, Kevin Spacey, and Jon Bon Jovi, were in attendance. Oscar, Emmy, and studio and charity events have all been celebrated at Spago.

THE MAGIC CONTINUES

The legendary Hollywood film pioneers who moved us from the silent era into talkies are gone. From D. W. Griffith, Cecil B. De Mille, Charlie Chaplin, and Dorothy Arzner (Hollywood's first woman director) to John Ford, William Wyler, and Billy Wilder, they sculpted and crafted their visions on celluloid. Robert Wise changed the American musical forever with *West Side Story,* and Orson Welles, *Citizen Kane*'s maverick director, is among the myriad filmmakers whose work has been a legacy. Today's directors still employ the story-telling techniques developed by their predecessors, but they can also choose from a staggering palette of special effects that yesterday's directors could not have imagined. Many modern Hollywood blockbusters now owe as much to computer wizardry as they do to traditional camera techniques, though the vision of the directors and producers remains the driving force behind the images on screen. The likes of the Wachowski brothers, writers and directors of the incredibly successful Matrix trilogy, constantly push the boundaries of Hollywood movies in search of ever greater verisimilitude and, of course, ever greater thrills. Now, as then, Hollywood celebrates in style its best and brightest from in front and behind the camera. The famous hand- and footprints outside Grauman's Chinese Theatre and the star-studded Walk of Fame attract millions of tourists, and the great annual awards ceremonies give rise to months of speculation and draw massive television ratings around the globe.

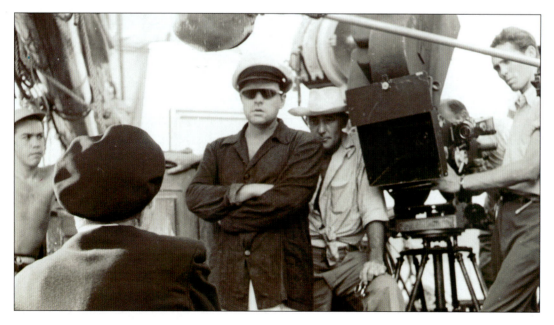

Above: John Ford in 1954. His contributions to celluloid history include some of the most critically acclaimed Westerns, including *Fort Apache, My Darling Clementine,* and *The Searchers.*

Left: Orson Welles on set early in his career. The director's achievements include *Citizen Kane,* held by many critics and fans to be the best movie ever made.

Far Right: Steven Spielberg with Drew Barrymore, who starred in his film *E.T.* in 1982. His career spans four decades, and recent movies include *Catch Me If You Can* and *Minority Report.*

Right: Larry and Andy Wachowski, who wrote and directed the *Matrix* trilogy, at the premiere of the first movie.

Below: Director Spike Lee on set. His directorial debut was *She's Gotta Have It* in 1986.

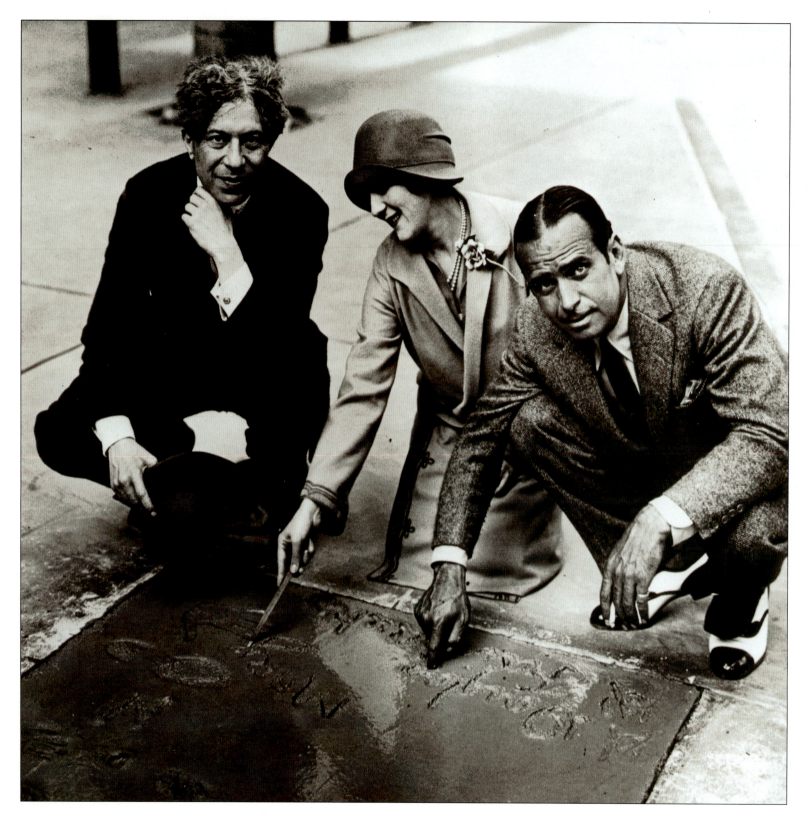

Left: Douglas Fairbanks and Mary Pickford, pictured here with Sid Grauman, in the very first hand- and footprints ceremony.

Right: The prints of Clark Gable, Bette Davis, Marilyn Monroe, and Cecil B. De Mille.

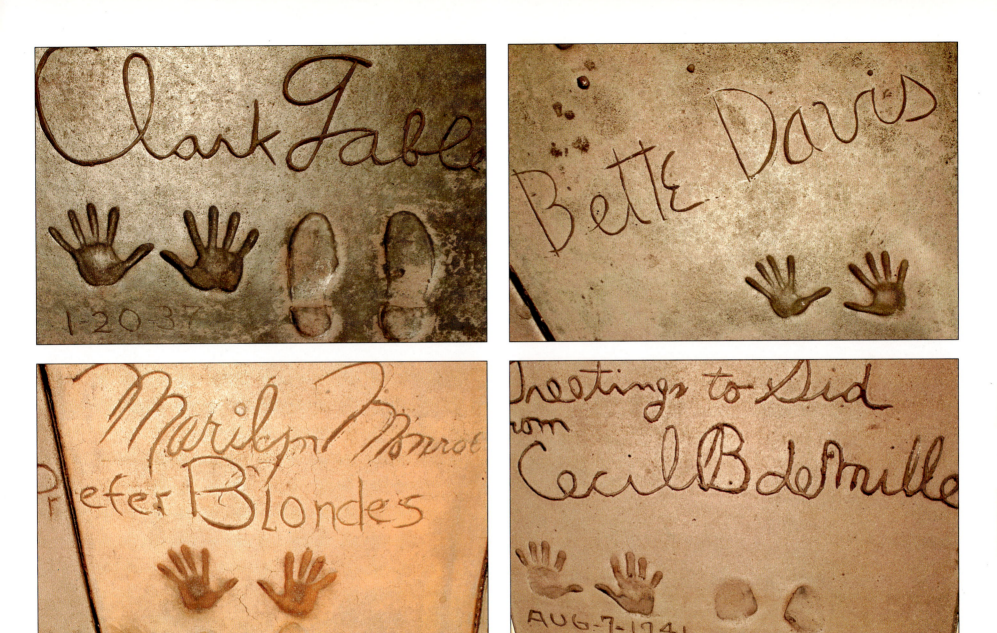

HAND- AND FOOTPRINTS CEREMONY

The famous hand- and footprints in the forecourt of Grauman's Chinese Theatre began back in 1927—by accident. Actress Norma Talmadge stumbled onto freshly laid cement in the theater forecourt, causing showman Sid Grauman to come up with the brilliant idea of having stars make impressions on the concrete on purpose. The very first hand- and footprints were actually those of Mary Pickford and Douglas Fairbanks on April 30, 1927. Norma Talmadge's ceremony was the second, on May 18, 1927—her unique block boasts two sets of footprints. Since then more than 240 celebrities have been immortalized in the forecourt. In 1939 when Ginger Rogers did her prints, she borrowed her mother's shoes, which were smaller. Steven Spielberg and George Lucas left sneaker prints. More recent hand- and footprints have been made by Anthony Hopkins and Nicholas Cage. Johnny Grant, ceremonial mayor of Hollywood, has been master of these ceremonies since 1980.

THE HOLLYWOOD WALK OF FAME

The world's most famous sidewalk began as a legacy from the famed Hollywood Hotel. When it was demolished in 1956, the gold stars that had been painted on the hotel ceiling had the names of celebrity guests painted across them. The idea evolved into the Walk of Fame, a permanent monument of the past, as well as the present. This tribute is a coveted recognition immortalized in a bronze star and embedded in pink terrazzo. Inside each star is the bronze engraved name of each artist and a distinctive emblem identifying in which of the five categories the artist has made his/her mark—motion pictures, television, radio, recording, or live theater. The very first Walk of Fame ceremony was held on February 9, 1960, honoring Joanne Woodward. Sixteen months later, when five acres of Hollywood sidewalks had been laid with bronze stars, 1,558 celebrities were forever immortalized in the sidewalk. Two dogs have stars imprinted: Lassie and Rin Tin Tin. In 1962 the L.A. City Council appointed the Hollywood Chamber of Commerce to oversee the Walk of Fame. Johnny Grant, chairman of the Walk of Fame Committee since 1980, presides over each of these ceremonies.

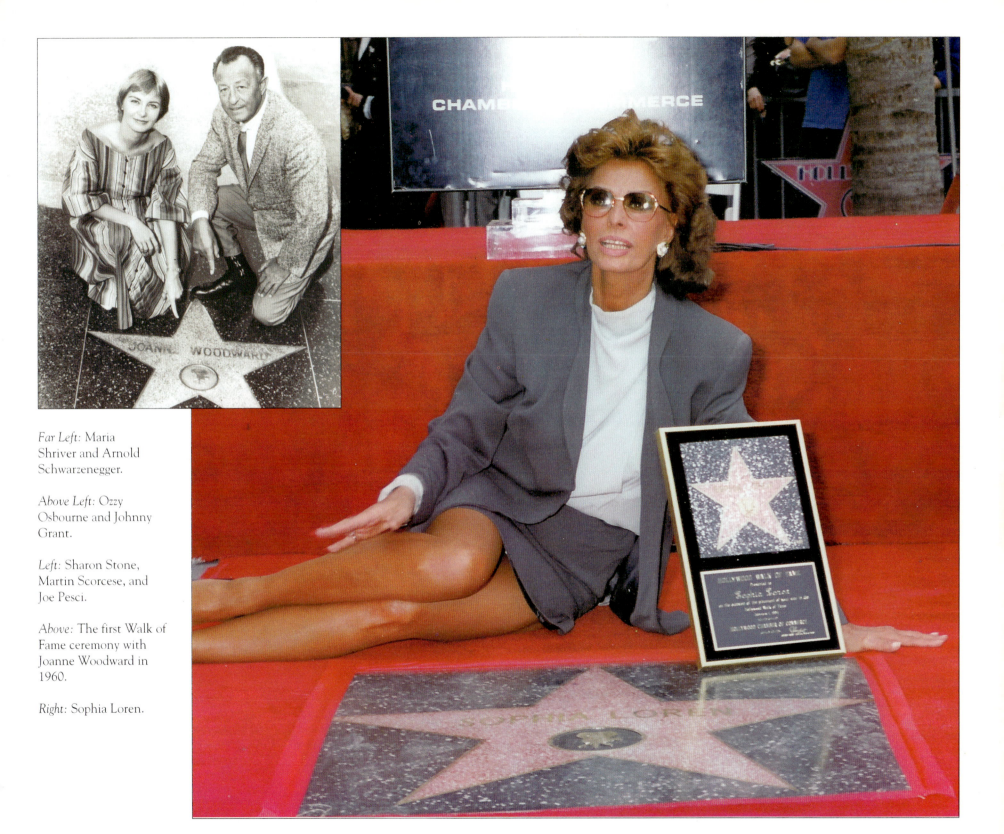

Far Left: Maria Shriver and Arnold Schwarzenegger.

Above Left: Ozzy Osbourne and Johnny Grant.

Left: Sharon Stone, Martin Scorcese, and Joe Pesci.

Above: The first Walk of Fame ceremony with Joanne Woodward in 1960.

Right: Sophia Loren.

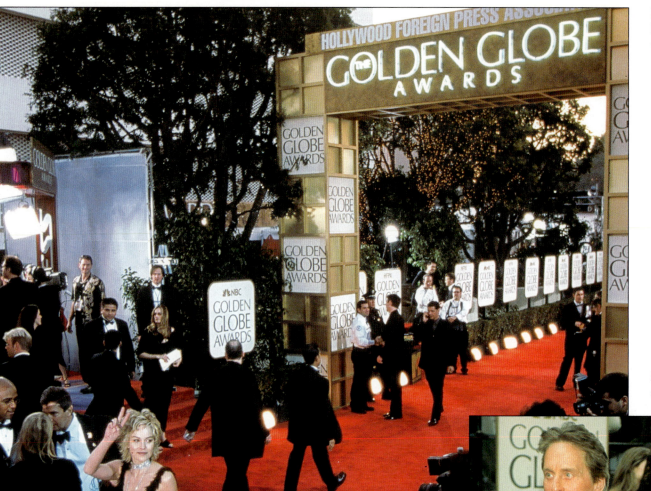

Left: The red carpet outside the Beverly Hilton hotel, where the Golden Globes are held every year.

Below: Hollywood golden couple Michael Douglas and Catherine Zeta-Jones arrive at the ceremony.

GOLDEN GLOBE AWARDS

In 1943 a number of well-respected foreign journalists living and working in Hollywood started the Hollywood Foreign Press Association, helping each other get stories home during World War II and sharing contacts and material. Over the years the association grew in numbers and prestige. They gave bon voyage luncheons to stars who were leaving to film in countries represented by the journalists. In the beginning, through polling nine hundred of their international papers and magazines, they found the male and female world favorites and added to those honors. This developed into the Golden Globe Awards, where the voting is strictly by membership.

The HFPA members represent magazines and newspapers in some fifty-five countries with a combined readership exceeding 250 million. The Hollywood Foreign Press Association attends more than two hundred interviews and activities with leading actors, directors, and writers. For voting purposes, the members see well over 250 films and television shows. The Golden Globes were born out of a wish to create a bridge between countries and cultures around the globe: a celebration rather than a competition. Perhaps this is why celebrities have always been delighted to attend the annual Golden Globe Awards banquet. Marilyn Monroe would turn up, as would Frank Sinatra, John Wayne, and Marlon Brando. The awards were first televised locally in 1962. The Beverly Hilton's International Ballroom has long been the setting for the ceremony. The show was popular and attracted the biggest names in Hollywood so in 1996 NBC began to broadcast it. The Golden Globes have become a remarkable predictor for Academy Award winners and are now seen in 125 countries. Many celebrities declare this "the best party in town."

Above: Jennifer Aniston and Brad Pitt.

Left: Liza Minnelli, Rock Hudson, and Elizabeth Taylor.

THE ACADEMY AWARDS

The first Academy Award banquet was on May 16, 1929, in the Blossom Room of the Hollywood Roosevelt Hotel. *Wings* won Outstanding Picture, Emil Jannings won Best Actor, and Janet Gaynor won Best Actress. Other categories included dramatic direction, comedy direction, adapted writing, title writing (for silent movies), original story, interior (art) decoration, cinematography, and engineering effects. The first talkie, *The Jazz Singer*, was given an honorary award, as was Charlie Chaplin for writing, directing, producing, and acting in *The Circus*.

The acting awards were given for a body of work. The winners were announced three months ahead of the banquet. The sealed-envelope system was first used in 1941 when the Shrine Auditorium first hosted the awards.

A trophy had been designed by MGM art director Cedric Gibbons: the Oscar, as it later became known. Judy Garland was given a petite juvenile Oscar, and Edgar Bergen and Charlie McCarthy received a wooden one. Walt Disney was given one regular-sized statue with seven little ones for *Snow White and the Seven Dwarfs*.

Tatum O'Neal remains the youngest competitive Oscar winner; she was ten years old when she won the Best Supporting Actress award for *Paper Moon*. Sophia Loren was the first actress to win the Best Actress Academy Award for a film in a foreign language for her role in the Italian film *Two Women*.

The 1930 Academy Awards ceremony, at the Cocoanut Grove, was the first to be broadcast on the radio. The first televised edition was in 1953 at the Pantages Theatre, with Bob Hope as master of ceremonies and Ronald Reagan announcing. In 1969 the show was broadcast from the Music Center. The awards then alternated between the Shrine and the Music Center.

In 2002 the Academy Awards finally moved into their own permanent home: the Kodak Theatre in the new Hollywood and Highland complex.

On Sunday, March 24, 2002, Hollywood made history, twice in fact. Halle Berry became the first African American to win the Best Actress Oscar, for *Monster's Ball*, and Denzel Washington won the Best Actor award for *Training Day*. It was the first time two African American actors had won the industry's highest accolades on the same evening.

Right: The major Oscar winners, March 23, 2003. Clockwise from top left: Nicole Kidman, *The Hours* (Best Actress), Catherine Zeta-Jones, *Chicago* (Best Supporting Actress), Pedro Almodóvar, *Talk To Her* (Best Original Screenplay), Chris Cooper, *Adaptation* (Best Supporting Actor), Martin Richards, producer, *Chicago* (Best Picture), Adrien Brody, *The Pianist* (Best Actor).

Below: In 2002, Halle Berry became the first African American woman to win a Best Actress Oscar.

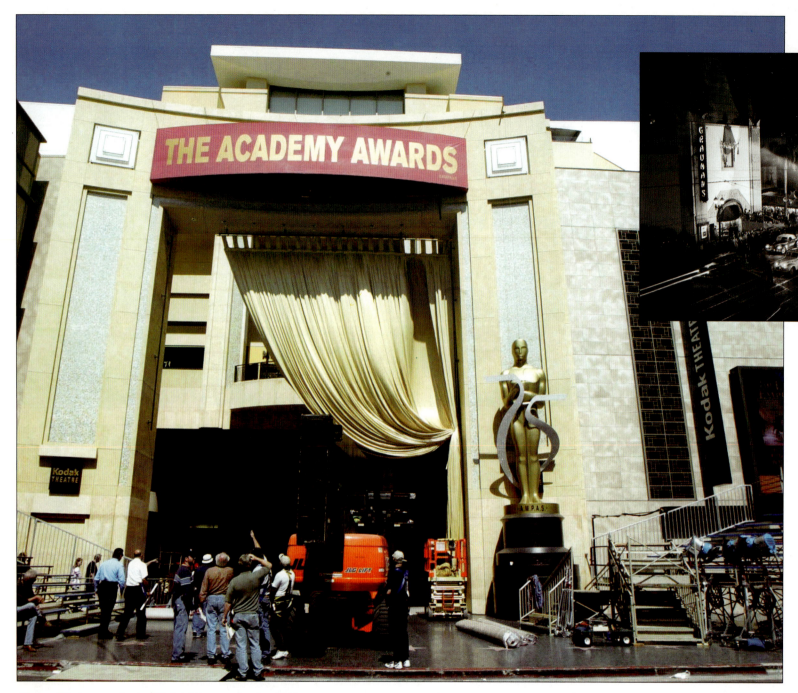

Above: The Academy
Awards ceremony at
Grauman's Chinese
Theatre, 1943.

Above: Workers ready the Kodak Theatre for the 2003
event. This was a comparatively low-key ceremony
because of the war in Iraq.

Right: And that's a wrap! Douglas Fairbanks, Mary
Pickford, and Charlie Chaplin.

INDEX